The Illustrated Rumi

A Treasury of Wisdom from the Poet of the Soul

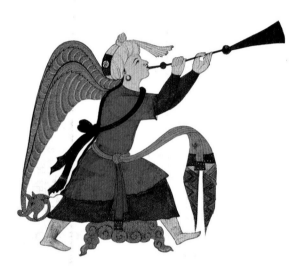

To each other

The Illustrated Rumi

A Treasury of Wisdom from the Poet of the Soul

A New Translation by

PHILIP DUNN, MANUELA DUNN MASCETTI, and R. A. NICHOLSON

Foreword by

HUSTON SMITH

HarperSanFrancisco

A Division of HarperCollins*Publishers*

Harper Collins books may be purchased for educational, business, or sales promotional use.
For information please write: Special Markets Department,
HarperCollins Publishers Inc., 10 East 53rd Street, New York, NY 10022.

HarperCollins Web site: http://www.harpercollins.com
HarperCollins®, 📖®, and HarperSanFrancisco™ are trademarks of HarperCollins Publishers, Inc.

FIRST EDITION
Produced by The Book Laboratory™, Inc., Mill Valley, CA
Designed by MoonRunner Design Ltd., Charmouth, UK
Editorial Assistance by Asha Johnson

Library of Congress Cataloging-in-Publication Data
Jalal al-Din Rumi, Maulana, 1207–1273.
[Selections. English. 2000]
The illustrated Rumi : a treasury of wisdom from the poet of the soul : a new translation
/by Philip Dunn, Manuela Dunn Mascetti, and R.A. Nicholson ; foreword by Huston Smith.

p. cm
Includes bibliographical references.
ISBN 0-006-062017-X (cloth)
1. Jalal al-Dan Rama, Maulana, 1207–1273—Translations into English. I. Dunn, Philip.
II. Dunn-Mascetti, Manuela. III. Nicholson, Reynold Alleyne, 1868–1945. IV. Title.
PK6480.E5 D86 2000
891'.5511—dc21 00-040761

Printed in USA
00 01 02 03 04 / QK 10 9 8 7 6 5 4 3 2 1

Contents

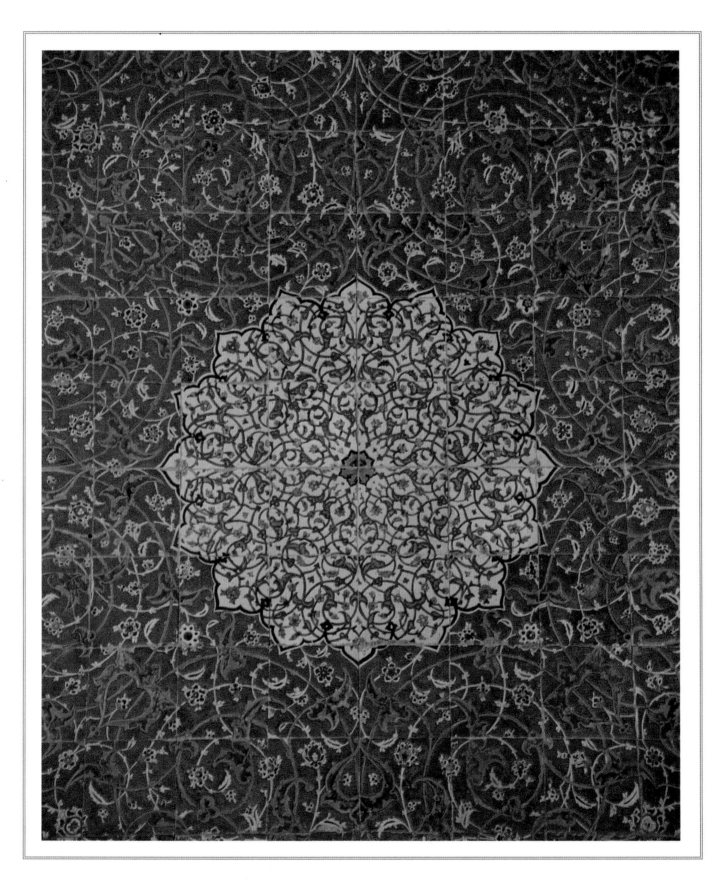

Foreword by Huston Smith

THRICE IN FOURTEEN CENTURIES of deeply troubled political relationships, the West has opened its heart to Islam and been touched by its soul.

First there was *The Ruba'iyat of Omar Khayyam*, which, in Edward FitzGerald's translation, created something of a cult in the West. Its best known stanza still rings in our ears:

A book of Verse underneath the Bough,
A jug of Wine, a Loaf of bread - And Thou
Beside me singing in the Wilderness -
O, Wilderness were Paradise enow!

Then came T.E.Lawrence, whose adventures gave rise to the motion picture extravaganza *Lawrence of Arabia*, based on his autobiographical *The Seven Pillars of Wisdom*. And now we have Jalalu'ddin Rumi, who, eight centuries after his death, has been for almost a decade the best-selling poet in America. It is not difficult to account for these romances, which are reminiscent of the West's romance with Zen following World War II. In the *Ruba'iyat*, poetry holds the key, for it speaks a universal language. In Lawrence's case the common objective of overthrowing the Ottoman Empire brought England and Arabia together for a time. As for Rumi, poetry again enters, but this time with mysticism added. This is a winning combination, for poetry and mysticism are both universal languages of the human soul and nowhere do they reenforce each other more than in the life and legacy of Jalalu'ddin Rumi. His name literally means Majesty of Religion (*jalal*, majesty; *din*, religion), and this is worth mentioning in a book that is itself a majestic tribute to Rumi's life and work.

Sufism, which westerners have almost come to equate with Rumi, is in fact the mystical dimension of Islam as a whole. Its name derives primarily from the coarse woolen garments its early adherents wore, and (though the adjective sounds odd here) it is not misleading to think of the Sufis as *impatient* Muslims. Every upright Muslim expects to see God after death, but the Sufis want Allah now, moment by moment at the very center of their lives. This takes doing, and those who were willing to make the effort attracted followers who (recognizing their attainments) considered them their *shaikhs*, or masters, and formed Sufi Orders around them. Rumi's father was such a shaikh in Konya, now in Turkey, and when he died his son succeeded him. However, Rumi's own creativity and spiritual attainment proved to be too great to fit the existing mold, and gave rise to a new lineage, the *Mevlevi* Order. The word *mevlevi* means "our lord," the title that Rumi's followers addressed him by, and etymologists have also conjectured that it carries traces of the word *tevellu* which appears in a Koranic dictum Sufis make much of, "Wheresoe'er one turns, there is the face of Allah." In any case, the Order became famous for

the sacred dance that was its central practice - on pages 10 and 11 it is depicted photographically, and on page 173 stylistically. Rumi often found himself drawn to circle a pillar in his mosque; with one hand cupped around the pillar, he would lean back from it while he gyrated. The symbolism of planets circling their sun may have contributed to the fact that the movement elevated him and caused torrents of ecstatic poetry to pour from his lips. His disciples came to mimic this movement when they gathered for their ritual meetings. In their case they circled not a pillar, but (for the first half of the dance) a red sheepskin in the center of the hall representing Rumi's teacher, the wandering *dervish* Shams of Tabriz, and for the second half, their Rumi himself when he entered the hall. From this practice, the *mevlevis* came to be known as Whirling Dervishes, *darvish* being the Persian word for "poor in spirit," or humility, as movingly depicted on the dust jacket of this book and on page 17. The Mevlevi Order acquired such strength that it came to span the two main branches of Islam: its larger, "traditional" Sunni branch (*sunnah* means traditional), and the Shi'ite branch which centers in what was formerly Persia. The word *shi'a* literally means "partisan," and refers here to the Partisans of Ali, Muhammad's son-in-law, whom Shi'ites believe should have been named Muhammad's successor but was unfairly passed over. In the course of time the Mevlevi dance took on the colorations of its respective hosts and the objective of the dance came to differ somewhat according to which branch of Islam it is performed in. In Shi'ism (the more emotion-

ally inclined of the two sects) the whirling of the ritual dance aims to induce God-intoxicated ecstasy, whereas among Sunnis it serves more as the means for encircling and approaching the divine lover who is Allah himself.

A second distinctive feature of the Mevlevi Order is its emphasis on music. Other orders tend to be suspicious of music, fearing the emotionalism it can easily induce, but the Mevlevis regard it as an approach to God. Novices are required to learn a ritually approved instrument or join a chorus, and these requirements made

Geometry, the symbol and evidence of order in the universe, appears in straightforward polygonal forms, but as often as not it is hidden in the foliage of a leafy arabesque, a word that openly announces its Arabic origin. Rhythmically repeated patterns remind us of infinity and a world of unity beyond forms. Conveying this message of unity is the ultimate function of Islamic art, and the selections in this volume realize that purpose impressively.

The text that accompanies the illustrations in this book uses primarily the six books of the *Mathnawi* - one of the two enormous compendia of Rumi's poems and teaching tales - as its organizer. The verses of the *Mathnawi* represent a highly accomplished spiritualization of Sufism while remaining completely true to Islamic orthodoxy. Their persistent themes are the longing for the eternal, the reuniting with Allah, enlightenment through love, and the merging of one's self with the universal spirit of the world. To add one of my favorite passages to the ones the editors have skillfully selected for this volume, it reads:

The senses and thoughts are like weeds on the clear water's surface.

The hand of the heart sweeps the weeds aside: then the water is revealed to the heart.

Unless Allah loose the hand of the heart, the weeds on our water are increased by worldly desires.

When piety has chained the hands of desire, Allah looses the hands of the heart.

We have it from Plotinus that to behold the beautiful is to become beautiful. If he was right, this wonderfully conceived and executed volume should help the project along.

the Mevlevi Order something like a school of Music for the Ottoman Empire.

It is the visual art of Islam, however - primarily its Persian motifs - that this volume sumptuously displays. As might be expected, calligraphy figures somewhere on most of these pages. Personally, I have never been able to decide whether Chinese or Islamic calligraphy is more beautiful, and I am glad that I cannot, because it allows me to honor both equally. Beyond its calligraphy, the blending of organic and geometric forms is a distinctive feature of Islamic art.

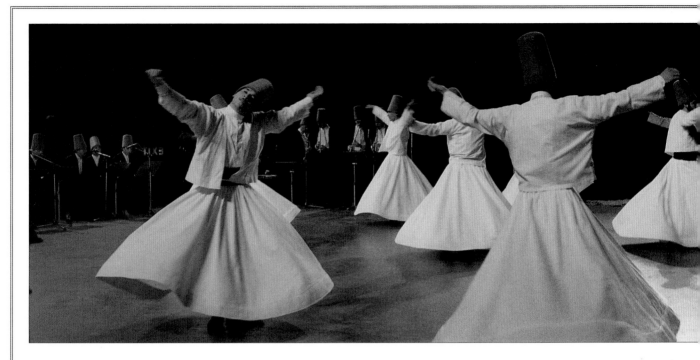

Notes on the Translation and Interpretation

*J*ALALU'DDIN RUMI WAS A STORYTELLER who spoke to those who listened in song-like tales that metered and rhymed like music. Persian sacred poetry rhymes and is written in quatrains (or couplets), but this material is extremely difficult to translate literally into English, as the two languages are so very different. Thus, Rumi has been hitherto translated in a number of different ways: free style, poetry, prose, and rhyming poetry. *The Illustrated Rumi* is both poetic and song-like. Primarily we have focused on the stories, which were originally written in Persian line songs as sacred poems. The book relates the tales that Rumi told and brings also a sense of the verse where it seems appropriate, essentially within the parts of the *Mathnawi* that are the spiritual teaching and within the sections devoted to Shams of Tabriz and Rumi's *Ruba'iyat*. The tales are therefore poetic parables with strong and enduring spiritual messages that touch us all eternally, and outside any particular spiritual tradition, though with often a strong flavor of Islam.

Because Rumi has attained great popularity in Western cultural awareness in recent years, with the help of the work of writers such as Annemarie Schimmel, Camille and Kabir Helminski, and Coleman Barks, most readers of Rumi's work in English imagine him to have been primarily a poet. These authors' works have permitted modern Western readers to comprehend the extraordinary nature of this "speaker of the divine word" in a way that translators have not done before, with the foundational aid of this century's single greatest influence on the works of Rumi—Reynold Nicholson, who has almost certainly provided the background to the work of every translator/interpreter of the Persian master during the 20th century. Nicholson did not attempt to express Rumi as only a poet but provided literal translations of the master, giving us all the bare bones of Rumi's Islamic, Arabic force in English in the best way anyone could. But there is no rhyme and there is no meter as such in the English version, so we are

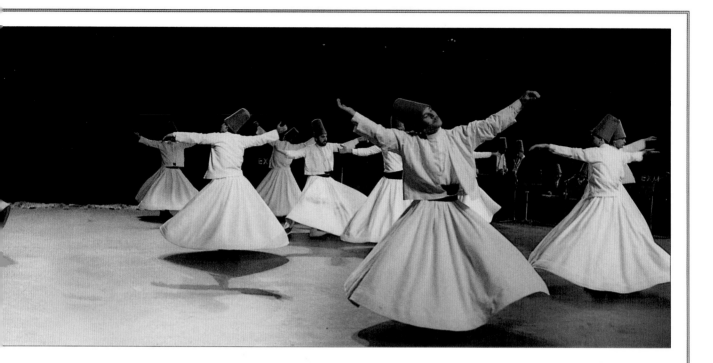

offered a naked skeleton upon which we may grow flesh, muscle, and skin to whatever extent seems right for the nature of each tale.

The Illustrated Rumi is a fresh interpretation of a selection of tales and poems from Rumi's best-known work, the Mathnawi, and from other of his works including a section from the Divani Shamsi Tabriz, written for his dearest life-friend, and from the Ruba'iyat of Jalalu'ddin Rumi.

The intention in this work is also, of course, to enhance the vision of the mystic with art that carries the reader into the essence of Rumi's time and the beauty of Sufism as it was then and remains now. The Illustrated Rumi is intended, therefore, as the classic Rumi. The text in these pages follows the style of the mystic in a way that was not undertaken in recent works by the Helminskis and Coleman Barks, insofar as here the reader will find a mixture of tales or parables and poetry, interwoven. It is felt that the tradition of

the storyteller was one that Rumi intended, and that this provides an extra dimension to the material. The tales chosen, therefore, are both parables of spiritual teaching and a joy to read as simple stories told by the master.

A large part of the visualization of this book is from the tradition of the Persian miniature, where scenes depict Rumi's various tales. In addition, we have included scenes from those parts of the world that most epitomize the Islamic tradition, as well as numerous designs and plates that bring the beauty of Islam and Sufism to the modern reader. The essence of the book is intended to be the essence of the particular nature of Islam, both in words and pictures, emphasizing its power and passion, its divinity and beauty, so that the modern reader may appreciate how the foundation of Islam was built on song, parable, and love, divine nature and inspiration, through the works of one very special individual.

Introduction

Jalalu'ddin Rumi

The Awakening

"These are our works, these works our soul displays;
Behold our works when we have passed away."

JALALU'DDIN RUMI WAS BORN in the year 1207 in Balkh, Afghanistan, during the Persian Empire. As a child, he and his family escaped Afghanistan to Konya in Turkey, as the Mongol armies invaded. Bahauddin Walad, Rumi's father, was a theologian and jurist who worked at the university of Konya. As a great religious teacher, he wrote texts of his ecstatic visions, entitled *Maarif*, that are still read today. Bahauddin took charge of Rumi's spiritual education through the boy's childhood, but upon his death he entrusted his close friend, Sayyid Burhaneddin of Balkh, with his son's further training. Rumi was twenty-four when his father died, and he continued with Sayyid Burhaneddin as his teacher for some nine years. During this time he learned about fasting and meditation, and he traveled to Aleppo and Damascus, centers of learning where he studied with the most renowned teachers.

As the years passed, Rumi became an excellent scholar himself, learned in the knowledge of the sacred texts of Sufism and in his own experience of the divine. Burhaneddin eventually sought the sanctuary of a secluded life and told Rumi as he departed, "You are now ready, my son. You have no equal in any of the branches of learning. You have become a lion of knowledge. I am such a lion myself and we are not needed here and that is why I want to go. Furthermore, a great friend will come to you, and you will be each other's mirror. He will lead you to the innermost parts of the spiritual world, just as you will lead him. Each of you will complete the other, and you will be the greatest friends in the entire world." Burhaneddin had foreseen the intimate and fundamental relationship that Rumi would enter with the Sufi master Shams of Tabriz much later in his life.

After his years of study with Burhaneddin, Rumi took over his father's position as sheikh in the dervish learning community of Konya: teaching, meditating, fasting, and helping people in the community.

The dervish communities of Persia, Turkey, and their neighboring countries were centers of learning and of the practice of Sufism, the mystical current of Islam. Today, Sufism claims global interest and curiosity among non-Muslims, partly because so many are inspired and awakened by the powerful tales and poetry of one of its most beautiful voices, that of

Nº Mowlana Djelaleddin, a turk of Natoly, author of the Mesnevi Romi, an excellent lit treatise of Ethics in Persian verses, sung all over Persia, turky and in India in Companies.

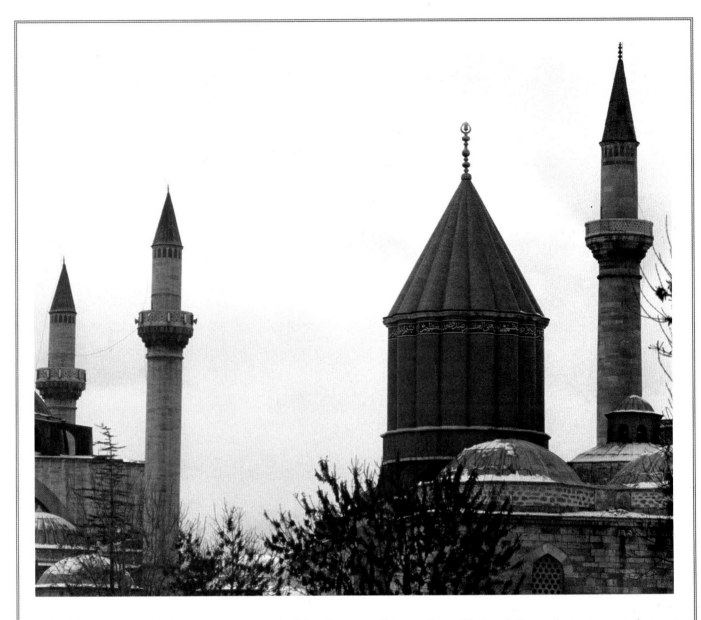

Jalalu'ddín Rumi. This interest is also sparked by the accessibility and appeal of the inward aspects of Sufism, the rose at the center of the mystery the pure heart of divine love and gnosis.

Derived from the Arabic word *tasawwuf*, the root of the word Sufism is linked to the *suffa*, or veranda, of the Mosque of the Prophet in Medina, home to several of his greatest Companions; to *suf*, meaning wool, the traditional garment worn by the mystics of Islam; to *safa*, purity; and to the Greek *sophia*, wisdom. Each of these derivations indicates important aspects of what Sufism is. As a scientific and spiritual way of self-purification and self-realization, Sufism represents the initiate path (*tariqa*), the inner reality of Islam (*haqiqa*) that complements its law (*shari 'a*) and deepens the awareness of its profound understanding. The central doctrine of Sufism is that of Divine Unity: *La ilaha illa 'Llah*, there is no God but God, who is One. The practice of Sufism is the seeking of truth through love and devotion to

God; a Sufi is a lover of Truth, of the perfection of the absolute. Rumi explains how far we are from the attainment of unity with this wonderful tale of *The Elephant in the Dark House.*

There was an elephant in a dark house, brought by some Hindus for exhibition. Many people went to see it and had to enter the dark stable to do so. Because it was so dark they could not make out the form of the elephant at all and had to work with their hands to identify its being, each person using his palm to find the shape. The hand of one fell on the creature's trunk and he said, "This is a water pipe." The hand of another touched the ear and found a fan. Another handled the elephant's leg and found a pillar, while another touched the back and discovered a throne. There were those who heard descriptions from these folk and made their own identifications, and there were still others who interpreted one shape as against another, all very diverse and contrary.

Like the elephant, existence, according to Sufi cosmology, is like an unimaginably vast tapestry woven from divine qualities. Only by distancing ourselves from the surface immediately before us can we hope to find its meaning and our own place in the tapestry. Each moment God manifests Himself to us in creation. In order to see the truth, a Sufi must see with his inner being, in harmony with divine nature. Through devotion to and selfless remembrance of God, *dhikr Allah,* the Sufi disciple's attention to the self falls away, and in turning to God, his heart and soul are transformed by God's divine attributes. In this spiritual state of the self-having-passed-away-in-God, or *fana',* a Sufi existentially realizes the Truth. This Divine Unity is the aim of Sufism.

The years of intense study, meditation, fasting, spiritual exercises, teaching, and absorbing the sacred scriptures of Islam had ripened Rumi's soul for a powerful spiritual awakening. The ground of being was fertile and ready to be sown: Rumi had become an eminent professor of religion in Konya and a highly attained mystic.

At the age of thirty-seven, Jalalu'ddín Rumi met Shams of Tabriz, a wandering mystic of great spiritual power. This meeting, which has been much chronicled, was like the spark that ignites the flame. It set two souls on fire with God's essence and produced in Rumi a poet and a lover of humanity like few before or since. It is said that Shams had been wandering from country to country, from community to community, in search of a vessel, a being that would receive his burning knowledge of God, and when he finally met Rumi his spiritual thirst was satiated. The two spent days and nights conversing about God and the mysteries, and their first encounter was as brief as it was powerful. Rumi was intoxicated both with Shams and with God, inebriated by a love few could understand, and this caused disturbance in his religious community. Sensing that trouble could come from Rumi's students, Shams suddenly vanished, leaving Rumi in a vacuum of unbearable loss. It was then perhaps, to fill the void, that he began to recite poetry; it is told that he would go to the mosque and there, holding onto a pillar and whirling around it, he chanted verse upon verse of praise for God, an expression of gratefulness for having been awakened by Shams. Rumi sent his son, Sultan Veled, in search of Shams, and the boy eventually found him in Damascus and brought him back home to his father. This time, Shams stayed,

living in Rumi's house and marrying a young girl brought up with the family. The intensity of Rumi's relationship with Shams was rekindled and so were the jealousies and concerns of the religious community that so loved Rumi. One evening Shams mysteriously vanished; some say he was murdered by Rumi's students. Rumi went in search of Shams and reached Damascus where, unable to find his friend, he turned back and realized that the search was not for Shams but rather that the search was inner, looking within his own spirit for the voice of the divine:

"Why should I search?
I am the same as he is.
His essence speaks through me.
His essence speaks through me."

In the absence of the object of his worshipful admiration, Rumi was forced to turn inward, to search inwardly for the fuel his great fire needed. This was then the moment when Rumi became a true mystic, forged by the fire of his own passion that now burned solely for itself. This was when Jalalu'ddín Rumi was able to fulfill his old teacher's prediction that he would one day "drown men's souls in a fresh life and the immeasurable abundance of God…and bring life to the dead of this false world with…meaning and love."

Rumi's genius is recorded in two great volumes of literature: the *Divani Shamsi Tabriz*, many verses of the most stunningly beautiful poetry, and the *Mathnawi*, 24,000 verses of a mystic's vision spanning the whole spectrum of life: from religion, to culture, sexuality, domestic matters, and character traits, as well as details of the natural world, history, and philosophy. Both the *Divani Shamsi Tabriz* and the *Mathnawi* are perhaps the greatest spiritual works written by one person and are a testimony to Rumi's great power and authority as a mystic and as a completed human being in whom the divine attributes are embodied. Rumi's own words in the preface of the *Mathnawi* give the dimensions of how powerful, how profound, and how transformative the poet's work is: his words are "…the roots of the roots of the roots of the roots of the Religion, unveiling the mysteries of attainment and certainty; and which is the greatest science of God and the clearest way of God and the most manifest evidence of God. It is the heart's paradise, having fountain and boughs…. Within it, the righteous eat and drink, and the free rejoice and are happy; and like the Nile of Egypt it is a refreshment to those who patiently endure but a grief to the people of Pharaoh and the faithless….It is the cure of hearts, and the purge of sorrows, and the interpreter of the Qur'an, and an abundant source of gifts, and the cleansing of character…since God observes it and protects it."

Rumi has influenced thousands of people across the centuries with his poetry and his vision of our relationship with God as a path of love. Today, he is considered the most popular poet in the United States and his verses are published in books, filmed on video, and set to music on CDs so that he remains the flame that keeps alive the force of the divine in every living heart that is touched by his words.

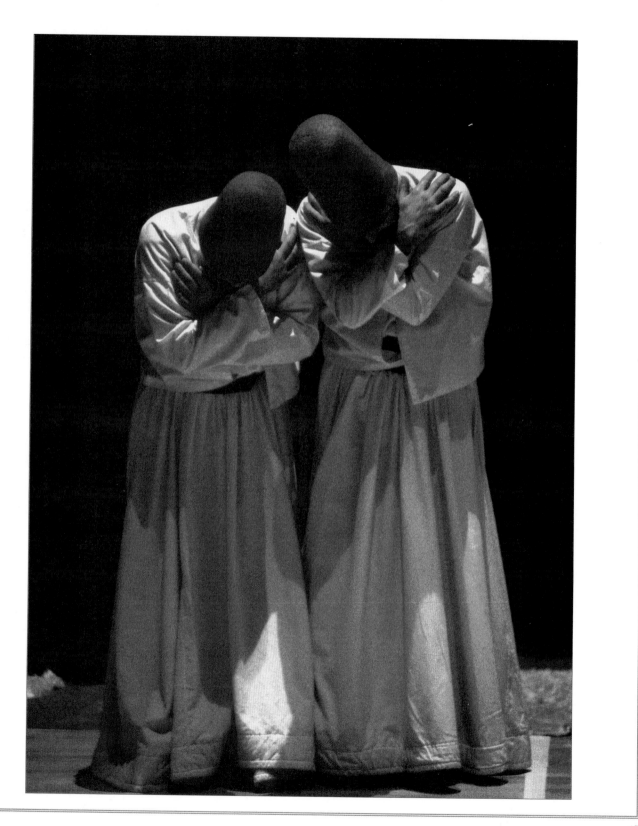

The Illustrated Edition

*W*ITHIN THE SUFI TRADITION the human being is considered the representative of God on earth. If we took this truth to heart and if for perhaps one day we would live as though everyone we love and relate to in our ordinary lives were the embodiment of the divine, then we would be completely transformed. What if you woke up next to your husband or wife and saw in them the radiance of the divine? What if you saw God's work in your children? What would happen to you then? A sense of awe and deep respect would settle into your heart, and also a sense of gratefulness for the bounty and beauty existence offers us every instant of our lives. And when the heart is filled with this kind of gratefulness, our being hums as though in prayer - not an outward act of saying a prayer, but rather a silent vibration, an adventure into the discovery that life is a gift, a mystery to be lived rather than a puzzle to be solved.

Here, then, is the embodiment of this new illustrated rendering of Rumi's work. Each section of the book represents a different aspect of Rumi's words, but all his words present the magic thread that we can follow to transform an everyday event into a jewel touched by divine wisdom. The book offers a new, modern translation of the sections of each of the works, so that we can practically apply them to our own lives and recapture the state of grace that Rumi engendered. The different works include material for lovers, for friends, for family, for advice on work, and many other aspects of our spiritual lives, in short, for situations that occur every day and that are potentially openings for a more profound experience of life's challenges and joys.

In Rumi's work is the soul of the universe; the interconnective tissue that heals all humans and their links to the divine, it embraces all peoples and all religions. His work unlocks love's precious secrets and initiates us into the mysteries of our most essential nature.

The Sufis understand the human heart to be the macrocosm, not just the microcosm, of the universe. Whatever is in your heart is everywhere. If you have anger in your heart, you will experience anger from others; if hate, you shall be hated; if love, you shall be loved. By knowing the mystery of your own heart, you begin to resonate with the mysteries of existence.

The Mathnawi

BOOK ONE

In The Name Of God
The Compassionate,
The Merciful

The stories and verses here
are from *"the Book of the Mathnawi,* which forms the roots
of the roots of the roots of the
(Mohammedan) Religion, in that it unveils the mysteries
that allow us to find the Truth, and attain certainty,
which is the science and the essence of God."

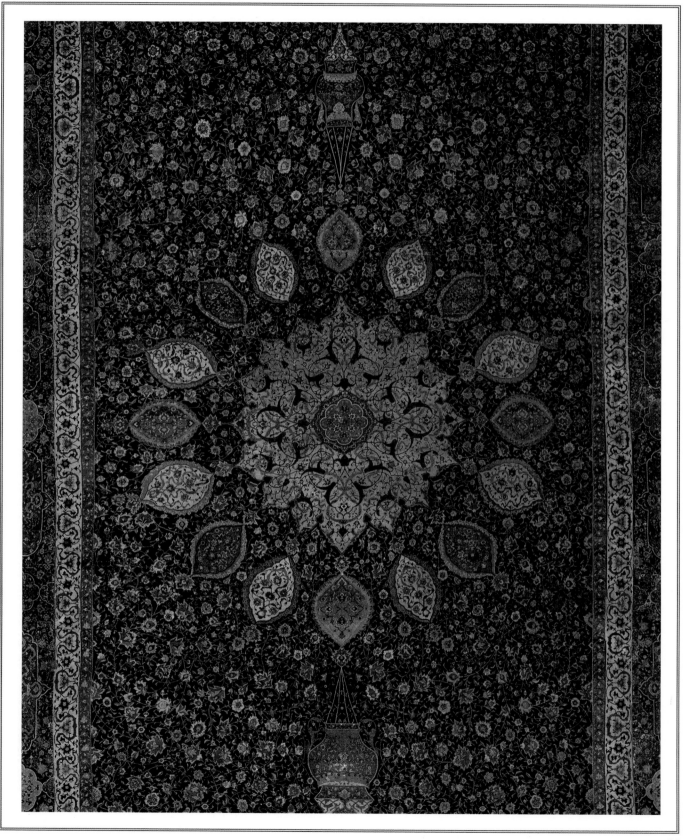

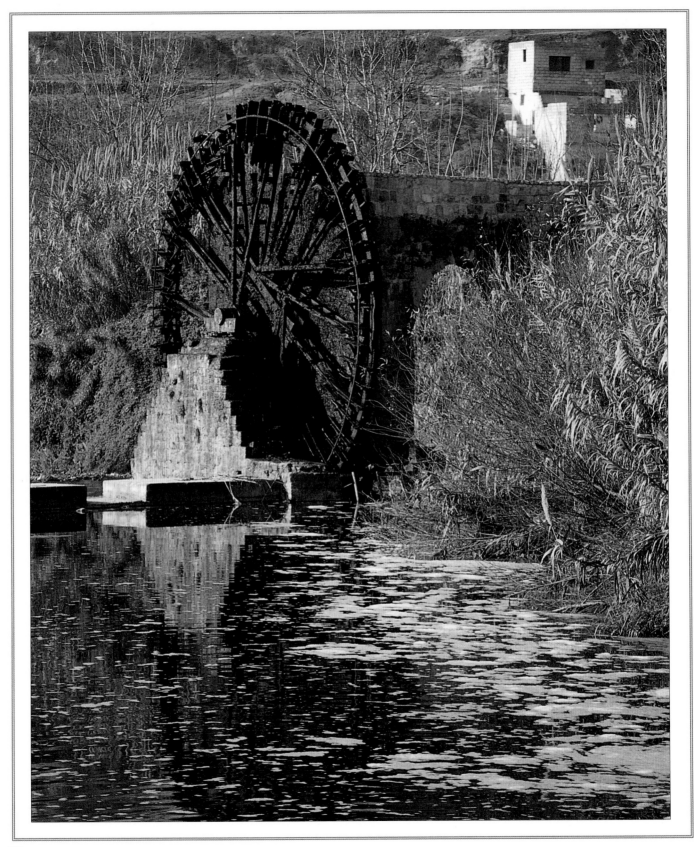

On Separation and Words

Listen to the reeds as they sway apart;
hear them speak of lost friends.
At birth, you were cut from your bed,
crying and grasping in separation.
Everyone listens, knowing your song.
You yearn for others who know your name,
and the words to your lament.
We are all the same, all the same, longing
to find our way back;
Back to the one, back to the only one.

Everywhere I told my story;
to the sad and the happy.
Everyone came close, but only
with their own secrets, never knowing mine.
My secret is hidden also from me,
for the light shines only outward.
The body and soul are intimate friends
but the soul remains secret from us all.

The sounds of the reed are like fire not wind,
and without this fire we are nothing.
The fire of the reed is the fire of Love,
the passion and heat of Love is in the wine.
This reed bends to spent lovers and friends;
its song and its words break the veil,
Both danger and delight, satyr and repletion,
the reed engorges and depletes, both.
The sensible are deaf; though the mindless listen,
the tongue wags only for the ear.

Our sadness spreads the days short, for time
walks hand-in-hand with painful thoughts and fears.
But let these loathsome days go by, who cares?
Stay in the moment, that holy moment,
your only moment, until the next—holier still.
We are thirsty fish in His blissful water,
like the starving buried in the feast of His sustenance.
So young our understanding, so mature
our surrounding—say less, learn more, depart.

All sons break free!
When will you let go your ambitions?
How much of the ocean fills your jar?
More than a day?
But the eye—never full—
yearns more than the heart—replete,
The oyster-shell forms the pearl only
when already filled.
Only the garment of love banishes desire and defect,
the panacea of ills,
As the garden-flowers fade, the bird's song dies.
The Beloved contains, the lover invades,
for the Beloved ignites the lover's pyre.
If love recalls, the lover swoops to the ground.
How blind my eyes when Her light is extinguished?
How will you see in the mirror
if the dust is so thick?
Love commands the word
for this is the marrow of your eyes.

The King's Handmaiden

*L*ONG AGO THERE WAS A KING who reigned in the name of man and God. One day he rode to the hunt and on his way met a handmaiden who caught his eye. His heart beating faster at her beauty, he brought her into his service, but once she was servant to his desire, she fell sick. The king had never loved like this, and as he learned to love, so the target for this love was being removed from him—he had been empty and was full, and now the fullness threatened to burst.

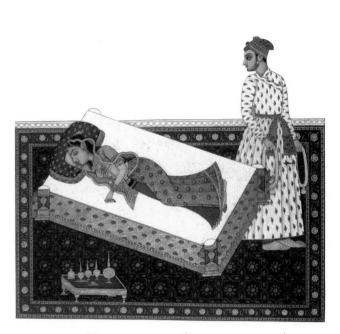

The king gathered his physicians about him and told them that his life and the handmaiden's were in their hands, that his life was of no account, for she was the life of his life. *"I am in pain and she is my remedy. Whoever heals her will have all my treasure."*

The physicians told the king that they would combine all their skills and that as they believed themselves to be the curers of all ills—Messiahs of the people—their powers would bring her back to the king.

In their arrogance and their hardness of heart they did not tell him that it was "God's will," and so God showed them their weakness, for the harder they tried their cures the more sick the handmaiden became. She was soon as thin as a hair, and the king's eyes flowed with tears from his suffering heart, like a bloody river.

The physicians' cures merely made matters worse as her body dried from their potions, and the king could see they were useless. He ran barefoot to the mosque and began to pray, the prayer-carpet becoming soaked with his tears.

"You whose least gift is the empire of the world, what should I say or do, for You alone know what the hidden truth is—and we have missed it yet again."

As he cried out in supplication and hopelessness, so life brought him the gift of an answer. He began to sleep deeply and dreamed of an old man who appeared before him.

The old man said, *"Good news my king, your prayers have been granted. Tomorrow I will send a stranger to you. He is a skilled physician—trust him for he is entirely true. His remedy contains magic and he speaks with the tongue of God."*

The following day the king sat expectantly in the belvedere as the sun rose and the daybreak burst over his horizon, the stars burning out of the sky to blueness. Coming from far away he saw the beauty and light of an exceptional man, bright and filled with light against all shadows that he passed. This

man was like the slender new moon's translucent light—transparent, almost nonexistent like a ghost, and yet the ghost bore a life of its own—a unique phantasm of such substance that the king was quite transported.

For in the spirit world such ghosts are common enough, their fantasy springing from emptiness. Imagine that the world should turn on such imaginings—peace and war built on dreams, pride and shame founded on ghosts! These are the dreams of the saints, born only from the legends and vapors of God's garden of hope.

The king walked toward this special guest from the Invisible World, knowing that he was a soul mate, saying, *"You are my most beloved, as 'Umar was to Mohammed. I will do whatever you wish of me."*

The king took the man to his heart, hugging him closely and kissing his hand and brow, inquiring as to his home and his journey, and leading him to a resting place. With great pleasure and happiness he spoke with him warmly and commended his being and his presence.

Then they went to the harem and the king told his guest of the girl's sickness as they sat by her bed.

The physician looked closely at the color of her face, took her pulse and checked her urine, all the time listening to the symptoms.

He told the king that the attempted cures from his other physicians were not only useless but damaging because they were ignorant of the inner causes of her malady. He could see a deep pain in her eyes and her being, but did not tell the king of this, because he knew that she suffered from a sickness of the heart.

Being in love manifests in a soreness of the heart—there's no sickness like heart-sickness, for love is the compass of God's mysteries.

So the physician told the king to send everyone far away, so they could not hear the things he would say to the handmaiden. Even the king had to leave, so that there was no one except the physician and the handmaiden.

Very gently, he said to her, *"Where is your home town, and who is related to you in that town?"* For the physician knew cures that were related to the native town of the patient, and the ones she loved or feared.

This physician was a keen detector of thorns. He asked her about the people she loved, and those she was related to, or friends with, and all the time he kept his hand on her pulse and listened to the beat of her heart as she gave answers to each inquiry. He would know of those she cared for, or desired, by the change in her pulse and by the color of her face. But there was no change. Her heartbeat remained always the same, and her face pale.

Then he asked her of people in another town nearby where she had lived, and of the people there. But still, there was no change in the beat of her pulse, until he asked her about the town of Samarcand—the sweetest city of them all—and her heart suddenly pounded fast and her face became red as she told of a goldsmith in Samarcand from whom she had been parted.

At once, the physician of the heart knew the cause of her sickness, so he asked her for the address of the goldsmith and told her to keep their secret to herself, and to tell no one else.

The physician pledged to take over her sadness. That his cure would do for her what the rain does for the meadow.

Upon her pulse he laid his gentle hand.
He spoke of the problems of life—
Like thorns in the foot, which are hard to find—
We moisten the spot, we touch the lip,
So painful, so tricky, a thorn in the foot,
Imagine how much harder a thorn in the heart?
If we all could find the thorns in our hearts,
No sorrow would gain the upper hand.

"Bury your secret
in the chamber of your heart.
Your unknown desire will burgeon.
Drop seeds to the bowels of the earth,
And the garden
will spring beyond belief."

And with this the handmaiden was greatly happier and gave up her fears.

Then the saintly physician left the handmaiden and went to the king and told him of what he planned. *"We must bring the goldsmith here for the sake of curing her sickness. Offer him gold and robes of honor."*

So the king sent just and competent messengers to Samarcand who beguiled the goldsmith with many compliments and flatteries, for the goldsmith was very arrogant and wanton. They told him that the king had chosen him for his skills as a goldsmith and his eminence as an individual.

The goldsmith set off to the king's palace wearing the grand robes he had been given, leaving his family behind him.

On arrival at the palace he was taken to the king where he might burn like a moth on a bright candle. He was offered further great riches and the company of the handmaiden. They were passionately joined and the goldsmith spent six months with her as they satisfied their strong desires for one another.

During this time the handmaiden was completely returned to health, and so the physician arranged for a potion to be given to the goldsmith that quickly reduced him to a yellow-cheeked and sallow man, and he became old and tired and much less than desirable to the handmaiden. And so she tired of him, for this had been only a love of outward beauty and was therefore easily disposed of.

His former handsome face
became his present disgrace,
* And so his sallow cheek,*
little by little unpleased her heart.
* Those loves that are only the pallor of the face,*
are not love at all,
* But only in the end disgrace,*
* For like the peacock's plumage,*
and like the finery of many a king,
* The outer ally of beauty*
became the inner enemy of ugliness.
* And soon he died from the poison*
administered by the physician.
* And the handmaiden*
was purged of her pain and love,
* For love of the dead cannot last, nor will it return.*
* And love of the living comes fresh.*
* Choose love of the living,*
drink the wine that brings more life.

This deed of killing may seem terrible, but it was committed by the hand of God through the holy physician, and one who can give life can also take it away. It was an act of good wearing the aspect of evil.

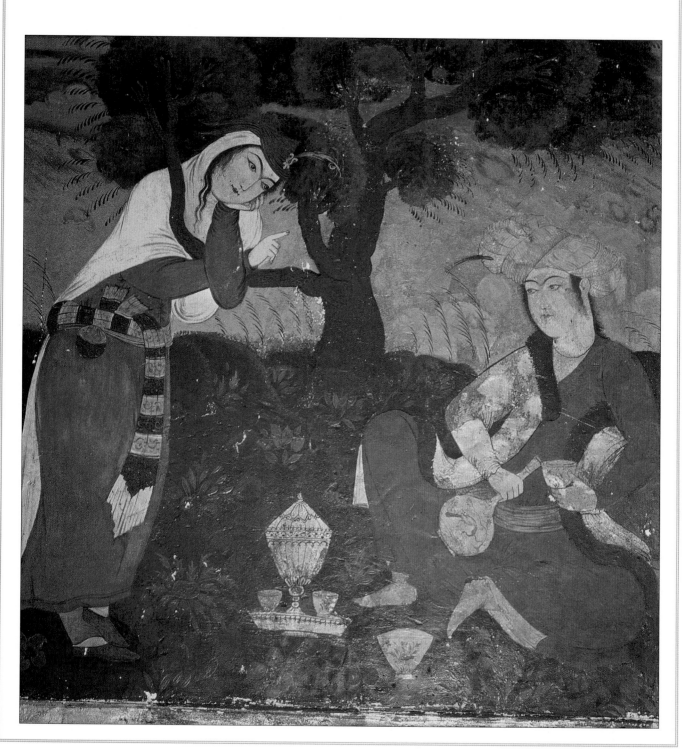

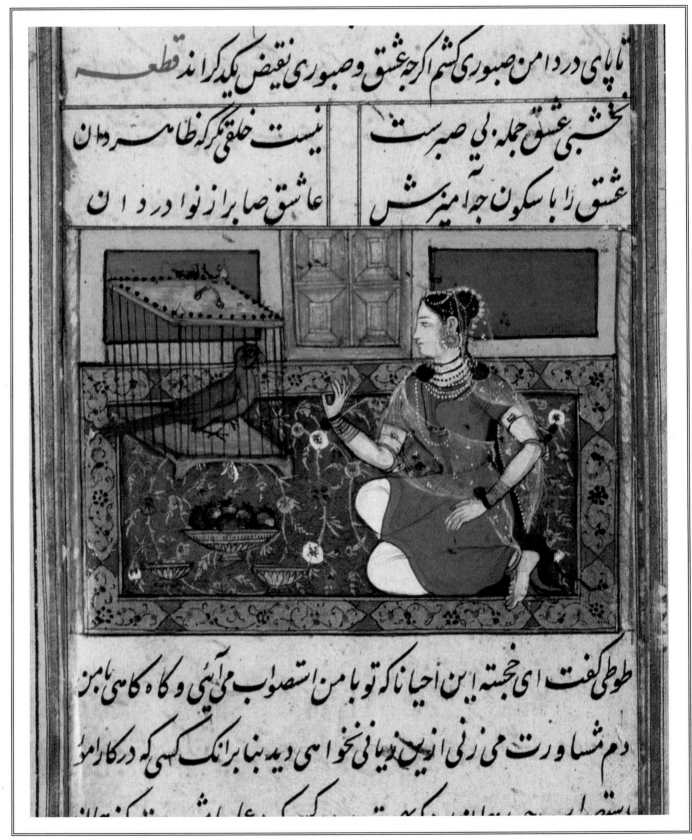

The Grocer and the Parrot

HERE WAS ONCE a greengrocer who had a sweet-voiced talking parrot. The parrot perched on a bench and watched over the shop when the owner was absent, talking to all the traders who came by. It was a very skillful parrot and would imitate the voices of all who came into the store, for its song was the best song of a parrot. But one day, it flew from the bench and upset a bottle of rose oil, and when the greengrocer came back to the store he sat on the greasy rose-oil and ruined his clothes. He was so angry he hit the parrot on the head and knocked all the feathers off, so that its head was bald. The parrot was extremely distressed by this violence and immediately stopped talking and would not say a word to anyone again.

The greengrocer was terribly guilty and upset by what he had done to the parrot. What would he do? The parrot had helped his business so much and now he could not make amends, even though he tried everything—prayers, gifts, treats—the parrot remained silent.

One day a bareheaded dervish came to the store, his crown so bald that it looked like a bowl. The parrot was intrigued and spoke to the dervish, saying, *"Hey you—were you mixed up with the green-grocer? Did you upset a rose-oil bottle?"*

The bystanders laughed at this inference from the parrot, as it believed the frocked dervish to be the same as itself.

Don't measure the holy man as you measure yourself,
 Like words have different meanings.
 In this way the whole world has gone astray.
 We fail to see God's lesser substitutes,
as they liken themselves to the saints.
 "We are men like them," they say,
"we eat and sleep as they do."
 In this blindness they miss the infinite difference.
 One will suffer from the bee's stings,
while the other is nourished from the honey.
 All deer eat grass and drink water, but from one
comes only dung, while another gives musk.
 All reeds drink from the same water,
but one will be empty while the other has sugar.
 Consider a thousand likenesses
and see the distances between them.
 Here there may be fertile soil and there may be dirt,
here is an angel and there a wild beast.
 Who knows the difference but a being with taste,
the difference of brine and sweetness.
 We see magic and miracle and think
that both are founded on deceit.
 There is many a devil with the face of Adam,
and we are so easily decoyed by the wrong song.
 The wild man will steal the song of the dervish
and chant spells at the innocent.
 The holy man's work is light and heat,
while the vile man's trickery is shameless.

The Lion and the Beasts ~ Trust Versus Action

A NUMBER OF BEASTS in a beautiful valley were being attacked by a lion. The lion would ambush them and carry them away, so that their pasturing was impossible and all of them were disturbed.

So they made a plan and went to the lion and said, *"We'll arrange to feed you all that you need on a fixed measure, if you agree not to feed on us beyond the allowance. This way our grazing will not be bitter."*

The lion answered that he agreed, provided they did not cheat him, as had others he had met.

"I'm exhausted by the fraud of men, bitten by the snakes and scorpions of men, but still worse, bitten by the man of flesh within me. I have understood that the believer is never bitten a second time, and I have adopted this into my heart and soul."

So the beasts said—

"In caution lies no power against the divine.
 In caution lies further suffering and sadness.
 Put your trust in God alone, much better.
 Don't stand against destiny,
you fierce and furious creature,
 For destiny may pick a fight with you.
 Die in the face of God,
and no fight will be made against you."

But the lion reasserted his belief in strength and acquisition, telling the beasts that if it was good to trust in God, it must also be good to trust in the means, for the Prophet had said he should *"trust in God, but bind the knee of the camel."* And that the worker was also beloved by God, because neglecting the ways and methods of getting results was also going against God's word.

But the beasts answered that work to acquire in the mouth of the beast was a deceit as big as the throat that swallowed it, and that there was no better work as the work of trusting and surrendering.

"Those who run from pain
 fall into pain again,
 And those who escape from the
 snake meet only the dragon."
For work is a man-made trap,
 That drains life's blood with
what he thought to be its heart.
 The door was locked
with the enemy still in the house.
 There are too many defects in human foresight,
 So better trust only in the greatest Friend.
 Better balance with the sight of God,
 Where you will find your desires.
 So long as the child has no strength
he rides on his father's neck.
 Once he becomes busy with the world
 he finds only sadness.
 He who gives rain from heaven gives also bread.

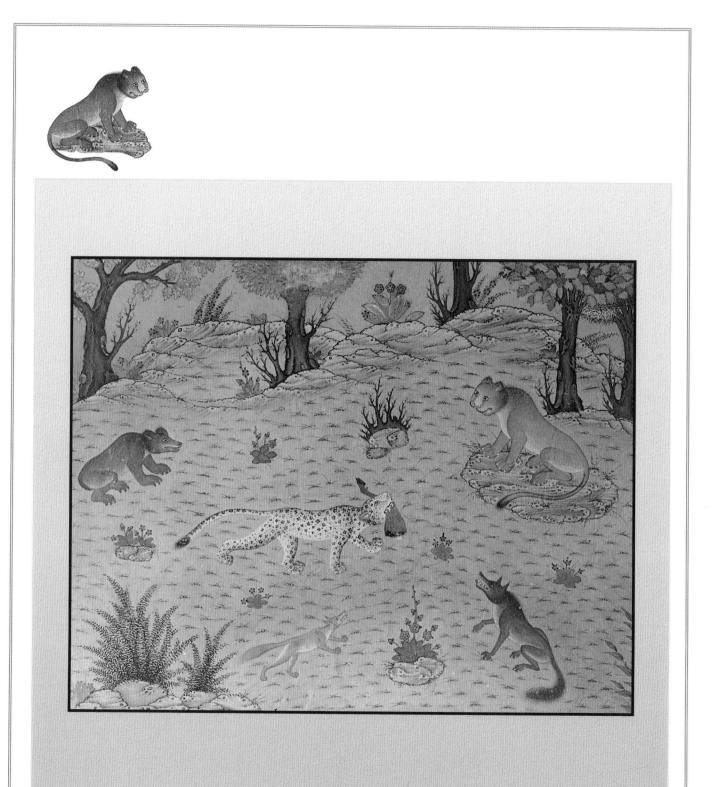

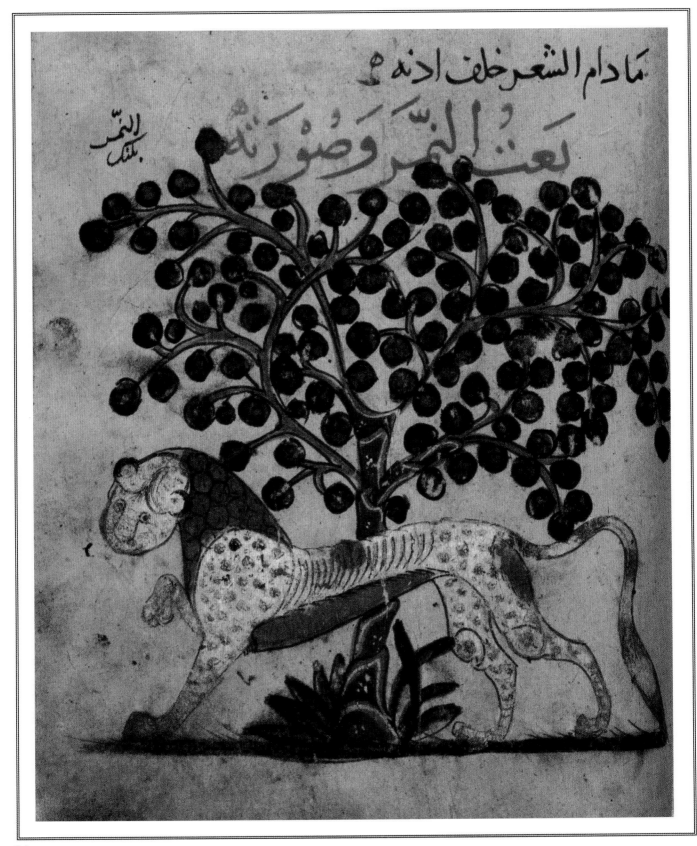

But the lion answered that God also set a ladder before his servants, so that step by step they could climb toward the roof, so being a fatalist is only to indulge in foolish hope.

You have feet, why pretend to be lame?
* You have hands, why hide the fingers?*
* When God gave a spade to his servant*
* there was no need of explanation.*
* The hand and the spade*
have implicit use,
isn't that clear enough?
* If we take the hand and spade to heart*
we'd better devote our lives to their use.

He will give you hints to help you understand, and remove the burden of responsibility, but still provide the spirit of life for you to undertake. If you carry His burden, He will allow you in Heaven. If you accept His commands, He will favor you. By taking on these things, you become God's spokesman, and find union with Him. Free will is a way of thanking Him for His gift, but fatalism is simply its denial. Be thankful and you increase your power to act freely, give up your power and fall into the arms of existence, and your power is gone.

Do you lie asleep in the road?
* Better not sleep in the road*
until you see the threshold of Heaven.
* Don't sleep, fatalist,*
except beneath the fruit-laden tree,

There alone will the wind.
Shake the fruit to the ground,
* Showering the sleeper with food for the journey.*
* Sleep as a fatalist and you call the robber,*
* The late bird catches no worm.*
* Make your own judgments about his signs*
* and you are truly strong.*
* Consider them with too much care*
* and you are weak.*
* Put your trust in God*
* for your own individuality,*
* Sow your own seed*
* and then rely upon Him.*

But the beasts disagreed with the lion—how come all those millions who strive through exertion never reach their goal? Since the beginning of time, generations have had so much desire that the world has changed beyond recognition. And all along, destiny has been maintained alone, with nothing owing to human efforts.

Acts of your own are left behind,
Acts of God come through alone.
Work is nothing but a name,
Endeavor is but a vain fancy.

But the lion kept talking, exhausting them.

Consider the prophets and true believers,

The efforts they made for good…
The blessed ones are always blessed,
Their efforts entrap the holy bird,
Even the deficient are efficient!

And so he went on and on…

If destiny didn't give you endeavor, what did? Why bandage an unbroken head, just try hard work for a day or two, you'll benefit forever. But work hard to renounce the world, not to gain from it. It's no good digging a hole in your prison and then remaining in the cell. Dig a hole in the prison and let yourself out.

And on…

Soak the boat and the boat won't float,
Stopper the jar and watch it from afar,
Watch it rise, on a storm of any size,
Wind-filled its heart, forever depart.

And the lion went on, with that lion-like energy, and some of the beasts began to give up their efforts to argue with him, becoming convinced that he might be right.

The fox, the deer, the hare, and the jackal
gave way to the disputation,
And moved to the side of the lion,
Ensuring his gain in the bargain.
The daily ration must be his without pain,
The lamb to the slaughter should run, run, run.

But when it came to be the time of the hare to give up his life, his tone of agreement became less resolved. *"How long should we put up with this injustice?"* he cried.

And the rest of the beasts became angry at the hare. *"We've sacrificed our lives all this time, with honor and loyalty. You give us a bad name, rebellious hare. The lion will be mad—go quickly."*

And the hare replied, *"Friends, grant me a chance to avoid this, and that way you can escape from the calamity yourselves, and by our cunning you'll save your own lives and your children's lives forever."* In this way the hare argued with the rest of the beasts.

All prophets have called in this way,
"Come to me and be delivered from evil."
Each prophet can see from Heaven
the way of escape
Though in truth
his pupils contract as he looks,
For the black of the eye will reduce,
and his "heavenly" sight grow small.

The beasts didn't like this talk to begin with. They counseled the hare in favor of not measuring himself against greater beings. *"Don't get above yourself hare—stay hare, or be unfair."*

And the hare replied that God had given him inspiration. *"I am weak, but wise counsel came to me."* And he proceeded to argue with them as the lion had done.

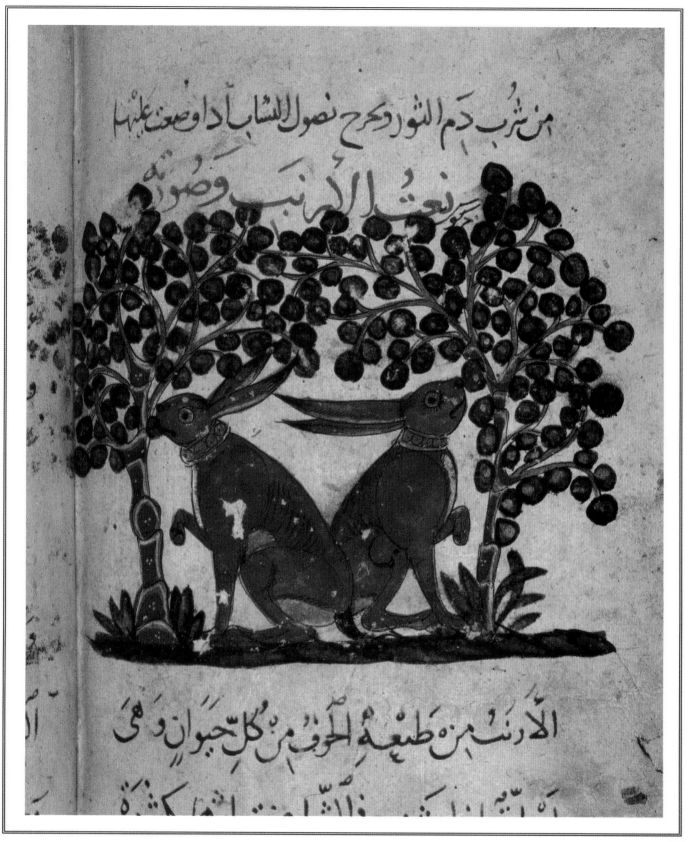

من شرب دم الثور وكرح نصول الشاب اذا وضعت عليها

نعت الأرنب وصورته

الأرنب من طبعه الحوف من كل حيوان وهي

God gave the bees the power of sweetness.
 Did He give this to the lion or wild ass?
 God gave the silkworm the power to feed the weave.
 Did he give this to the elephant?
 God gave Adam the power to reach up to Heaven,
 And so broke the fame of the angels,
confusing all those who "knew."
 These priests had the muzzle of prevention
that they wrapped around our eyes,
 To keep us away from those lofty castles,
nor drink the milk of sublime.
 Dogma and doctrine blinded,
the sense and perception in darkness.
 No milk for all those.

But into the blood-heart a jewel,
which God gave not to the seas and skies.
 When will we race from this form,
how long will the soul lack reality?
 If form is our only virtue,
then man and Mohammed are the same.
 The likeness of Adam—is this Adam?
 Where is the spirit—go find the jewel
so rarely found.
 The lion was brought down
when God shone His light on humanity,
 And what is written in words
doesn't justify the greatness of the spirit,
 For the spirit shines like the sun
from the place that is nowhere, and everywhere,
 Without place, not even in the sky.

And so it can be said that this topic has no end, but we must listen to the hare with our hearts and not our minds, or we'll never comprehend what his words are telling us. For in this way the hare had a plot to catch the lion, but through a form of knowledge that arose from the spirit. Those who have this knowledge make the lion and the crocodile helpless.

And the other beasts asked the hare to tell them his secret, and relate what he planned to do against the lion. They suggested to him that to share his secret would make it stronger, "Take counsel with those you trust." But the hare would not tell them the secret, and said to them:

Sometimes odds are even and evens are odd.
 Breathe your secret on the mirror
 and the mirror becomes dim.
 Never tell when you leave,
 Never tell of your wealth,
 Never tell of your beliefs,
 There are those
 waiting to know of these things,
 That they might take advantage of you.

 And if you tell a few,
 Goodbye to the riddle,
 For two can keep secret, while three tell the world.

So the hare deliberately delayed awhile before going to the lion, and then eventually went to this great beast who tears flesh, and because he was so late the lion was clawing at the ground in furious roaring.

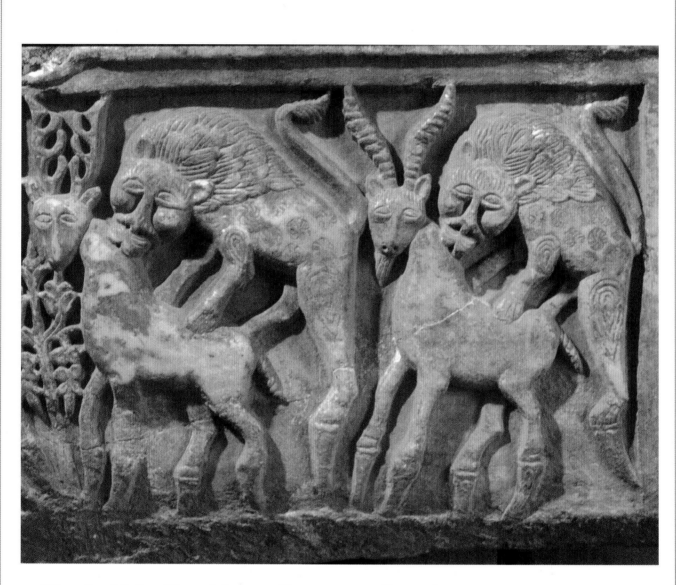

"I knew," said the lion, "those vile beasts would deceive me,
 Their palaver has duped me, how long will this last?
 I'm a foolish prince going nowhere.
 The smooth road is full of pitfalls,
and their word is meaningless.
 I'm blind from listening,
wounded by a wooden sword.
 I'll not listen more to these demon words,

But tear them to pieces,
for they have nothing but skin,
 A skin like specious words and ripples
on still stagnant water."

And the lion ranted once again, furiously roaring that their reasoning was entirely superficial and lacking any spirit, like a bad kernel that hides some secret that would make only for disappointment.

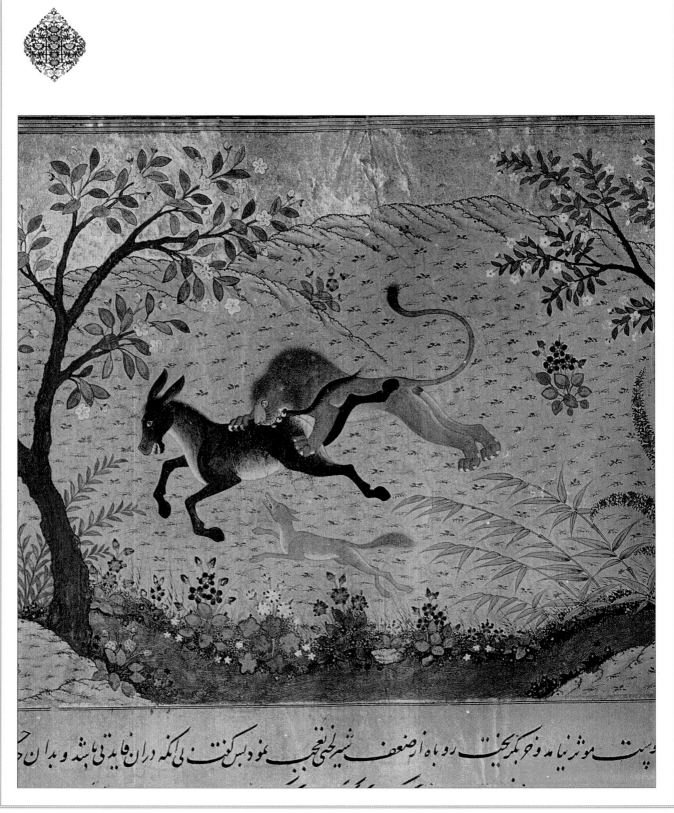

But the hare had thoroughly rehearsed his plan to dupe the lion. He planned to whisper only small hints of what he intended and make the lion crazy with his reasoning, all the time delaying his arrival to stand square before the lion.

Think how many words
are in business with reason.
 In this sweet ocean, our forms are moving fast,
 Like cups on the surface of water.
 Until they are full
they will float like bowls on the sea,
 But then they overflow and sink within the ocean.
 Reason is hidden, only vague things are shown,
 Our form is but a spray of that sea,
 To be cast away by the depths.
 So long as the heart is blinded to the Giver,
 Unable to see the bow that sends the arrow,
 So the horse that sits beneath him is hidden,
 Even though it bolts like the wind on the road.
 O rapid rider in search of your horse,
come home to yourself.

The lion had watched the hare coming along the road, looking angry and fearless, for the hare knew that if he came humbly the lion would be suspicious. Coming boldly would dispel all appearance of doubt. Once the hare reached the entrance to the lion's den, he heard the lion shout, *"Hey villain!"*

I who have torn oxen limb from limb,
I who have vanquished the ferocious elephant...
How does a half-witted hare dare to disregard me?
Give up your unconscious fearlessness,
and listen to my roar.

"Mercy," the hare cried, "I have an excuse, if your lordship would give me a helping hand."

"What excuse?" replied the lion. "You short-sighted fool, is it right you come so late into my presence?" And the lion began to rant at the hare that his head should be cut off and that the excuses of fools were not his concern.

The fool's excuse is worse than his crime,
 Excuses through ignorance poison wisdom,
 What ass-eared fool do you take me for?

But the hare had an answer as always. "O king," he replied, "allow one as worthless as I a moment's worthiness. I have suffered so much oppression. Make an offering of mercy from your high place to one who is lost."

The ocean gives water to every stream,
 Lays its gifts upon all garbage,
 And by this bounty never reduces.

But the lion was not taken in by this.

I will give bounty where bounty is due,
 I'll cut the cloth according to the
stature.

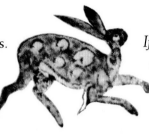

"Listen," cried the hare, "if I'm not a fitting object for your grace, I'll surrender myself to your violence. At breakfast time this morning I set off to come to you with a friend, appointed by the beasts to accompany me as a companion. On the road we were attacked by another lion, and although I told him that we were your pitiful slaves, and that you are the king of kings, this lion was not impressed and called you an idiot and a useless lion. He threatened to tear us and you to pieces if we tried to leave his door.

" 'Let me for the last time behold the face of my king, and I will tell him also of you,' " I said to the lion. "He said that if I left my companion with him as a pledge he would allow me to visit you, and although we pleaded with him to let us both go, he seized my friend and left me to go alone."

From now, then, this lion has barred the road,
 The thread of our promise is broken.
 Forget our covenanted allowance from now,
 For I tell you the bitter truth.

If you want the stipend then clear the way,
 Come forth and repel the irreverent one.

"Come on then," the lion said. "Show me where he is, and you go in front to prove to me that you speak the truth. I will give him, and others like him, the punishment they deserve, or if it's a lie, then I'll give you your deserts instead."

The hare set out in front of the lion, acting as a guide, and leading the lion to his snare—a deep well that would drown him. Eventually they arrived near the deep pool of water hidden beneath straw on the ground.

The water bears a blade of straw,
 How will a blade hide a mountain?
 The snare of his guile was a noose for the lion,
 A marvelous hare who'll carry off a lion.

As Moses drew the Pharaoh,
 With his host as the army, into the river Nile.
 As a gnat with half a wing
holds like a suture to Nimrod's skull,
 Don't listen to the soft-spoken word,
for this is the snare full of bait.
 If he gives you some candy, regard it as venom,
 If he cares for your body, regard it as cruel,
 For a jewel is a stone, and jasper is wool,
 When we're drunk with the perversion of the senses.

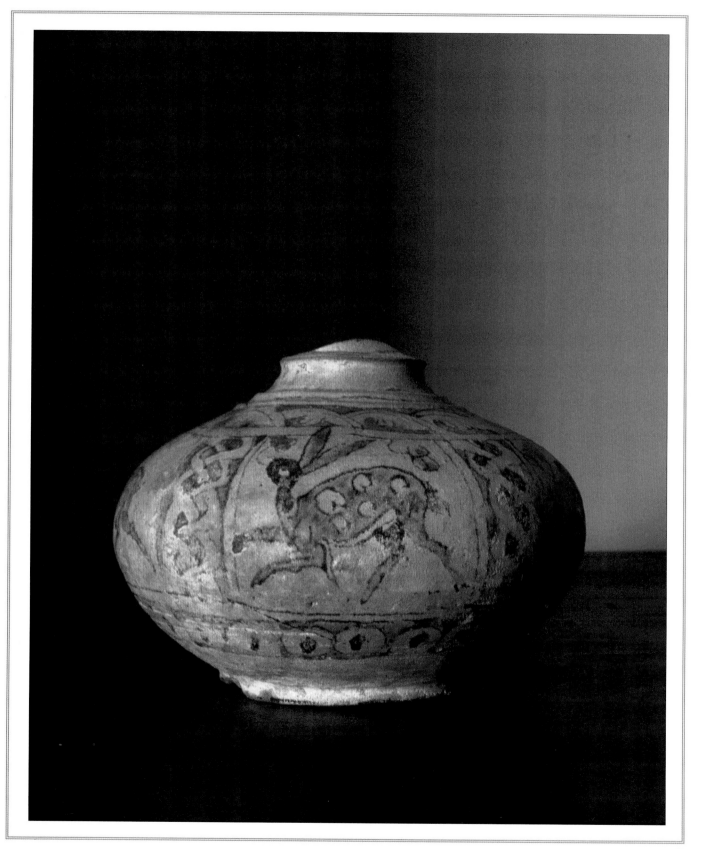

Once the lion and the hare came closer to the well, the hare pulled back, and the lion grew suspicious. *"Why do you pull back, come on."* The hare replied that he had lost his power to step forward because his soul trembled with fear and his courage had fled.

"Don't you see the color of my face, so pale? My paleness gives evidence of my inner trepidation. Have pity on me, for the color of my face indicates the state of my heart; give your love to brighten my heart and face. A red complexion declares satisfaction, while a pale one is not thankful."

This comes upon all humans and animals,
minerals and plants,
 And the world is hopeful and then thankful,
 The garden dons a green robe and then is bare.
 The sun rises fire-colored and then sinks headlong.
 The stars shine in the four quarters of the sky,
 And then are consumed.
 The moon is draped like a phantom,
 And then excited with fever.
 This earth lies silent, and then erupts with quakes.
 This inherent woe
has shattered the mountains to grains of sand,
 And the air from freshness to foul stink.
 Sweet water, vital friend to the spirit,
stands still to be bitter.
 Fire—puffed up with pride
dies quickly with the wind.

From the turmoil of the sea,
 can you tell of its changes?
 The whirling heaven,
ever seeking and searching,
 Now high, now middle, now low
—Here too is fortune
and misfortune for the hosts of stars.
 And you, whole as well as part,
take note of every single mixture,
 For the whole suffers grief from each part,
 How you must know the paleness of decay,
 And the uncooperative elements
—Of water, earth, of fire and air.
 For life is the peace of contraries,
 And death is the proof of this war.

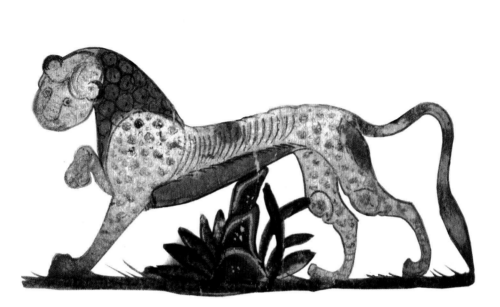

And the hare continued to tell the lion of his proof—that God had given enmity to the lion and the hare because they were so much opposites, and since the world is so sick and a prisoner of these contrasts, it was no wonder that the hare was almost passing out.

"I have lagged behind," said the hare, " because of these bonds upon me."

So the lion said to him, "Among all these maladies that you speak of, tell me the most important one, for this is what I really want to know."

And the hare replied that the lion who had taken his companion along the way lived inside the well that lay beneath the straw ahead of them, for this was a good place for him to keep safe against harm.

Spiritual joys come only from solitude,
So everyone wise chooses the bottom of a well,

For the darkness down there
beats the darkness up here.
He who follows at the heels of the world
never saves his head.

"Come on," said the lion, "take a look down there and tell me if the lion is present."

"I'm terrified," replied the hare. "Please take me beside you to look, for with your mine of generosity I can pluck up the courage and open my eyes down into the well."

So the lion and the hare bounded toward the well and as soon as they looked down into the water, the lion saw his own reflection and that of the plump hare beside him, the light sending the image back to the lion. There lay his adversary in the well, so the lion left the hare and leaped into the well, his iniquity coming back on his head.

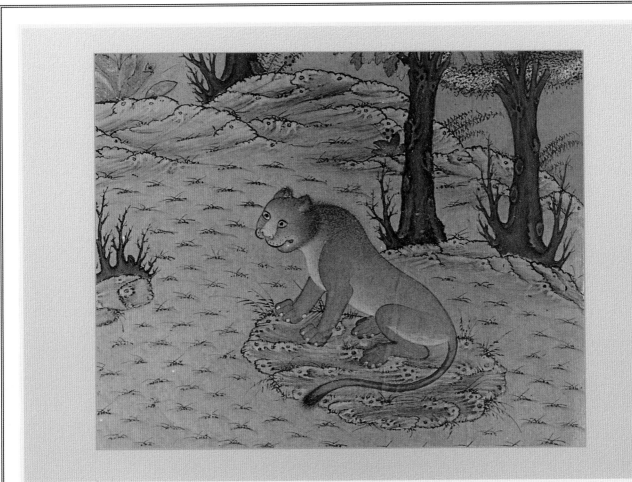

All evildoers find a dark well, so say all the wise.
 The worse the iniquity, the more frightful the well,
 Worse for worse, penalty for sin.
 Whoever is evil will build his own trap,
 Don't weave like the silkworm,
a cocoon for yourself,
 You're digging a well, so dig not too deep.

The lion saw himself through the dust of his fury,
 And could not have known who he was,
'cept enemy of himself,
 As many iniquities seen in the world
are the truth of none else but yourself.

You see what is evil, you strike what is bad,
 You watch a reflection; you beat your own head.

 Don't run away from yourself, holding up the blue glass to a blue world; unless you are blind, what you can see of the blueness comes from you. The true believer sees only by the light of God, and thereby finds the plain truth, the right color.

See by the fire of God, the truth of good and evil.
 Throw water on the fire,
that your fire becomes light.
 Throw, O God, your purifying water,

That the world fire become wholly light.
All water and fire's under your command,
And fire makes sweet water, or water makes fire,
These gifts are completed, without effort,
Everything sought without search.

So the hare was very happy at being delivered from the lion and ran toward the other beasts through the desert. Having seen the lion killed in the well, he bounced with joy, skipping through the meadows and clapping his hands because he had escaped the jaws of death.

Bough and leaf were set free from the earth,
Lifting their heads to the wind.
Blown high on the trees, and burst from the bough,
The flourish of life gave thanks to its god,
And the clay of the earth gave birth to the root,
Which danced in the air of divine clear light,
Flawless the light of the moon.
Shame on the lion befooled by a hare.
Such a disgrace at the bottom of a well,
Your "how?" and "why?"
have been your death knell.

The lion-catcher ran to the beasts crying, "Be happy everyone, the bearer of great news is coming. Great news! Glad news merrymakers! The hellhound has gone back to hell. The teeth of our enemy have been torn out by the Creator. The one who tore heads with his claws has been swept away by the broom of death like a piece of rubbish."

All the beasts assembled, laughing and happy in a rapture of excitement. They formed a ring around the hare, and bowed in homage to him, like a candle in the center, wanting to know the whole story of how he conceived his idea and how he executed it so they could keep it for the future as a great legend.

The hare related how all of what he had done was not really his doing, but an act of the divine, for a hare such as he could not have achieved anything so glorious.

If you give up the world for the brief time of life,
You'll dip your mouth in the drink of paradise.
But remember all those who've slain the outside,
There remains the enemy within.
The death of your foe, like the lion by the hare,
Is not the work of great reason.
For hell is a dragon not slain by an ocean,
For it drinks up the seas and still blazes.
Be straight like an arrow, and escape from the bow,
This way you'll hit square to the mark.
Turn back from the outer,
set your eyes to within,
Deem small of account,
the lion you face,
For the lion
must conquer himself.

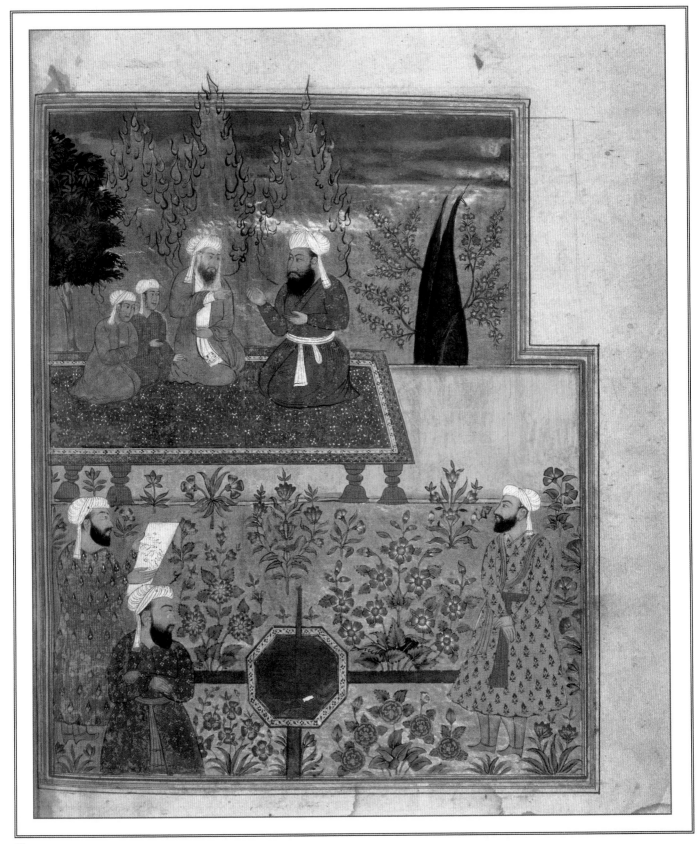

From the Merchant and the Parrot

The saint isn't harmed
by the poison he drinks,
 Though all may be there to see,
 Because he has grown to spiritual health,
 Set free from the need to abstain,
 While the poor seeker remains in a fever.

The Prophet declares, "Bold seeker beware!
 Don't run with all those who are sought."
 As Nimrod remains from the fire!
 Be Abraham first, before you set out.

Till you're swimmer and sailor,
 Don't jump in the sea,
 Only saints fetch pearls from the bottom.
 From losses they gain to emerge once more.

The perfect being makes gold from dirt,
 While the poor turn gold to ashes.
 The righteous hand is the hand of God,
 The unrighteous is touched by the Devil.

The saint brings knowledge to ignorance,
 While ignorance haunts
even the knowledgeable fool.
 The sick man stays sick,
while the perfect stay whole,
 Infidelity is religion in the hands of the sage.

When a woman and a man
become as one, this one is you.
 When the separate parts are annihilated,
behold you are the singularity.
 You made this "we," this "I,"
to play the game of worship.
 To play the game of love, "you" and "I"
are the fabric for the tapestry.
 For what? To drown in the Beloved.
 All this is true, Lord who transcends all being.
 The body sees only reflections of itself,
 Imagining pictures of sadness, of joy.
 The heart, bound by its borrowed cradle,
 Cannot see you as you really are.

In the endless verdant garden of love,
 Sorrow and joy are not the only fruits.
 Love lies higher on the trees than these two,
 Remaining through all seasons, green and fresh.

Speak to us of the soul that is torn in pieces,
 Tell us of the amorous glance
that brands the heart anew.
 I give my heart freely, why do you run from me still?
 Why pour more sorrow on the hearts of the sorrowful?

You who gave grace
to every dawn that shone from the East,
 Overflowing with the fountain of the sun.
 How then did you dodge your frenzied lover?
 Your sweet priceless lips untouched.

The Story of the Harper

THERE WAS ONCE A HARPER who was known as one of the greatest of his age. The nightingale was beside herself with his skills, and his beautiful voice turned one rapture into a hundred. His breathing was extraordinary, bringing great gatherings to listen, and when he sang, the dead would rise again, like Seraphiel, whose voice was able to bring souls back into the bodies of the dead. His music could make elephants grow wings.

The ears of normal humans cannot hear the spiritual notes that emit from the prophets, for their many sins deafen them. And the highest and most extraordinary note is the note of the heart, which cannot be heard by normal humans, for humans are prisoners, captive to the entrapments of ignorance.

As time passed the harper grew old, and from the resulting weakness his soul was no longer a falcon but a catcher of gnats. His back became bent like the back of a wine-jar, and his brows grew over his eyes. His once charming, soul-refreshing voice grew croaking and worth nothing to anyone. The tone that had once been the envy of Venus was now like the bray of an old donkey.

> *What fair thing fails to be foul?*
> *What roof fails to be straw?*
> *Except the voice of inspiration,*
> *Whose breath blasts a trumpet*
> *for the resurrection of life.*
> *Theirs is the heart for all hearts to be*

drunk.
> *Theirs is the world where all worlds are born.*
> *The saint is magnet to thought and voice;*
> *The inward delight to inspire and mystify.*

And so with age, the minstrel grew feeble and could not earn his keep. He had to borrow even to eat bread. He said, *"You have given me long life and respite, God. You've done me many favors, even though I'm a wretched person. For seventy years I've committed sin, and yet you have never withheld your generosity and bounty from me. I cannot earn any more, so today I am your guest and I will play the harp for you."*

He took his harp and went in search of God in a graveyard in Medina, all the time crying of his misfortune. As he went, he cried, *"I pray for the price of harp strings, for He will accept my poor coin."* And he played the harp for a long time and then, still weeping, lay down on a gravestone with his harp as a pillow.

Sleep overtook him, and his soul escaped from his body, letting harp and harper go, darting away from them. The soul of the harper was suddenly freed from the pain of the world, entering the vastness of the spirit world. Once in this vast place the soul begged to stay.

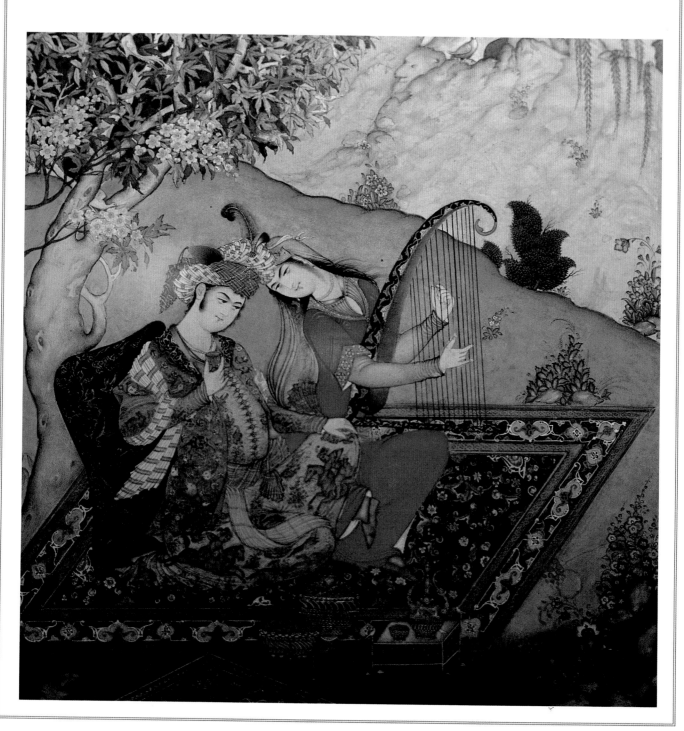

If they'd just let me stay,
I'd be happy in spring gardens of now,
Drunk with this far-reaching
plain and mystic field.
No head or foot I'd continue my travels,
No lip or tooth I'd still eat sugar.
Memory and thought would be free of my brain,
I'd play with the dwellers of Heaven.
In blindness I'd see, handless pick roses,
My soul in a sea of honey,
Job's fountain to wash and refresh me.

The minstrel's soul in this fabulous dream received a divine command and lingered there in that vastness to find God's mercy and benediction.

And so the minstrel waited and waited for the voice of God who instructed His servant 'Umar to save the old man from his pitiful condition for he was favored by God. 'Umar jumped at God's command and found that he had been given seven hundred dinars to take to the old minstrel so that he could go to the market and buy silk as strings for his harp.

'Umar was to tell the harper that God had instructed him to say that once the money had run out he should return to the graveyard again.

'Umar ran to the graveyard and searched everywhere for this favorite of God, but all he could find was the poor old man lying on the gravestone. He couldn't believe that this was the one and so continued to search until he was exhausted.

"How can an old harper be the chosen of God?" But then he could still not find anyone else in the graveyard so he sat down next to the old man, and while pondering what to do, he sneezed and the old harper jumped in the air, landing on his feet full of fears and trembling. 'Umar saw that the old man was ashamed and pale from his condition, so he said to him, *"Don't be afraid. Don't run away, for I've brought you something wonderful from God. Sit down beside me, for God has even made me love your face, and I wish to whisper His message closely in your ear, to tell you of this divine favor. God sends you greetings and asks how you are managing in this distressful time of boundless sorrow. He sends you also pieces of gold to pay for silk. You should spend it all and then come back here to this place."*

The old man heard what 'Umar told him, and trembled all over, biting his hand and tearing at his clothing. *"Oh wow, what a unique God."* The poor old fellow almost turned to water out of shame. And after he had wept for a long time and his sadness had gone beyond all bounds, he took his harp and broke it into pieces.

Harp that has barred me from God,
Harp that has robbed me from the highest way,
Harp that has drunk my blood for so many years,
Harp that has made my face dirty,
Disgraced from divine perfection.
Have mercy generous God
who keeps pace with my sin,
God who gave life with value each day,

I have breathed it away in treble and bass.
In minding my music I was mindless of parting,
In memory of the minor muse,
I forgot the major heart.
Help me with my self O Lord,
who is nearer me than I.

'Umar advised the harper to give up his moaning and groaning and come into the present, where he would more easily find the reality of God, and that seeking was only seeking, for there was nothing to seek. And the harper came to sudden realization and his heart was awakened to the truth.

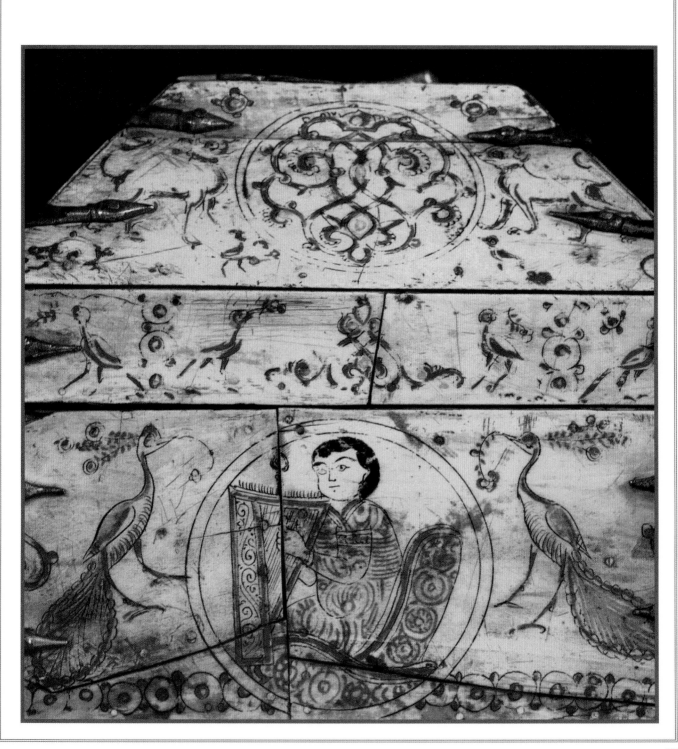

From the Bedouin and His Wife

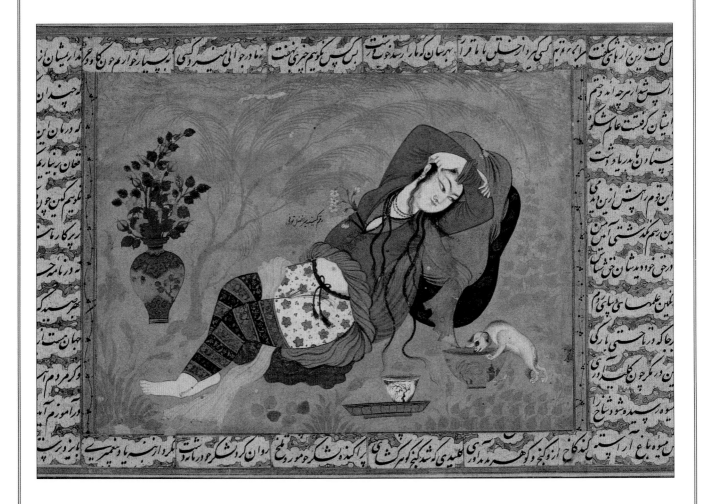

*W*oman shines in God's eye,
Long past earthly love,
Creating—not the rib of man.

*O*pen to me, so that I may open.
Provide me your inspiration
So that I might see mine.

The Graduate and the Boatman

A CERTAIN CONCEITED GRADUATE traveled in a boat and spoke to the helmsman, asking him if he had ever studied languages. The boatman replied that he had not, and the graduate told him that half his life had been wasted without such knowledge.

The helmsman was deeply hurt by this suggestion but at the time said nothing in reply. Later, on the journey across the water, the boat was caught in a storm and the helmsman asked the graduate, *"Tell me, do you know how to swim?" "No,"* cried the graduate in his most pleasant tone.

"Well graduate, the whole of your life has been wasted without this knowledge, for it is worth nothing in a sinking boat if you can't swim."

Selflessness works where knowledge will fail,
 In surrender you'll float, while in confidence sink,
 Die to the flesh, die to the mind,
 And the sea will carry you high.
 Bear your knowledge like a jug to the sea,
 Carry no carafe to an ocean.

The Man of Qazwin

HERE ARE A PEOPLE who live in the region of Qazwin, and they have a custom of tattooing their bodies with blue designs, such tattoos being intended as talisman against evil. A certain man from Qazwin went to the barber, where tattoos were inscribed with a sharp needle, and asked the barber to give him a tattoo of a lion, and to undertake to do the work with great artistry. *"My sign is Leo, so this is an appropriate design. Undertake the work well on my shoulder blade."* The barber agreed.

The moment the barber began to use the sharp needle for the tattoo, the man felt the pain sincerely, and deeply in his shoulder, and began to groan with discomfort.

"O illustrious one, this needle is killing me—what are you doing back there?" The barber replied that he inscribed a lion as instructed, what should he do?

"What part of the lion do you work on now?" asked the man in suffering.

"Why the tail is where I've begun," said the barber, and the man exclaimed that he should leave out the tail, for his breath was stopped by the lion's tail, and by the expectation of the rump that he knew would choke his breath and kill him.

"Let the lion go without a tail, O lion-maker, for my heart is faint from the pinpricks of your craft."

So the barber began pricking on another part of the man's shoulder, forcefully and without mercy. The man yelled at the top of his voice, *"What are you tattooing now?"* And the barber replied that he tattooed the ear of the lion.

"O Barber, let the lion have no ears, for the sake of God, leave out the ears." And so the barber moved yet again to another part of the man's shoulder and once again the man from Qazwin began to wail in pain, *"O lord barber, this is the third place you start—what do you tattoo now?"* And the barber explained that this was the belly of the lion, no less.

"Leave out the belly for God's sake, leave out the belly—what need of a belly with so much dye already injected."

By now the barber had become distraught with bewilderment and stood there for a long time with his knuckle crunched between his teeth in frustration. He cast the needle to the ground and cried that this was insane—that no one had ever created a lion without a tail or a head or a belly—no such lion ever existed under the hand of God.

O brother endure the pain of the pin,
 For the end will bring more than joy.
 For the sun and the moon and the sky itself,
 Will honor your selfish denial,
 Will distinguish
 your presence in One.

The Friend Who Said "I"

*A*MAN CAME KNOCKING at the door of his friend, *"Who are you?"* the friend asked from within.

"It is I who come to your door," said the man,
 "Go away, not now, this isn't the time,
 No place exists here for the raw."
 So the wretched friend left from the door,
 And traveled afar for a year, his mind and heart
 Were burned by the world,
till eventually he came once more.
 And again he knocked at the door of his friend,
his heart in his mouth with fear.
 "Who's there at my door?" his friend asked.
 "Is it you, my closest of hearts?"
 "No, it's you at the door, not I anymore."
 "Then come inside my house, for here I can tell,
 There's little or no room for two."

The Deaf Man and the Invalid

A DEAF MAN WAS INSTRUCTED by a local wealthy individual to visit an invalid, and he said to himself, *"Being deaf, how will I understand what this sick man is going to say to me?"* He did not, out of pride, want the sick man to know that he was deaf, so had no escape but to make the best of the situation, and he decided to try to read the invalid's lips—though this was not one of his skills. He also decided to rehearse what the invalid was likely to say to him. All this seemed a very good plan to solve his difficulty.

He would say, *"How are you, my suffering friend?"*

And he conjectured that the invalid would say, *"I'm fine,"* or *"I'm quite well thank you."*

He would then say, *"Thank God, what medicine have you been taking?"*

And the invalid would say, *"Some sherbet,"* or *"A special concoction of good food."*

Then the deaf man planned to answer, *"May you enjoy better health, and who is your doctor?"*

And the invalid would reply with the name. Then the deaf man planned to congratulate the invalid on his choice of doctor and say that for sure such a man would bring him good health.

So, well rehearsed in this way, the deaf man set out to see the invalid, and on arrival at his house, started his conversation.

"How are you?" he asked.

"I'm at the point of death," replied the invalid.

"Thank God," cried the deaf man, at which the patient growled angrily, saying to himself, "Why does this idiot sound so happy at my discomfort? He must hate me."

"And what medicine have you taken?" asked the deaf man.

"Poison," he said.

"May it do you good and improve your health!" exclaimed the deaf man, at which the invalid began to rage inside himself.

"And which doctor is attending to you?" asked the deaf man.

"The Angel of Death is coming; get out of my house you idiot."

"Oh, this doctor is the best, his presence will be a great blessing," said the deaf man, and left the house happily, believing himself to have achieved his purpose completely.

The invalid was convinced that the man had been sent to curse him and was now an enemy for life, his mind discovering a hundred abusive words and curses that he planned to send to the deaf man and his master. Though he had been too weak to utter his fury loud enough for the deaf man to hear, he now lay upon his bed weaker than ever before, his body and mind consumed with anger and exhaustion.

Many are they who tend to the poor,
 Many who visit the sick.
 But they go with the purpose of saving themselves,
 And achieve but their own peace of mind,
 Their own hearts approved by devotion.
 In this is the falseness of piety, for pure is foul,
 And kindness attack,
a fire of resentment has kindled.

The Mathnawi

BOOK TWO

In The Name Of God
The Compassionate,
The Merciful

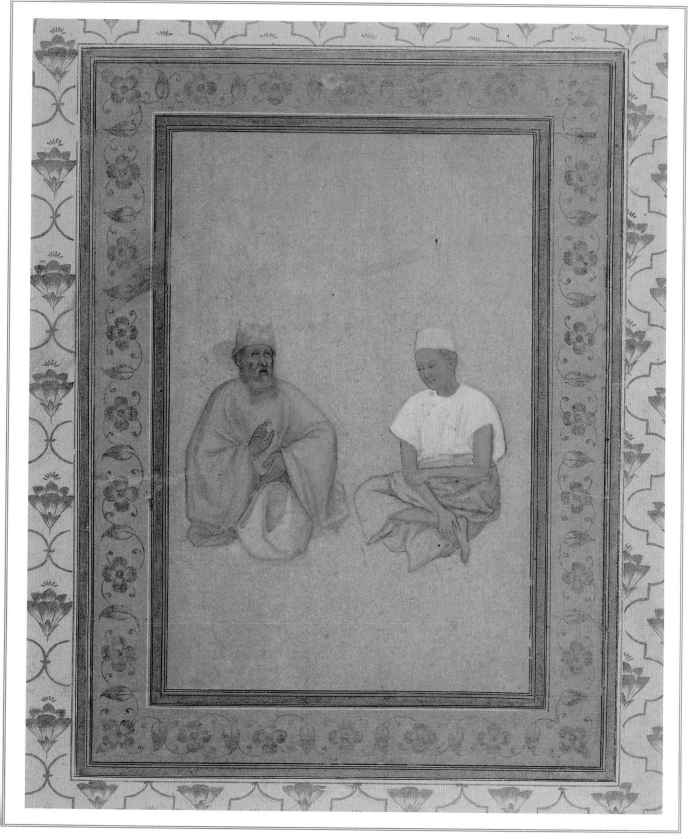

The Shaykh and the Confectioner's Boy

HERE WAS A SHAYKH who was always in debt because of his generous nature. He accumulated masses of debts by borrowing from the wealthy and giving it to priests and poor alike. He even built a monastery for the Sufis by running up a huge debt, and he devoted his whole life and energy to God.

The shaykh was repaid over and over again by the grace of God, for God made his life beautiful and happy and sent angels to pray for him, who asked that the shaykh always receive the granting of all the best wishes, and that the stingy who gave nothing were deprived. In this way the shaykh understood that the soul was rewarded, and that the rewards of the body weren't so important.

The shaykh behaved in this way for years, taking from the rich and giving to the poor, knowing that on the day of his death he would have spent his life well and would then receive the result of all the seeds he had planted.

When he reached that day, lying upon his deathbed, all the creditors came to sit around his bed, and the poor shaykh melted upon himself like a candle. The creditors were despairing and sour-faced, their hearts in pain and their breathing hard and furious with anxiety. The shaykh despaired also and asked God if he did not have the four hundred dinars that were needed to pay all the debts.

At that moment, a boy came to the front of

the house and shouted his message of available goods, *"Halva, I have halva for sale."* The shaykh considered that if he could give the creditors the halva, they might feel better disposed toward him and less agitated about their money, so he sent the attending Sufis to the boy to offer to buy all the halva from him. The boy laid the halva before the shaykh, though the cost of it was only promised, not given.

The creditors ate all the halva very quickly and were much sated by the gift that the shaykh had intended for their pleasure. And once the tray was empty, the boy came and demanded his money from the shaykh.

"But where am I going to find the money? I am in debt and going toward nonexistence," the shaykh gasped, lying on his deathbed.

The boy was devastated, throwing the empty dish on the ground with a crash, the few remaining crumbs of the halva scattering about. *"I wish both my legs had been broken on my way here. This would have been better than being swindled out of halva and the money. You lickspittle gluttonous Sufis, you are dogs at heart and wash your faces like greedy cats after a meal."*

As he cried and moaned in anguish, a crowd gathered around the boy as he wailed at the shaykh that his master would kill him with blows for losing the halva and not getting a penny in return.

The creditors, too, were shocked at the trickery of the shaykh.

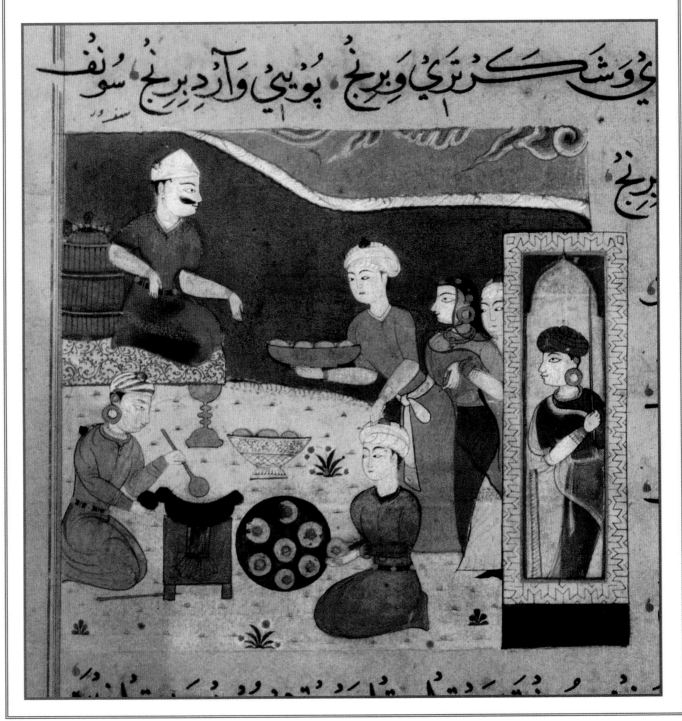

THE SHAYKH AND THE CONFECTIONER'S BOY

"You have devoured our property, and still you carry your iniquity into the next world, and now you also add a new crime, depriving this boy of his goods and giving nothing in return."

The shaykh simply lay back in his bed and covered his face with the blankets, unconcerned with their abuse and anger, withdrawn into the pleasure of eternity, happy with death and with no interest in what was good or bad, high or low.

He in whose face the Beloved smiles like candy,
* What harm can befall*
from the sour looks of others?
* He on whose eye the Beloved lays a kiss,*
* How should he grieve at Heaven and its fury?*
* On a moonlit night, what cares the moon,*
* For the barking of dogs and the crying of babes?*
* Everyone executes their little lives,*
* Nothing is lost by the cries and the sadness,*
* Water stays pure with the floating of weeds,*
* Passing on by, passing on by.*

It would have been so easy for the creditors to give the boy a little money each to cover his costs and stop his master from beating him, but the goodness and generosity, the spiritual warmth of the shaykh prevented them from seeing their own lack of care, and the boy got nothing from them.

By the time of afternoon prayers, however, a certain local dignitary who knew the shaykh and his ways sent his servant to the bedside with a tray carrying four hundred dinars, and in a corner of the tray lay another smaller amount in a special package, containing the exact amount due to the boy for his halva.

The shaykh unveiled the tray for all to see, and it seemed as though he had performed a miracle in front of everyone present. His previous calm and lack of agitation gave everyone this impression— that he was a miracle maker, and had known all along that the money would come to match his debts exactly.

Everyone, the creditors and the Sufis and the boy were filled with shame and begging the pardon of the man they now called the King of Shaykhs—praising him and shamefacing themselves. But the shaykh swept aside all their gestures and apologies, saying:

I forgive all that talk and palaver,
* I acquit you all of your deeds.*
* The secret lies in my request to God,*
* Who showed me the right way to go.*
* And it came to pass by the boy's dreadful wail,*
* His entreaties were loud and the mercy aroused.*
* Remember the child is the child of your eye,*
* And gaining your wish is dependent on tears.*
* Whatever your need should come ready there,*
* When the child of your eye*
weeps over your heart.

The Quest for Reality

A CERTAIN STRANGER in a new area of town was urgently searching for a house, so a friend took him to one that he knew of near his own home, though it was in ruins. He suggested to the man that it would be nice for him to have a home near to his friend, and if he were to add a new roof, the house would be a good home for him, and if he added another room it would be ample accommodation also for his family.

"This is true," said the stranger. "It would be nice to be near a friend, but one cannot really live in an 'if'."

Everyone seeks joy in this world,
 And on account of the hope comes fire.
 The old and the young are ever gold-seekers,
 And they know not the difference,
the gold from the tin,
 For the common of heart cannot see so well,
 The good from the bad, the cheap from the pure.
 If you have your own touchstone,
then all will be well,
 But those who have none should seek one who does,
 Seek one who knows the difference,
 All others will lead you astray.
 Don't follow the cry of riches to be,
 Don't trek to the spot where the promise is made,
 For there all you'll find
are the wolves and the lions,
 And the day will be spent,
life lost, and the road far off.
 Find the Work of your life, and the Worker too,
 For both exist as one—this is you.
 Discover vocation, creation,
and joy will come like clairvoyance,
 Where blindness is gone before.

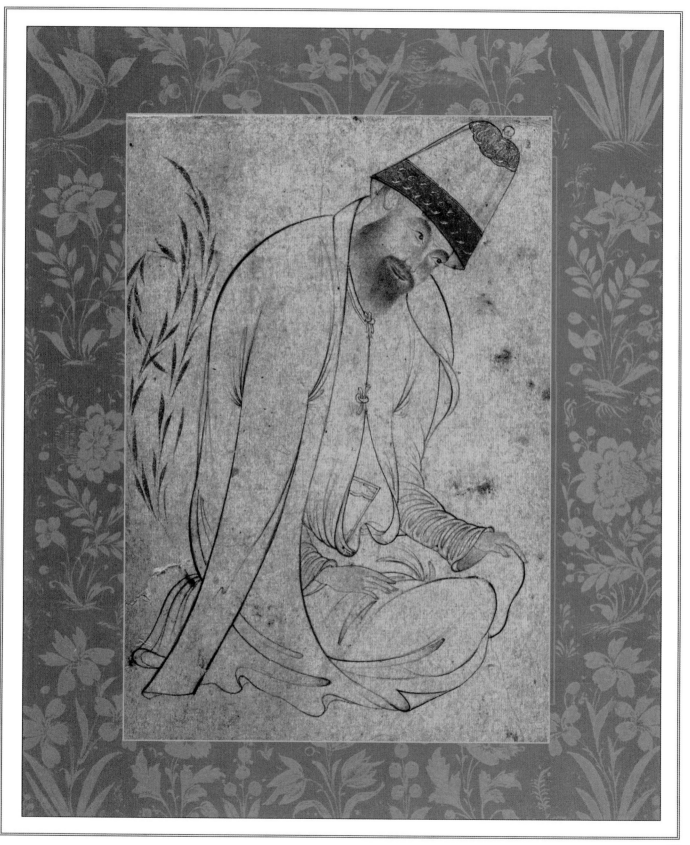

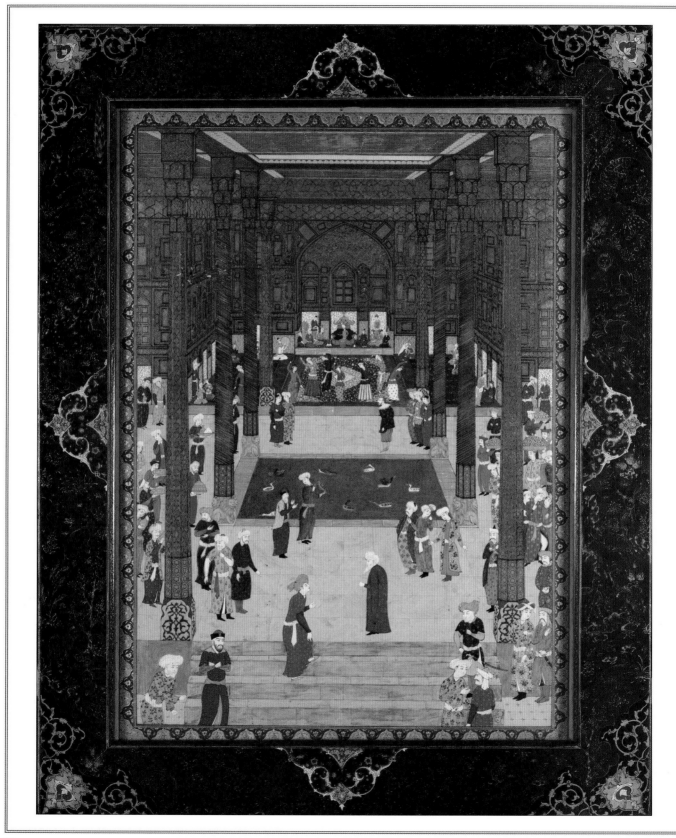

The King and His Two Slaves

*A*KING BOUGHT two slaves very cheaply and conversed extensively with one of them, whom he found to be quick-witted and with always-sweet answers.

What issues from sweet lips but sugar water?
 Man is concealed beneath his tongue,
 The curtain over the gate of the soul.
 When a gust of wind rolls up the curtain,
 The secret within is disclosed.
 We see maybe pearls or grains of wheat,
 A treasure of gold or snakes and poison.
 We see if there's treasure or serpents behind,
 We watch past the watcher who guards.
 The king saw the slave and his eloquence there,
 At the door of his words there seemed a sea,
 With pearls of eloquence
and a light from every pearl,
 Each one giving turns of truth and of false,
 The light of divine seemed to shine from within,
 Both the question and answer described.

When the king saw that one of the slaves was possessed of keen intelligence, he commanded the presence of the other slave. This slave, by contrast with the first, was smelly, with bad breath and black teeth. And although the king was distressed by the odors that emitted from his mouth, he nevertheless made enquiries to discover what might lay hidden within the man. The king counseled the slave that although the mouth was smelly, this could be cured.

Do you burn a blanket for its fleas?
 Should I ignore you for your faults?
 Sit down and speak on some topics,
 That I may learn the form of your mind.

The king then sent the man away to a bathhouse to wash himself clean and scrub away the bad odors, and he summoned again the first bright and intelligent slave to speak with him once more.

He told the slave that he considered him worth a thousand other slaves and that what he had heard from the smelly slave seemed not to be true—that he was not to be trusted and that he (the king) should not trust him because he was a thief and dishonest, ill-behaved and immoral.

The favored slave told the king that his friend was a truthful man and that the king should not discard

the man's judgment against him, for he tended to be right and direct, and the king should keep in mind what he had been told by the other, and that perhaps the other saw faults in him that he did not see in himself. All in all, the favored slave's answer was self-effacing and generous toward the other.

So the king asked the favored servant to make similar judgment about the other slave, as he had done about the favored one.

The favored servant said to the king, *"I will tell you sir of his faults, though I consider him to be a pleasing fellow-servant."*

His faults are affection and loyalty both.
His faults are sincerity and keenness of mind,
Of cordial nature and great good friendship.
His least fault is bounty and the giving of life,
I'd trust him with mine, even mine.

The king said to the favored servant that he should not be over-generous in praising his friend, or give more out of his own good nature to mask the truth of the nature of the other. *"I'll bring him to the test and then shame will fall on you as a result."*

But the favored servant swore by all that was good, by all that could be sworn, that his fellow servant was as he had described and better, and he continued endlessly in this respect until the king stopped him from exhaustion and demanded that he tell more of his own good values and great virtues. But the servant could not, in all modesty, tell the king of his own values and spoke only at length of the accidents of life and how he had been fortunate and his friend unfortunate, and that none of this was his doing but simply that of fate. He never spoke badly of the other, nevertheless.

In this complex way he informed the king of his servant-friend's nature, and when the other returned from the baths the king spoke with him again, telling him that the favored servant had described him as double-faced, and that although this might seem a remedy for life, it was in fact a disease.

The foul-mouthed servant became furious and spoke terrible words about the favored slave, and foamed at the mouth and reddened in his face and gushed forth billows of vituperation that exceeded all boundaries.

And with this the king knew the truth, for the favored servant had not spoken one word against the other, even though the smelly-breathed one had scandalized him in his turn, whereas the foul-mouthed servant had spoken only bad about the other, continuing to show the depth of his nature.

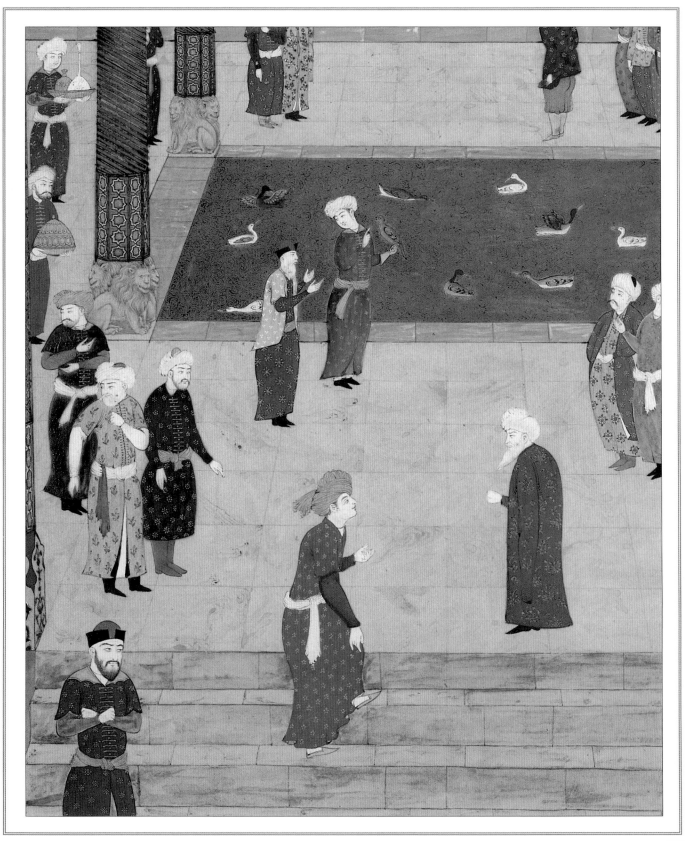

The Thirsty Man Who Threw Bricks

ON THE BANK OF A STREAM stood a high wall, and on top of the wall sat a sad, thirsty man. The wall prevented him from reaching the river, and he was desperately thirsty, like a fish.

Without warning, he suddenly threw a brick into the water, and the sound of the splash reached his ears like words spoken by a sweet and delicious friend, making him drunk, as though it was wine instead of water. So touched was he by these sounds that he began tearing the bricks from the wall, but then the water started to complain about having a brick thrown at it.

The thirsty man told the water, "I have two reasons for not stopping my destruction of the wall—the first is the sound of the water."

The sound is like an angel's trump,
A sound that brings back life.
Or like the noise of thundering spring,
From which the garden grows its flowers,
and other wondrous things.
Or for the poor, the days of alms,
or freedom from a jail.
It's like the breath of God Himself,
a gift to every sinner,
Or like the scent of grace that strikes upon the soul.

"And the other advantage I get from tearing off the bricks from this wall is that with every brick I get nearer to the running water. With each brick I remove, the wall gets lower."

My destruction of the wall is remedy enough,
To bring me in union with the water.
The splitting of the bond is true to my prayers,
Bringing me to God, in just the way that He
Has told me to draw near.
So long as this wall remains lofty and proud,
It stays an obstacle to my bowing head.
I cannot gain deliverance from the body of earth,
Till I prostrate myself on the Water of Life.
The greater the thirst atop this wall,
The quicker the bricks must be ripped.
The more love for the sound of water,
The greater tearing of the bonds before it.
Drunk is he that hears the rush,
While he that fails hears only the splash.

From The Sagacity of Luqmán

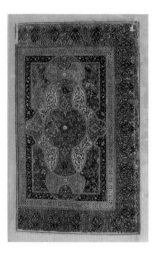

*L*ove makes bitter sweet;

Copper gold;

Shadows vanish;

Death into life;

Leaders into slaves.

From understanding comes love.

Has foolishness ever brought you so high?

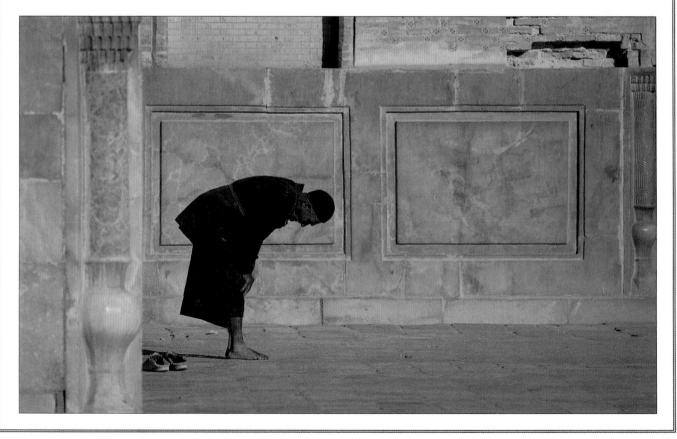

Moses and the Shepherd

*M*OSES CAME UPON A SHEPHERD along the way who was talking to himself saying, "*O God, who chooses whomever you wish, where are you that I might be your servant and repair your shoes and comb your hair? I can wash your clothes and kill your lice and bring you milk. I can kiss your small hand and rub your small foot, and at bedtime I can sweep your little room. I will sacrifice all my goats to you, and all my cries of sadness and exclamation shall be to you.*"

The shepherd spoke these tender intimate words in this way and so Moses said to him, "*Whom are you talking to?*" And the shepherd replied, "*The one who created us and who created our power to see earth and sky.*"

"You idiot," Moses said, "*you're not a Muslim but an infidel. What babble are you talking, what blasphemy and raving, stuff cotton wool into your mouth! The stench of your blasphemy has made everything stink. It's turned a silk robe into a sow's ear. You talk of shoes and socks—these are things you might wear, but not He who is the sun.*

If you don't shut up, a fire will consume everyone, and if not it has already burned your soul to blackness and caused your spirit to be rejected by God. If you know that God is the Judge, how can you imagine this sort of familiar talk is right?"

And the shepherd said, *"O Moses, you've closed my mouth and burned my soul with repentance."* And he tore his clothes and heaved many a great sigh, hastily turning his head toward the desert and running away.

That same day, Moses had a revelation that God came to him and said:

You send away my servant—did you come here to unite or to separate? The thing you should avoid most is separation. I hate divorce. I have given everyone the power to act in special ways, with their own particular forms of expression. The way the shepherd talked is worthy of praise, while the way you talked is worthy of blame—with regard to him, honey, with regard to you, poison.

I'm not interested in the difference between what's pure and what's impure, or what's lazy and what's not, in terms of how you worship me. I never ordained divine worship for profit, but as a kindness

to my servants. Every religion has its particular forms of worship, and none of them sanctify me, but themselves. Each one who worships sanctifies himself, becoming pure and radiant in the act. I don't look at the tongue that speaks or the words that are spoken, but the heart, the spirit and the feeling from which it comes.

> I gaze into the heart, lowly it may be,
> Though the words be higher still.
> For the heart is all the substance,
> The speech an accident.
> How many phrases will you speak,
> Too many for me.
> How much burning will you feel,
> Be friendly with the fire, enough for me.
> Light up the fire of love inside,
> And blaze the thoughts away.

Moses, you should realize that the ones who know the conventions are of one kind, while those whose spirits and souls burn are another kind.

> For lovers there's a burning that consumes all the time,
> You should not tax a village already ruined,
> If the lover speaks badly, do not call her bad,
> For all the martyrs bathed in blood,

> Do not wash their skin.
> Martyrs' blood excels the water,
> One such act exceeds a hundred right ones.
> Who cares if the diver has no snowshoes?
> Drowning is better than walking on water.
> Seek no guidance from a drunk,
> Don't ask those with torn garments to mend them.
> The religion of love is its own religion,
> The religion of lovers is God.
> If the ruby has no seal, no harm,
> For love drowned by sorrow is not sad.

After this God buried mysteries that cannot be spoken into Moses' inmost heart by secret ways of thought and vision.

> How many times beside himself,
> How many times returned, was he?
> How many times infinity,
> How many times eternal?
> Unfold this tale and foolishness,
> Is all I could achieve.
> No explanation here,
> Within our understanding.
> To speak like this roots up men's minds.
> To write in this way shatters pens.

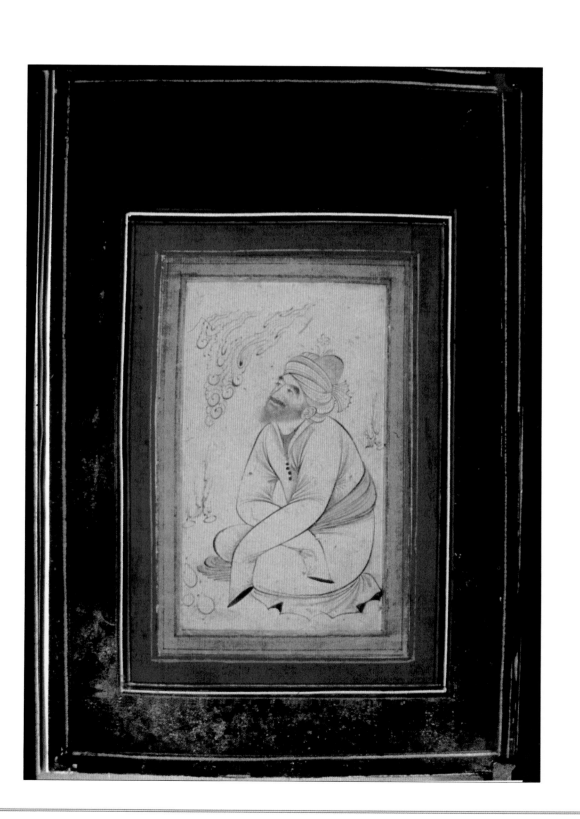

When Moses heard God's reproaches he ran into the desert and began frantically to search for the shepherd. He followed the footprints of the bewildered man and scattered dust from the skirt of the desert. He knew this man's distraught tracks from others because:

> At one step pranced a rook,
>> From top to bottom straight,
>> The other going crooked,
>> Crossed just like any bishop.
>> Now here he'd lift his crest, a wave,
>> And here fish-like on his belly.
>> The dust depicted all he felt,
>> As though he drew the story,
>> And last great Moses overtook,
>> To bring him great glad news.

"God has given you permission to speak whatever way your distressful heart desires. There are no rules now, and even your blasphemy is true religion—the light of the spirit. You're saved and through you, the whole world has gained salvation. You're secure from God, who does whatever he wishes, so go loose your tongue without concern or regard for what you say."

"Moses," cried the shepherd, "I've gone beyond all that and I'm so bathed in the depths of my heart and a hundred thousand miles on the other side. Your words applied the lash to me, and broke my shield, so that I made a massive bound and passed beyond the sky itself. Thanks to you in all ways, thanks be on your hand and arm! This state that I express to you, though, is not my real state, for my real state is beyond telling."

What you see lies in the mirror,
 Though it's your own, and not the mirror's.
 The breath that's blown within the flute,
 Who owns it, flute or you?
 When you speak praise or thanks to God,
 It's like the shepherd's unseemed words.
 It matters not what comes from you,
 But how God takes it over.
 A woman's prayers still stained in blood,
 No worse than yours with guile.
 A stream may wash away the blood,
 But who can wash away your heart,
 That plies from dark impurity?
 But one can clean the impure heart,
 It's only He the Maker.

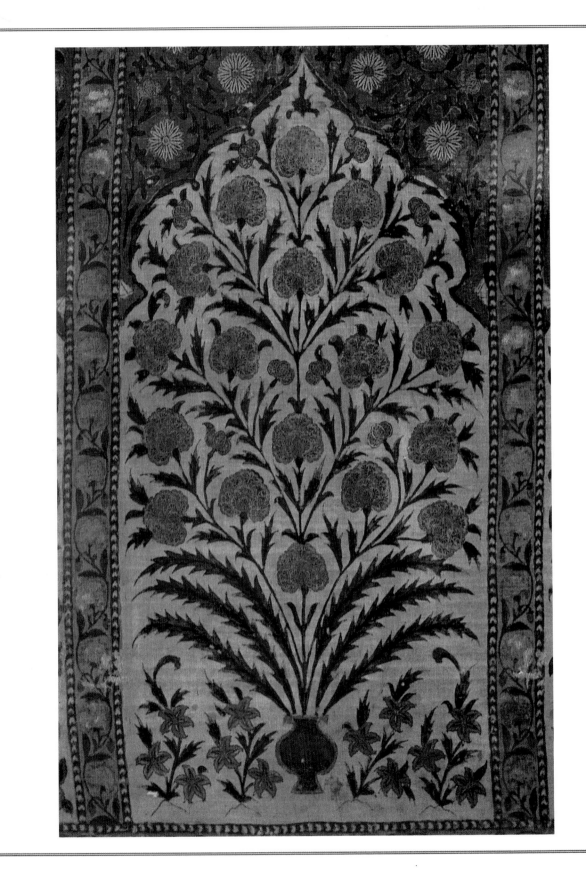

The Man Who Swallowed a Snake

A WISE MAN WAS RIDING ALONG when he saw that a snake was about to slither into the mouth of another man sleeping alongside the way. The rider hurried to try to prevent the disaster, but was too late, and the snake went down the man's throat into his belly.

The rider, a highly intelligent man, took his staff and began beating the poor man who'd swallowed the snake, who ran beneath a tree to avoid the attack. The tree was surrounded by its fallen and rotten apples, so the rider began to stuff them into the poor man's mouth, forcing him to eat as many as possible, until they were falling out of his mouth all down his chest and back onto the ground again.

"What have I done to you to deserve this terrible treatment," the poor bursting man shouted, between mouthfuls. *"If you have a quarrel with my soul, then please, draw blood at once. Cursed is the hour that I came into your sight, and joy to him that never sees you. I'm mixing blood with my words here, please only hand out the retribution that's deserved and no more."*

But the rider equaled the complaints of the poor beaten man with more strikes from his staff, telling him all the time, *"Run here, run there!"* The rider's blows and his feet were as swift as the wind, so that the poor man could do no other than obey his commands, now and again falling on his face along the way.

The man had recently eaten and had been lying beside the road to rest off his overfilled belly when the rider began to beat him, and now he was also covered in bruises and wounds from the staff of the rider, but the battering continued into the night until eventually the poor man began to vomit from exhaustion and suffering. All that he had eaten, good and bad, came pouring from his mouth, and along with all this came the snake, which shot out of his mouth too. When the man saw the snake he fell to his knees before the wise beneficent man, his grief and pain departing him at once.

You are the Gabriel of divine mercy,
You are the lord of bounty.
Blessed is the hour that you saw me,
For I was dead and you gave me life.
You sought me like a mother her child,
As I ran from you like an mule.
The mule escaped the master,
Like a fool before the wind.
The master chases the mule,
Like a wind to cool the brow.
O you, whom the pure spirit praises,
What idle words did I express?
O lord and emperor great,

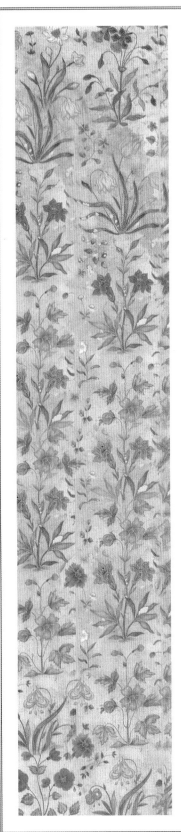

Please don't punish my mistake.
I should have praised you from the start,
But knew not what you planned.
Your silent beating shook my head,
So small my brain within.
Pardon me my hasty words,
Forgive me with your goodly care,
For I uttered in a frenzy.

The rider said, in reply, *"If I had told you what I was doing, your courage would have departed you and your body would have fallen and died before me. Mohammed taught that telling the disciple of the true darkness within the being causes only collapse and death from the horror of imagining it. In this knowledge the body has neither strength to fast nor the ritual for prayer."*

Thus we are good for nothing,
 Like a mouse before a cat, distraught,
 As a lamb before a wolf, stricken.
 So I tended you speechless,
 Mute with David's staff,
 So by my hand it came to pass,
 The wings restored upon the bird,
 Whose plumes were torn away.

From Ibráhím, Son of Adham

*A*lready,

don't you rush toward the garden?
That garden that contains the joy you seek.
Already, don't you clear the way?
Smell that fragrance,
Seducing your soul.
You only need so little,
Let the scent draw your soul,
Make that scent the light of your eyes.
Cast this light on everyone you see,
Like prayer and ritual take this light
To all the senses that are linked together,
All grown from a single root,
Each giving strength to the other,
Each bringing sustenance to all.
Seeing with the eye increases the word,
As the word makes the eye more sharp.
The sharp eye makes sharper wit,
And all that senses grow.

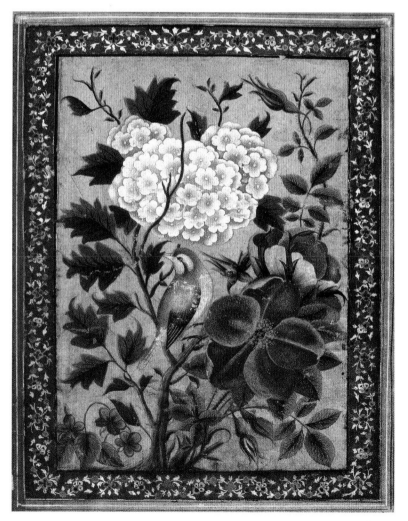

The Tree of Life

A LEARNED MAN ONCE SAID, for the sake of telling a story, that in India there is a certain tree, from which whoever eats the fruit, he will never become old or die as a result of the fruit.

A king heard this tale from one who hoped to gain from his wealth, and he became obsessed with the tree and its fruit. As a result, he sent an envoy to find the tree, and for many years the envoy wandered about India in quest of the desire of his master. He roamed from town to town, from mountain to valley, from island to island, and from plain to plain, leaving no place untouched in his search.

Everyone that the envoy asked about the whereabouts of the tree mocked him, saying, *"Who would search for such a tree unless he was crazy? Who would have spent so much time already in this quest without success, unless there was a good reason?"*

And there were those others who would tell him sarcastically of the presence of such a tree, *"In such and such a place there is such a tree—a very huge tree, a green tree, a very tall tree, a very broad tree, with every branch so big that you will not believe."* And such messages and advice hurt and caused the envoy to grieve, for none of it was intended to help him one bit.

But the envoy, who had braced himself for this difficult quest, kept trying, and traveling, and searching for the tree that his master so eagerly desired, sending money for support all the time.

Eventually, however, after so long and so hard a search, the envoy became exhausted by his quest and couldn't seek any longer. No trace of the tree was found and no result came to give even the slightest hint of the whereabouts of the tree that would give everlasting life and immortality. So the thread of his hope snapped and the thing that he sought became unsought in the end.

He resolved to return to the king and set out shedding tears of despair. Along the way he met a shaykh who asked him why he so despaired on his way through life. The envoy related his tribulations and his searching for the tree of life, and the shaykh laughed and explained that this tree that he sought was the tree of knowledge of the wise, and that it was very high and very grand and very far-branched and that it contained the water of life from the all-encompassing Sea of God. *"You have searched for the form of the tree not the essence. Sometimes it is known as the tree and sometimes the sun, sometimes the sea and sometimes the cloud."*

> *It is that from which a thousand places,*
> *Life comes everlasting,*
> *Even though its source is single,*
> *It brings a thousand doubles,*
> *Innumerable names befit its form,*
> *Without design it has all virtue,*

Whoever seeks it finds his own.
Why stick to one shape or another,
You'll fail to find the tree, and find ill fortune,
Disappointment only will be your bitterness.

Pass on from the name,
and look closer at the source.
The source will show you what you seek.
Leave the form behind.

The Mathnawi

BOOK THREE

*In The Name Of God
The Compassionate,
The Merciful*

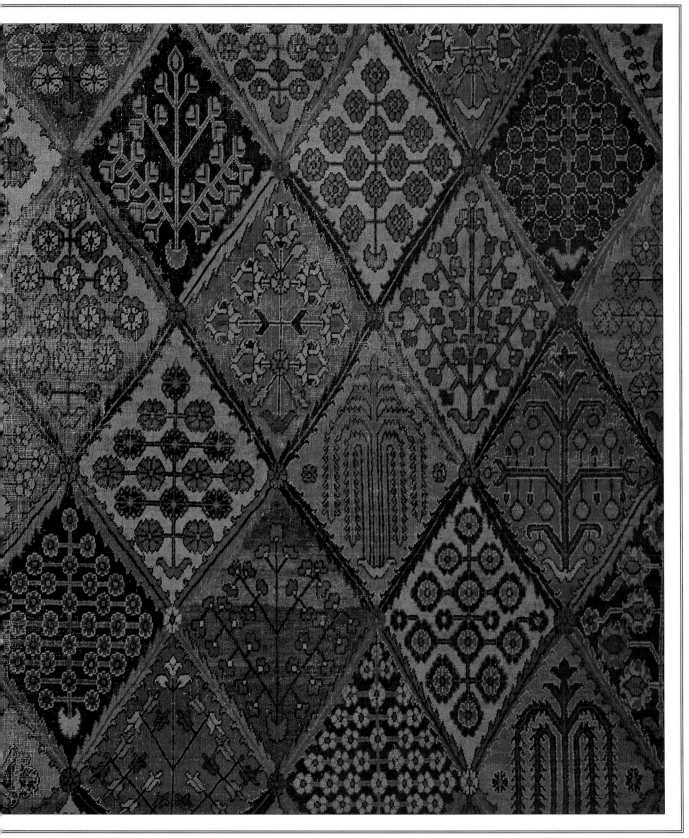

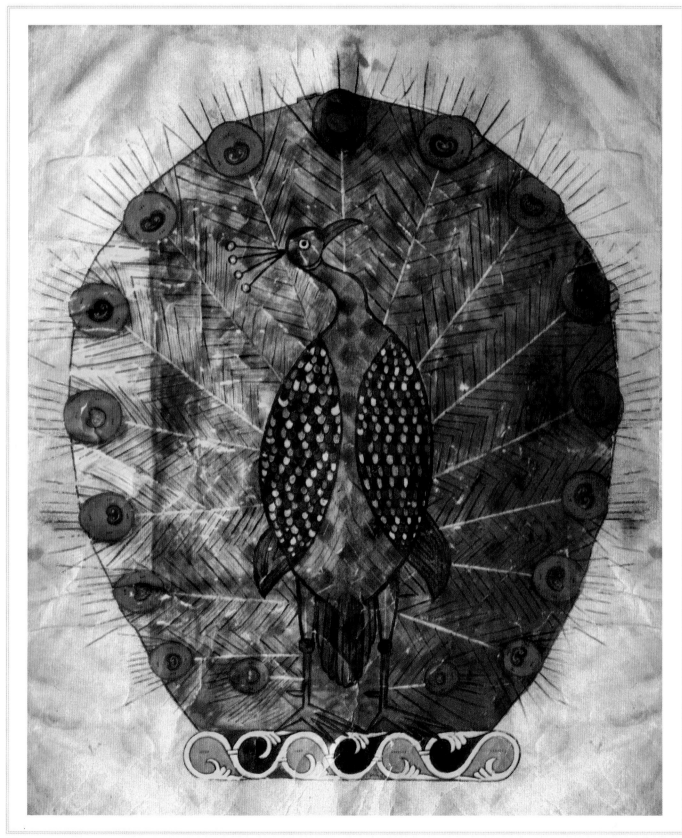

The Jackal Pretending to Be a Peacock

A CERTAIN JACKAL fell into a dyeing vat and after swimming around for a while emerged multicolored and boasting that he was transformed into the greatest peacock of all time. His colored fur had gained incredible brilliance, and the sun shone upon the colors so brightly that the creature was stunned by its own effect.

He saw that he was green and red and roan and yellow, so he pranced before the other jackals in delight of himself. They said to him:

Little friend what is this dream, this delight?
It sets you apart from us all.
Where has this arrogance arisen from,
Full of disdain, full of disdain?

One of the jackals approached the multicolored one and asked him:

Are you true or are you false?
Are you a saint or a liar?
Will you jump upon the pulpit
and lecture us all in prayer?
But where's your spiritual ardor,
Does it lie like a piece of disrespect?

Spiritual ardor belongs to the saints and prophets, and becomes only disrespect in the hands of the imposter. The imposter draws the attention of everyone around him, as he utters his external joy, and his heart cries deeply with unhappiness.

The Snake Catcher and the Frozen Snake

*A*SNAKE-CATCHER went into the mountains to catch a snake with his arts.

> *Whether slow or speedy, he that seeks will find.*
> *Always apply with both hands the pursuit,*
> *For search is an excellent guide.*
> *Though lame and limping, though bent and crude,*
> *Creep ever toward the goal.*
> *Now by speech and now by silence,*
> *now by smell and now by sound,*
> *Catch from every quarter the senses of the king.*

The snake-catcher searched around in the mountains for a big snake at a time when the snow fell deeply. Eventually he found an enormous dead dragon of a snake and, being one who loved to impress the people of his town, he took the snake and brought it to Baghdad in order to create much excitement. He carried the enormous creature, as big as the pillar of a house, until he arrived in the town and began to proclaim his triumph to everyone he met, telling them that he had struggled and fought with the dragon until it died at his hands.

The only problem was that the dragon snake was not dead at all, but still very much alive and slumbering around his neck, fast asleep from the bitter cold. Not knowing this, the snake-catcher set up a public show at the crossroads of the town near the river Tigris, and a hubbub arose in the city from all those who wanted to see this extraordinary phenomenon, the dead dragon-snake of the snake-catcher from the mountains.

"A snake-catcher has brought a dragon—a marvelous and rare beast he has captured—we must go and see."

Myriads of simpletons (short beards) assembled, prey to his story, as he was prey to the story himself, all waiting to see this extraordinary dead dragon—the better the crowd, the better the income, so he waited too for the myriads to assemble. Soon enough they came, packed together like crows in a tree, soul to soul, straining their necks.

When the snake-catcher unveiled the dragon from the coarse woolen clothes that had covered it on its journey from the mountains, they saw that it had been bound in ropes, and yet, despite this precaution the sun of Iraq had been shining on the bundle for several hours and warmth had imbued the monster's flesh. It had been dead and now it was revived and the dragon began to uncoil.

The response of the crowd was a thousand fold more dramatic and excited than before, and with shrieking and crying they began to flee from the event of this uncoiling, the bonds of the snake imposed by the snake-catcher cracking and bursting with every movement. Soon enough it had broken free and slithered out, a hideous dragon roaring like a lion. Many of the crowd were killed and injured in

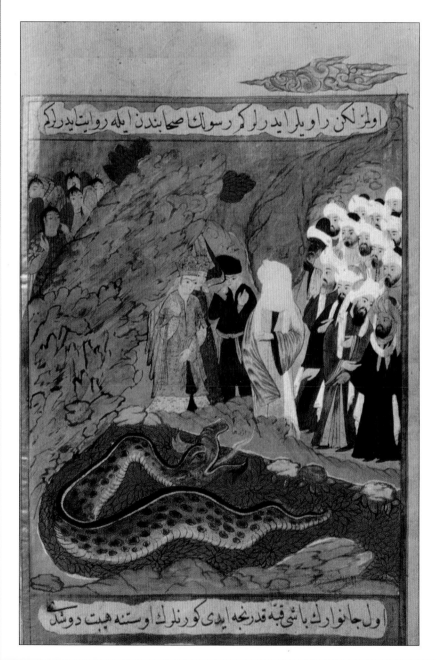

the commotion and the snake-catcher was paralyzed with fear where he stood, crying, *"What have I done, what have I brought from the mountains?"*

The dragon-snake, with one huge gulp, swallowed up the snake-catcher without hesitation, gulping his blood with no conscience. It crunched his bones as if they were sticks, no problem at all.

*The dragon is your sensual soul,
how is it dead?*

*Its frozen state is only grief,
only lack of means.*

*Give it power and sun to heat,
and fly it will, fly it will.*

*Keep it frozen in the snow
and never will it stir,*

*Give release and on its gain,
a mouthful will it make of you,*

*Flapping like the bat of hell,
consuming all it finds.*

*Always keep the dragon safe,
bound in faithfulness,*

*Unless you have a Moses strong,
his staff to kill it sure, and sound.*

The Elephant in the Dark House

HERE WAS AN ELEPHANT in a dark house, brought by some Hindus for exhibition. Many people went to see it and had to enter the dark stable to do so. Because it was so dark they could not make out the form of the elephant at all and had to work with their hands to identify its being, each person using his palm to find the shape. The hand of one fell on the creature's trunk and he said, *"This is a water pipe."* The hand of another touched the ear and found a fan. Another handled the elephant's leg and found a pillar, while another touched the back and discovered a throne. There were those who heard descriptions from these folk and made their own identifications, and there were still others who interpreted one shape as against another, all very diverse and contrary.

Had there been a candle in each hand,
 The differences would have come from speech.
 The eye of self-perception is like the palm and hand,
 For this has power to touch but part, not whole,
 The eye of the sea is one thing, the foam another.
 Leave the foam and look through the eye, marvelous!
 We dash against our sight like boats,
 Our eyes are blind, missing clear water.
 The water has water driving it,
 The spirit has a spirit calling it.
 Take the spirit home and let it drive,
 For it will find the shape and size and know the whole,
 Without a glance, without a touch, but always whole.

The Lovers and the Love Letter

A CERTAIN MAN, when his beloved allowed him to sit beside her, produced a letter and read it to her. In the letter were verses and praise and glory and lamentations, wretched feelings and many humble entreaties. The beloved said to him, *"If you're reading this for me at this time while we sit together, then you're wasting my life. I'm here beside you and you read a letter! It doesn't seem to me to be quite the way lovers should behave."*

And so the man replied, *"You're beside me, but I don't feel that I am really getting closer to you. Last year I felt something different, which I don't feel now, though I am still close to you."*

I have drunk cool water from the fountain,
 I have refreshed eye and heart with this flow.
 In you I still see the fountain,
 But now no water flows, stolen by a thief.

So she replied to him:

Then I am not your beloved,
 For I am somewhere else,
 And the object of your desire departed.
 You're in love with love,
 And love is not in your control,
 So I am not the whole you seek,
 But only part right now.

The temple of love
 is not love itself;
 True love is the treasure,
 not the walls about it.
Do not admire the decoration,
but involve yourself in the essence,
 The perfume that invades and touches you
—the beginning and the end.
 Discovered, this replaces all else,
the apparent and the unknowable.
 Here is the master of all emotions, independent;
 Time and space are slaves to this presence,
 This god, king of all he surveys, even death itself.
 Thorns and stings become narcissus and wild roses.
 He who depends on the state remains human,
 For the state comes and goes, good and bad.
 You're in love with your state, not me,
 And only He directs it, not you.
 Your love for me gives hope for greater things,
 And this does nothing but sink,
 And he who sinks will bob and drown,
 Not the true beloved, who's neither fire nor flow.
 He may be the mansion of the moon,
 But not the moon herself.
 He may be the picture of adoration,
but not the presence.

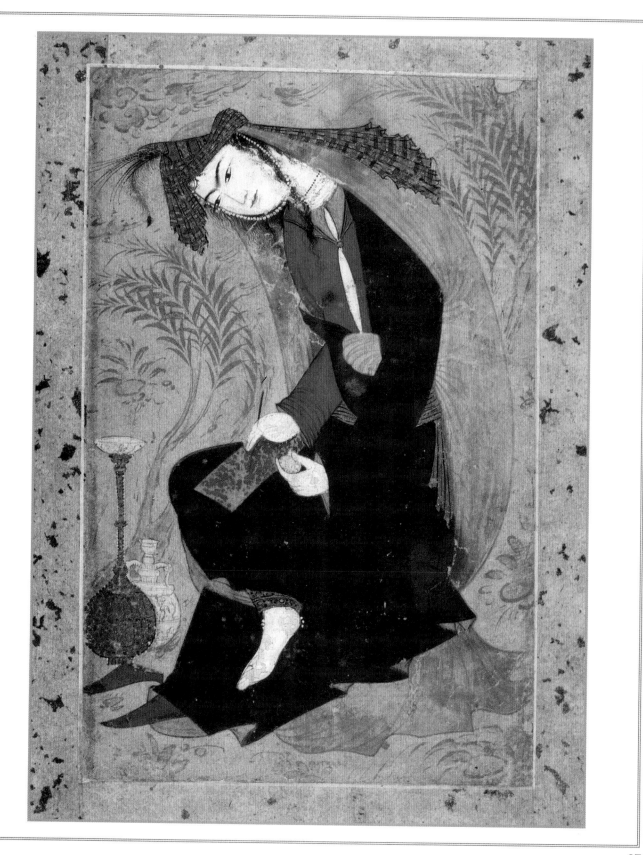

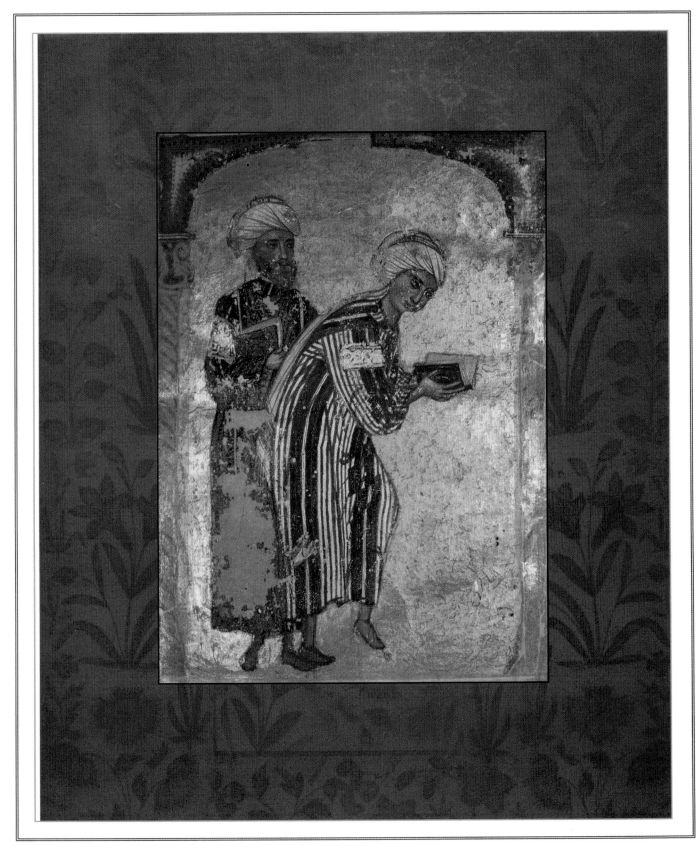

The Teacher Who Thought He Was Sick

Go seek a love like this, if you truly live,
 Or else remain the slave to time,
 And whatever state you seek,
 Your lips so dry, must always drink,
 Drink up and up and up,
 Till dry-lipped still, you reach the source.
 For all your skills have given wealth,
 Your quests, your handicrafts and works,
 Don't they begin in thought,
 Begin beside the river?

HERE WERE A NUMBER OF BOYS in a school who had a teacher who made them work so hard that they had become exhausted. They consulted together to figure out a way of stopping the work so that the teacher would have to let them go free.

No sickness befalls him,
 We get no break, no escape from learning
 This master is fixed like a rock, unmovable still,
 What can we do, what can we do?

So the cleverest of all the boys came up with a plan to say to the teacher:

Master, master, I see you so pale,
may it be well with you.
 Your color is changed; perhaps it's the air,
 Or maybe a fever's set in.

With this the boy imagined the master would begin to think himself sick. So the bright boy begged his friends also to speak to the teacher in this same way, so he'd be persuaded by numbers.

When you come in the door,
tell the master your thoughts,
 "Sir, is your health in such a good state?"

And the third and the fourth, will behave likewise,
Showing sadness and sympathy this way.
And with thirty such statements directed at him,
Surely all this opinion will lodge in his mind.

All of them agreed, at the insistence of the bright boy that this was a wonderful idea and took a covenant not to alter the words and swore not to tell anyone of the essence of the plan.

So the school day began and the boys arrived at the school. They all stood outside, waiting for the teacher to go in first. One of the boys entered the class and said to the teacher, *"Master, I hope you're OK. Your face is a little discolored."* The teacher replied, *"There's nothing wrong with me boy—go and sit down at your desk. Don't talk nonsense."* He denied what the boy had suggested but the dust of imagination touched his heart slightly. Then another boy came and said the same thing, and so increased the sense of doubt in the mind of the master. Other boys continued to tell him similar things about his appearance, and gradually the teacher's imagination gained strength until he was beginning to question his own state of health.

He began to walk slowly and with difficulty. Once he got home, he became angry with his wife. *"She doesn't love me or she would have noticed how sick I am,"* he muttered to himself. *"She didn't tell me how pale I look. She must feel disgraced and want to get rid of me."*

"She's intoxicated with her beauty,
 And the manifest display of her charms,
unaware that I'm broken down."
 Coming home, he burst the door,
the boys close on his heels.
 His wife gasped, "Is all well with you?
Why are you home so soon?
 I hope that no evil has come to you."
 "Are you blind?" he said.
"Can't you see?" he said.
 "Look at my color and guise.
Every stranger laments my affliction.
While you sit at home, with hatred and lies,
Can't you see the hardship I'm in?"
 "My man you are fooling yourself,
There's nothing at all wrong with you.
It's only your vanity making the pain,
Your opinion, your ideas, no more."
 "You strumpet, denying me still,
You must be both blind and deaf."
 "I'll bring you a mirror," she said,
 "Then you'll see how innocent I am."

But the teacher would have nothing of the mirror and cursed his old wife profoundly, telling her angrily to lay his bed down so that he could tend to his sore head. The old woman brought the bed-clothes and spread them out, anxious not to make a bigger fight and not to let him think she had some plan to be alone without him during the day, a plot to do some wickedness.

The master collapsed onto the bed, moaning and groaning at his imagined discomfort, and the boys sat around him, reciting their lesson still, thinking that perhaps their plan hadn't been quite such a good idea, for here they were trapped in another building instead of the schoolroom.

The clever boy once again had the idea to recite the Qur'an loudly and make the master sicker still. At this, the teacher threw them out of the house.

They felt happy at last, bounding off into the day like birds in search of grain. But once at home, their mothers didn't believe what they told them—that the teacher was sick—and swore to visit him the following morning to discover the truth.

When they arrived, they found the master still in bed, his body covered in quilts and sweating from the covers, moaning softly at his agonies. At this, the women also cried, *"Poor teacher, we weren't aware of your sickness of the soul, we hope you'll soon recover."*

When a man is busy in earnest,
He is blind to the sight of his pain.
Like a warrior in battle, his arms cut and bruised,
His soul does not see what he's doing.
Thinking himself intact,
And after the battle is done,
The blood has gone out of his body,
Far more than he would ever have known.

Know then that the body is merely a garment,
Go seek the wearer, not the cloak.
The knowledge of the unity of God
Lies sweeter on the heart than flesh.
The hand of the soul, the foot of the soul,
These limbs of the soul are not limbs of the state.
As the soul goes forth, therefore,
Never fear its departure,
for it will walk and touch still.

The Miracle of the Water Skin

A CARAVAN OF ARABS ran out of water while traveling through the desert, and was close to death with dehydration. Suddenly Mohammed appeared, as he had seen this great caravan engaged in its terrible journey on the scalding sand with the tongues of the camels hanging out and the people strewn about in terrible condition. He took pity on them and said:

"Listen, go at once to this sand hill,
 Where a black man will come.
 He'll carry a gourd that he brings to a king,
 Guide him here to me, by force if need be."
 The Arabs obeyed and soon came the man,
 His camel weighed down by the gourd.
 They spoke with him softly
what Mohammed had said,
 But the black man stopped,
not knowing their Prophet,
 And questioned their quest with his journey.
 "He is that moon-faced sweet-natured one,"
they said.
 But the man was afraid,
and thought him a wizard,

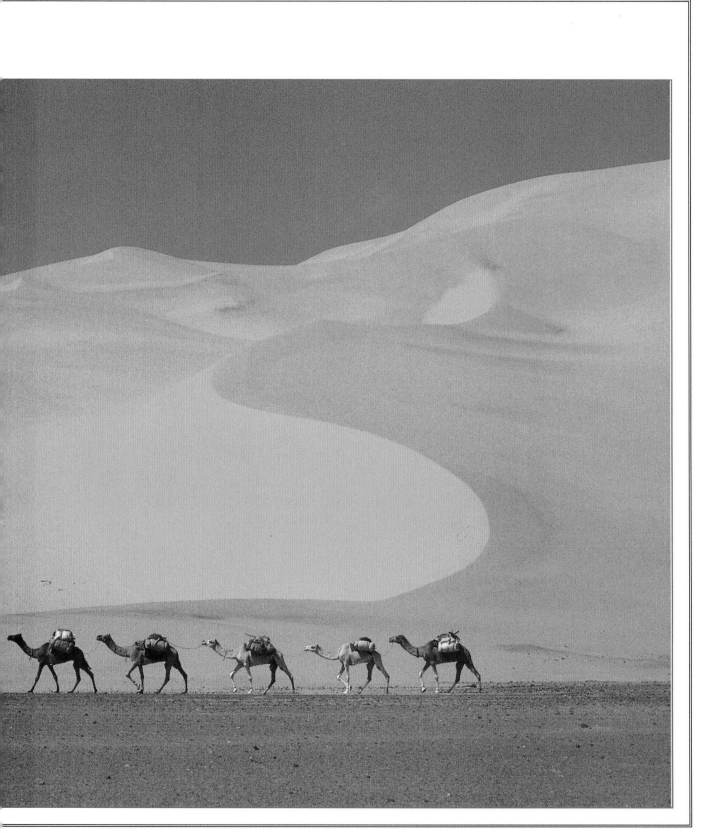

Not wanting to go any farther.
So they dragged him along,
and he screamed and cursed,
Until they arrived in his presence.
Mohammed spoke clearly and ordered the man,
To let all those present take solace and drink.
Their thirst was soon slaked, the camels and men,
The multitude of water-skins filled again.
Even the clouds in the sky were distraught
For no one and nothing had seen such display,
That the burning in hell of so many thirsts,
Could be cooled by a single gourd.

The people of the caravan were totally
amazed at the Prophet's deed, and cried in joy that
Mohammed had even the nature of the sea that he
could make water from nowhere. The Arabs realized
that what he had done was to lift the veil between
the human idea of cause and effect and the reality of
God's magic and mystery.

So the Prophet turned to the black man and
said:
"Slave behold your gourd is still full,
 And there's no longer need for complaint,
good or bad."
 The man was amazed at Mohammed's miracle,
 His faith emerging from beyond.
 He saw that a fountain had poured from the air,
 And his gourd could no longer hide from the truth,

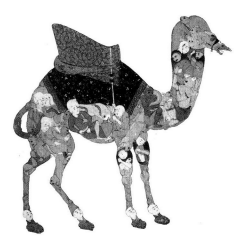

Being filled from the ocean aloft.
His eyes burst with tears, forgetting his king,
Ignoring the place he should go.
But the Prophet leaned forward
and spoke in his ear,
 That bewilderment need not be his partner,
 That he should go forward, and take a new fortune,
 For this was a gift to his soul.
 The black man poured kisses all over Mohammed,
 And thanked him a hundred times,
 As the Prophet laid hands on his face.

And at that fair moment, fairer than all moments,
 The black man's face became white,
his slavery gone in a flash of light.
 The man transformed, found his way home,
and told all his people the story.
 And carrying with him a full set of skins,
he delivered the water complete to the king.

The Woman Whose Children Died

HERE WAS A WOMAN who gave birth every year, but no child lived longer than a few months. She would cry and complain each time in terrible lament, that she had all the problems and discomforts of pregnancy, and then perhaps a month or two of delight with the baby, followed by the terrible remorse of death. Twenty children had died in this way, and she kept trying to find an explanation, going to the priests and holy men around her.

But one night she received a vision of an everlasting garden, filled with beautiful flowers and verdant color, the most beautiful garden she had ever seen.

And at this sight, she collapsed with joy,
 Seeing her name on a palace,
 A palace belonging to her.
 "This bounty rewards your constant devotion,
 You have done much service to God."
 And she cried as the spirits delivered the message,
 And entered within to find all her young,
 Inhabiting that glorious garden.
 "They were lost to me, but not lost to God,
 Residing here beyond my eyes,
within my spirit still."

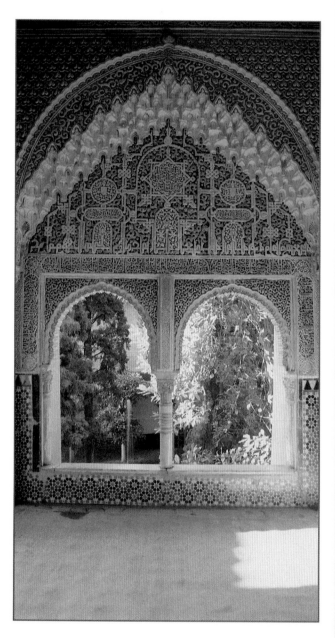

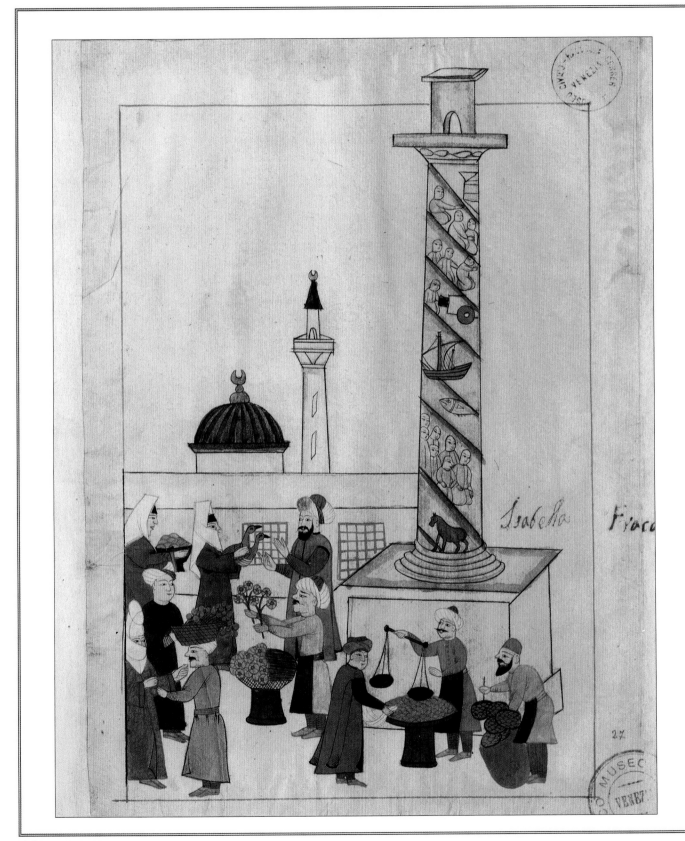

The Man Who Was Always Being Swindled

HERE WAS A CERTAIN MAN who said to the Prophet, *"I'm always being swindled in business. The ways people sell or buy is like magic to me, and I end up paying too much or earning too little."*

The Prophet said to him:

When you're afraid of being duped, my friend,
Give yourself three days to think and choose.
Consider the dog or cat, my friend.
See how they smell at the morsel you throw,
Sniffing and sampling with careful concern.
We are all endowed with equal skills,
The wisdom to smell, the intelligence to think.
God could have made the world in a blink,
A hundred worlds, a hundred heavens,

But considered He, six days and more,
Till satisfied, deliberate, matured, complete.
Forty years for a man to reach wisdom.
God could have made you and fifty more,
Without so much as a single breath.
Consider your deals, consider your sales,
Consider your life, and consider your God—
Take time like the river that never grows stale,
Keep going and steady, no hurry, no rush.

From the Beloved Attracts the Lover

We race hotly after the lover,
But when the lover comes, we are absent.
You're a lover of God, but He is such
That when He comes, there isn't a drop
Of you remaining, for with His look,
A hundred like you will wither away
You're like a shadow in love with the sun.
When the intensity of light appears, you vanish.
Chasing yourself away.

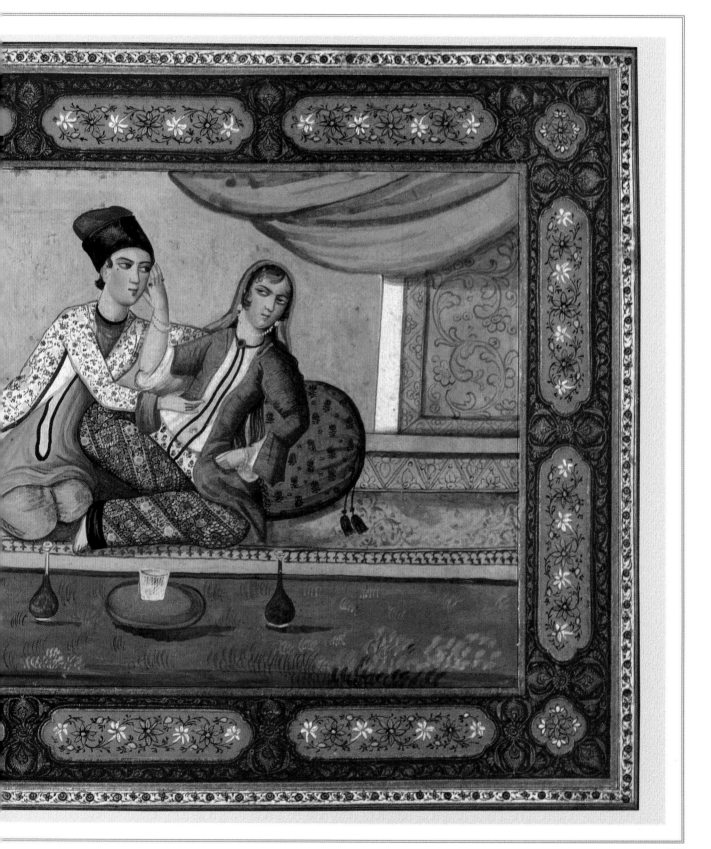

The Unworthy Lover

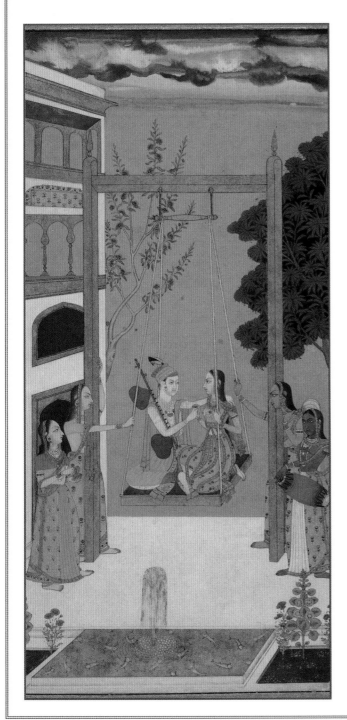

A CERTAIN YOUNG MAN was totally enamored of a woman, but he had not been able to get close to her. Love tortured him terribly, and he had no experience of the pain that love brings at the beginning.

Why is love murderous first,
so he who suffers runs away?
 He'd send a courier fast to her side,
and the messenger'd fall in love too,
 And steal the road they'd made for him,
 Jealous to bar him from love.
 His secretary wrote a letter to be sent,
 But the reader would change all the words,
 Making her doubt the lover's intent,
 And making him sound absurd.
 If he sewed his entreaties to the wing of a bird,
 They would burn the wing, and never be heard.
 At first expectation gave comfort to him,
 Dampening sorrow, hope gave him color.
 But as failure continued that self-same sorrow,
 Turned hope into doubt, and doubt into dust.

 For seven long years the youth dreamed of love,
 But the dream came to phantom,
 and the phantom to shadow,

But the shadow of God brings a seeker to find.
Knock on a door, knock, knock enough times,
And a head will come forth from behind.
So the lover of hope kept on trying and trying,
Till a meeting was granted by chance and fear.
The youth feared the curfew patrolled by the cops,
Afraid apprehension would carry him off,
He ran to an orchard nearby.
And there she stood, his beloved, full bright,
Like candle and lamp among the trees,
Only chance had brought them there.

The girl, for whom he had waited almost eight years, was standing in the orchard where the youth had gone to escape the night patrol, purely by chance arriving beside the spot where she appeared to be searching with a lantern for a ring in the small stream of the orchard. So the youth, excited and delighted, uttered prayers to God in favor of the night patrol who had inadvertently sent him there. For once a policeman had done a favor, though without realizing it, and was being blessed by the youth's prayers till the end of his rotten time!

But then he attended quickly to the task of conquering the beautiful woman he had waited to see all those years, rushing toward her and attempting to kiss and embrace her.

"Be mindful of good manners," she said.
"Don't behave like a thug," she said.

"But there's no one here," he said.
"The water is close and I'm a thirsty man," he said.
"There is no movement but the wind,
So who will hinder my success?" he said.
"Oh, you idiot and fool,
you don't listen to the wise.
The wind that moves comes
with the Mover of the wind," she said.
"Beware of the wind that it changes,
From eulogy to foul speech it changes,
From venal to kindliness it changes,
From cold and violent to perfumed
and balmy it changes.
One wind He makes deadly and another delight,
And the wind in you
may make such changes too," she said.
"So be gentle not harsh, be honey not venom,
Know that with every move there is a Mover."

And the youth complained, *"If I'm poor in manners, I'm wise in faithfulness and eager pursuit."*

She turned toward him and replied quite simply, *"Your manners are visible, your faithfulness is not, foolish man."*

The Mathnawi

Book Four

In The Name Of God
The Compassionate,
The Merciful

From the Prophet's Choice of a Young Man

Silence lies in the ocean,
while words flow through the river.
The ocean waits for you, don't wait for the river.
Look to the ocean and watch its message,
It will come, it will come.

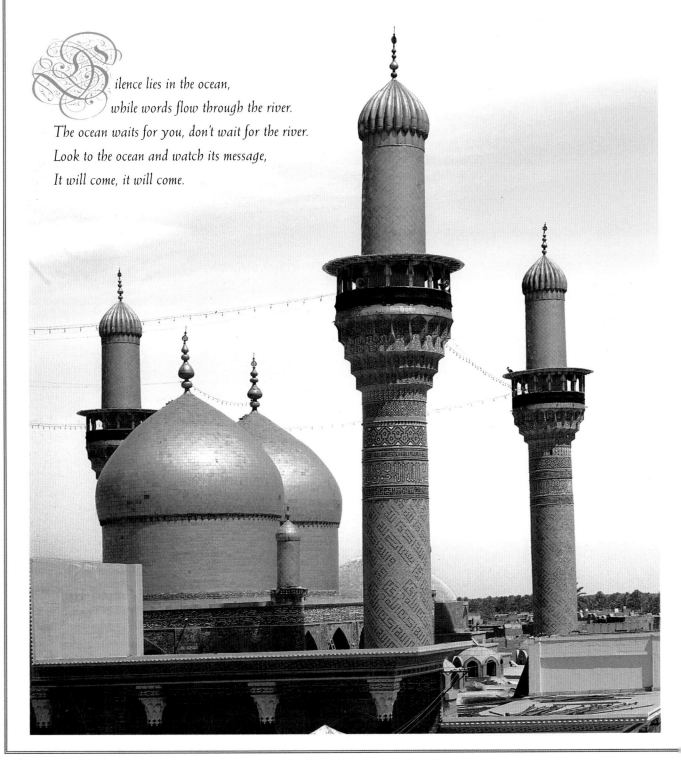

Camels on the Roof

*W*HILE RESTING, a man heard sounds at night on his roof. There were loud footsteps and he wondered what could be happening. He shouted outside the window, *"Who is it? Is this a genie on my roof?"* An extraordinary and magical man bent his head down over the window from above and said, *"We are going around by night searching."*

"What are you searching for?" the man asked.

"Camels," he replied.

"Oh really," he exclaimed. *"Who would seek camels on a roof?"*

"Camels, yes. In the same way as you seek God on His throne. Is this so much more extraordinary?"

It was this and no more.

No one saw the man on the roof again.
He vanished like a genie in flight.
But he made his point of the madness of man,
That a camel that flies is no more crazy than he
Who seeks God on the throne of delight.

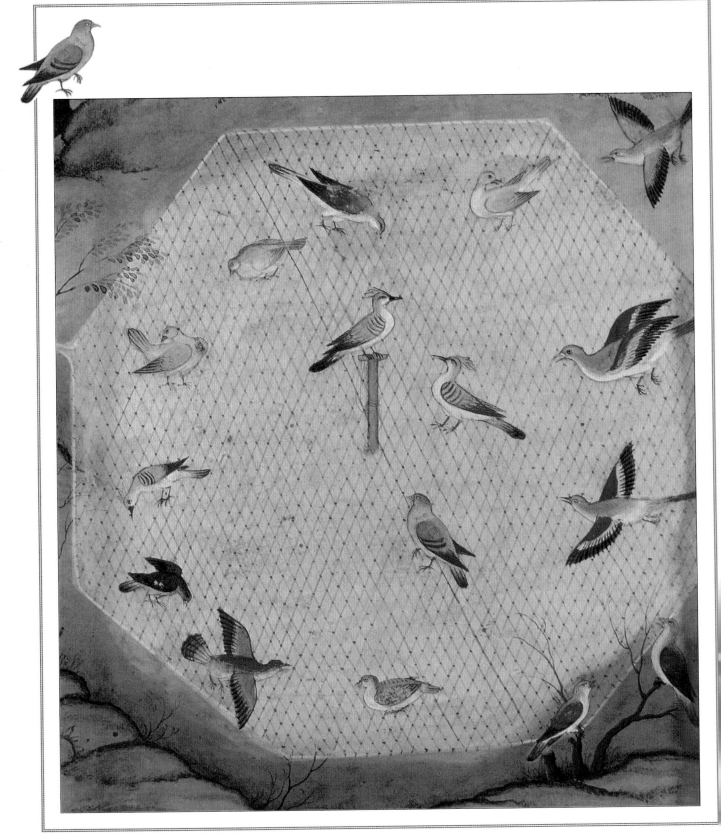

The Bird's Wise Counsels

BIRD WAS TRAPPED BY A MAN and once held by the man, the bird said to him, *"Noble sir, you've caught and eaten many oxen and sheep and sacrificed many camels. None of these creatures have satisfied your hunger, and neither will my body help this situation. Rather than just eating me and feeling dissatisfied, instead, let me go and I'll give you three pieces of wisdom that will be better for you than a simple meal. I'll give you the three counsels step by step, the first one while I am trapped here on your arm, the second on the roof, and the third from the tree over there. These three counsels will bring you great fortune, so let me go now."*

And the first counsel was:

Never believe absurdity, whoever speaks the word.

And with this the bird was freed and went to perch on the roof of the man's house. Here he gave the second counsel:

Never grieve that which is past,
When things have passed feel no regret.

And after giving this second counsel, the bird told the man:

In my body, carefully concealed,
A large and precious pearl exists.
This jewel, I can tell you sure,
Would have been your fortune,
And the wealth of your children.
You missed the pearl, not meant for you,
A pearl not found in all of life.

The man began to wail with sadness and distress, making a terrible noise with his regret. The bird said to him:

What did I just say to you, silly man,
Let there be no grief in you,
for past events that failed.
Since this event has passed and gone,
Why do you mourn and wail,
why do you so complain?
Did you not perceive my gift,
or are you simply deaf?
And as to counsel number one,
That you eschew absurdity,
how do you think that such a pearl
Could hide in this small frame?

At this, the man recovered his wits and asked the bird for the third piece of excellent wisdom. And the bird replied:

I see the use that you have made,
With both the counsels up to now.
Why should I tell you more?
Giving wisdom to a fool
I might as well cast seed in sand,
Than give you further gems of mine.

At this he flew away.

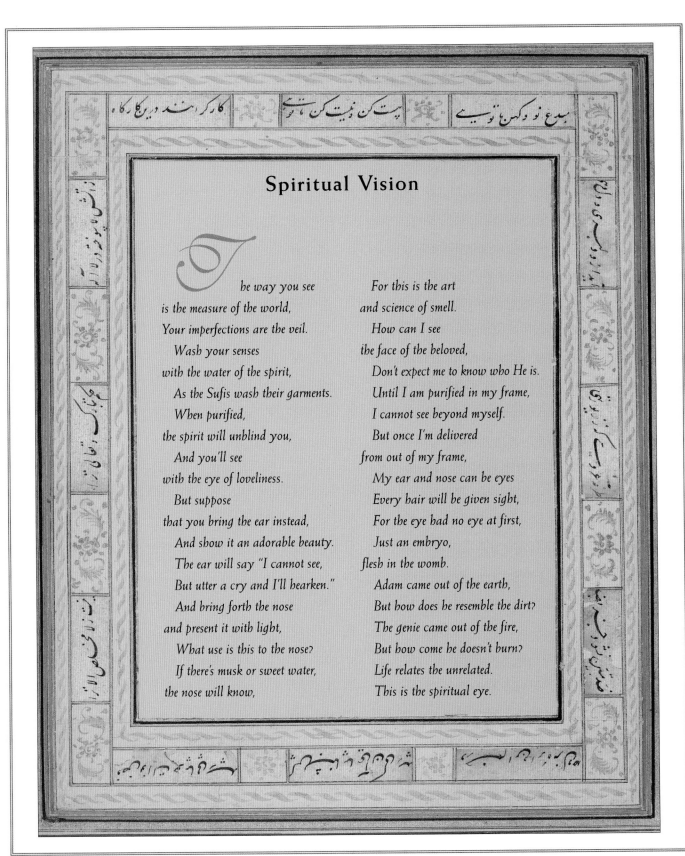

Spiritual Vision

The way you see
is the measure of the world,
Your imperfections are the veil.
 Wash your senses
with the water of the spirit,
 As the Sufis wash their garments.
 When purified,
the spirit will unblind you,
 And you'll see
with the eye of loveliness.
 But suppose
that you bring the ear instead,
 And show it an adorable beauty.
 The ear will say "I cannot see,
 But utter a cry and I'll hearken."
 And bring forth the nose
and present it with light,
 What use is this to the nose?
 If there's musk or sweet water,
the nose will know,

For this is the art
and science of smell.
 How can I see
the face of the beloved,
 Don't expect me to know who He is.
 Until I am purified in my frame,
 I cannot see beyond myself.
 But once I'm delivered
from out of my frame,
 My ear and nose can be eyes
 Every hair will be given sight,
 For the eye had no eye at first,
 Just an embryo,
flesh in the womb.
 Adam came out of the earth,
 But how does he resemble the dirt?
 The genie came out of the fire,
 But how come he doesn't burn?
 Life relates the unrelated.
 This is the spiritual eye.

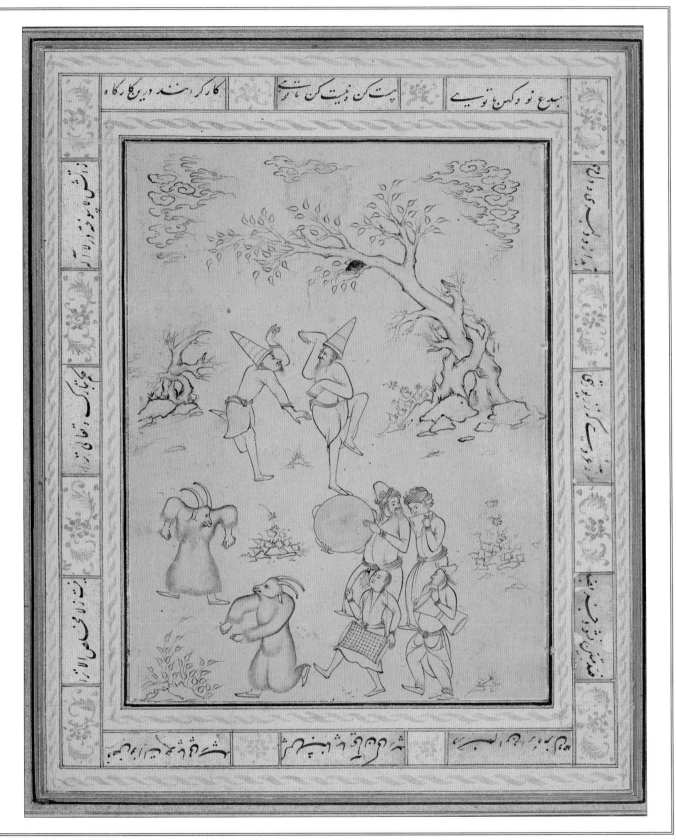

How the Prophet Saved the Life of a Child

A WOMAN CAME TO A PROPHET and said, "One of my children has gone up to the water source, and if I call him he refuses to come down to safety, and if I leave him there, I'm afraid that he will fall and damage himself. He has no interest in safety and will not listen to my admonitions. However much I ask him to pay attention to me, to my motherly advice, he will not listen. I am terrified of the result. Please help me."

The prophet told the woman to take another child up to the water source so that the boy would see a compatriot and would then come quickly down because like is attracted by like.

So the woman did as the prophet had advised and took another child to where the first was hiding, and the hidden child immediately came across from the source of the water, and to safety without falling to his death.

For each object of love is like a full jar,
One with pearls and one with dregs,
Both will make you drunk,
One for God and one for doubt.

The prophet behaves like a man or a woman,
For he shows the way through example.
The Prophet is simply a man like you,
That he comes to your side like a friend.
Wherever there's need, an attractor resides,
Like man and his angels, side by side.
Work like with like, love with love,
Bring angels to the body,
The heart with the soul,

The Atheist and the Mystic

ESTERDAY A MYSTIC SAID that the world originated in time, this Heaven is passing away and God is its inheritor. An atheist replied:

How do we know the beginning of time?
How should the rain know the start of a cloud?
We're not even a mote in the eye of the course,
How should we know the start of the sun?
The wriggling worm that's buried in dirt,
How should he know the start of the earth?
We've heard all these rumors from fathers and sons,
Through nonsense we believe it is right.
Tell me the argument, tell me the truth,
Or shut up and talk to me less.

And so the mystic answered the atheist:

I saw two people who debated this question,
They argued and fought and disputed all day,
So a crowd was gathering there.
One man was saying, "The sky will disperse,
Without any doubt what's built has a builder."
And the other disputed as follows:
"All that's eternal moves timelessly on,
No builder exists except of its own,
The building is building the building itself."
"This is denial of He who creates,"
the mystic replied in disdain.

"I'll not accept all these ignorant claims,"
the atheist said in reply.
"Bring me the proof, all I need is good reason,
and nothing you say is of sense to me."
"The proof lies always within my soul," he said,
"It's no fault of mine if your eyes are blind,
If the moon is invisible to you.
There's no reason for anger because I see truth,
And you see the words on a page."

The debate continued in this way, back and forth, and the gathered audience became more and more perplexed as to the beginning and the end of this well-ordered celestial roundelay. The mystic knew the truth of time and the universe, while the atheist wanted always to have it in writing and proven scientifically. In short, the atheist believed always in what he could see and never in what he could not see, while the mystic, the believer, knew in his heart that life was created, that the building was building the building.

In the end it's all about fire.
Drop the mystic and scientist down to the pit,
Let them burn and see who comes up still alive.
For he who looks up at the moon from the fire,
Sees the moon and the sun and the stars.
No proof is needed, for his sight is within,
While the atheist burns and burns,
Still searching for the finger that points.

Why God Said He Loved Moses

ONE DAY God said to Moses, "My chosen one I love you." Moses asked, "Bountiful One, tell me what in me is the cause of your love for me, so that I may make it grow." God replied, "You are like a child in the presence of its mother. When she chastises the child it still wraps its arms about her and loves her. The child knows of no one in the world but her, and finds all sorrow and joy from her presence. If she should be angry with the child it still comes to her, for it never seeks any help from anywhere else.

You are like this child Moses, for your heart never turns from Me to anyone else."

We long for You in our worship,
In trouble we ask from You alone.
We worship You for the purpose of love,
In trouble we ask exclusively.
We perform the worship to You alone,
We have hope of help from You alone.

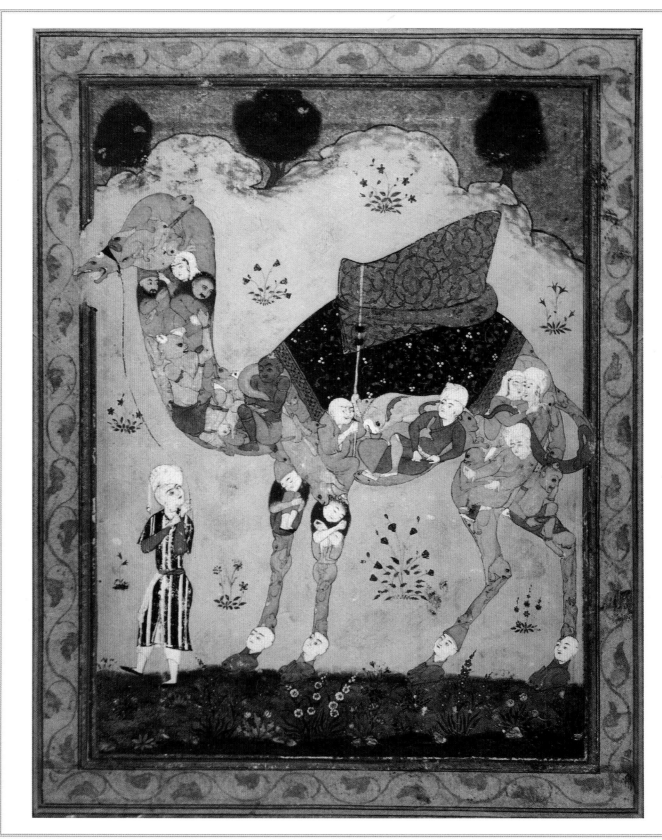

The Mule and the Camel

ONE DAY A MULE was in the same stable as a camel and asked the camel, *"Why is it that I frequently fall along the way in the marketplace and on the hills where I travel, particularly when going down the mountainside to the bottom I fall on my head from fear. You don't fall on your face. Why is that? Is it because you're destined always to be happy?"*

"Am I like the unintelligent man,
 Who breaks his vows through corruption?
 He constantly comes down on his head, lame horse,
 For his load is too heavy
and the road full of stones.
 He always gets blows from the dark, poor mule,
 That man of luckless nature,
for breaking his vows of prayer.
 And acting in foolish disdain of the pure,
 For spitting in scorn out of weakness.
 Is this me?" asked the mule, *"Is this me?"*

"O camel, are you a true believer and therefore never fall upon your face because you don't turn up your nose in disdain at the pure of spirit?"

The camel replied, *"Though every joy comes from God, there are many differences between us. I have a higher head, and therefore my eyes are higher too. Lofty vision is a protection against injury. From the top of the mountain I can see the pathways more easily, every hollow and level, step by step, in the same way as the Prophet saw all the way to his death. You, on the other hand, because of your animal senses, are in pawn to them. From the weakness of this trap your eye sees only in front of your foot, and you're weak therefore, so your guide is weak also."*

The eye is the guide to the foot and hand,
 For it sees both the right
and the wrong place to step.
 If the eye be pure, so the nature is pure,
 And my eye is so, a child of God, not perdition.
 Your arrow flies crooked when the bow is bad.

The mule agreed with the camel that what he had said was sadly true and began to cry floods of tears, falling at the feet of the camel and begging him to allow the mule into his blessed service.

The camel replied that as the mule had made full confession and been humble in his presence, he could receive the camel's blessing and go forward in his life without the contaminations he had previously suffered.

You have gone into Eden the secret way,
 He has taken your hand to the abode of bliss.
 You were fire, now you're light,
 You were grape, now you're wine,
 You were star, now you're sun,
 Rejoice mule, God has seen you as right.

The Pear Tree of Illusion

HERE WAS A WOMAN who enjoyed embracing her lover in the presence of her foolish husband. To do this without getting into trouble she would say to the husband that she was going to climb a tree nearby and gather some fruit. Once up the tree, she would burst into tears looking down upon her husband on the ground.

"What on earth is the matter with you wife, have you gone crazy?" the husband would shout. "Why are you crying? There's no one here on the ground but me. Come down from the tree, for your mind is gone and it's not safe up there."

When the woman came down, her husband went up the tree to see what she had been fretting about. While he was up there she would take her lover in her arms and kiss him passionately while the husband watched them. He would scream and shout as she had done because he saw the other man and felt great anger and jealousy. But the wife told him, "No husband. There's no one here on the ground but me, you're going crazy, don't talk utter nonsense."

The husband continued to shout his threats and claims against his wife, but she told him, "You fool. This is exactly the same as I did when I was up that tree, watching you make love to another woman. It is the fault of the pear-tree because it makes illusions by some bad magic, believe me. Come down and see that there is nothing here but me, all is illusion for sure."

These joke stories instruct, so listen in earnest,
 Don't be fooled by the foolishness here.
 Lazy folk seek the pear-tree,
and there become dizzy,
 For it's a height far away
from which to gaze down,
 Dizzy-eyed, dizzy-faced, the eyes become crossed,
 And giddiness falsifies truth.
 Come down from the tree and find your true feet,
 Placed fairly and squarely on earth.
 Like the pear-tree itself, that reaches to heaven,
 Its branches and leaves touch the sky.
 Let go all illusions, and come down from the tree,
 And God will transform what you see,
 For out of illusion and accepting your failing,
 A new way of seeing will come to you,
 And out of humility your vision will grow,
 And the pear-tree will offer you shade and fruit,
 Its branches grown straight and God-revealing,
 Its roots fixed on earth buried deep and strong.

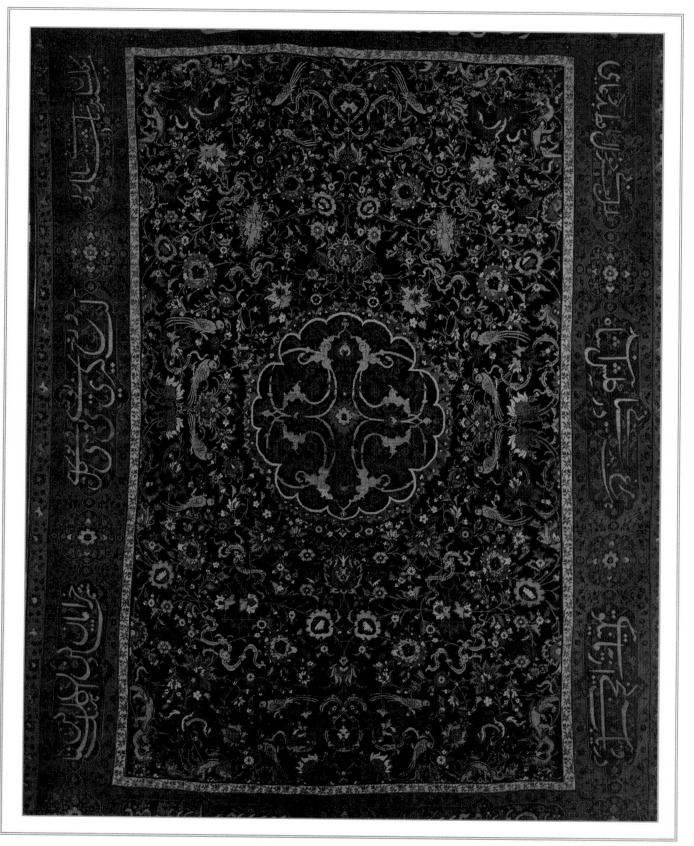

The Mathnawi

BOOK FIVE

*In The Name Of God
The Compassionate,
The Merciful*

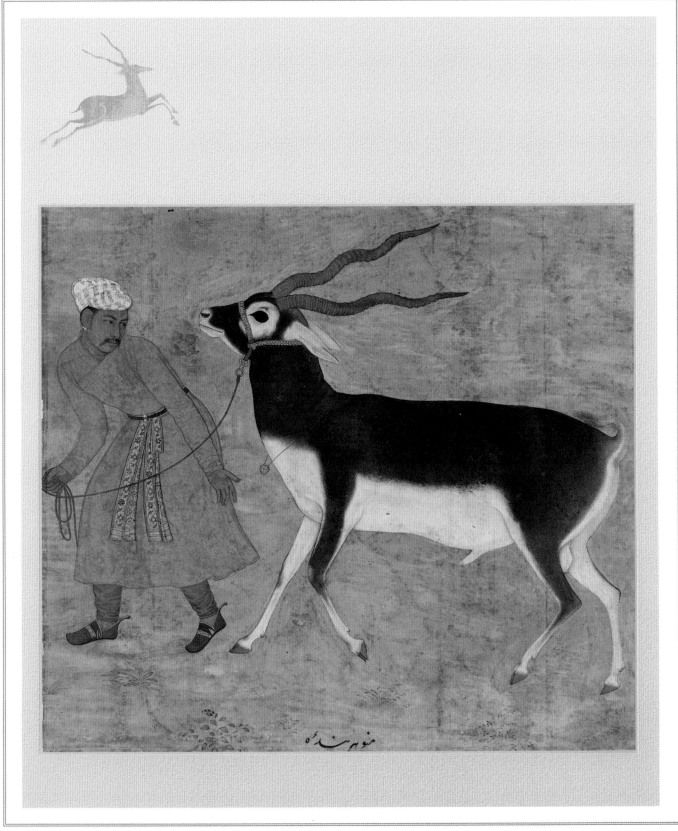

منوهر شده

The Gazelle in the Donkey Stable

A HUNTER CAPTURED A GAZELLE and mercilessly put it into a stable full of donkeys and cows, a terrible prison for a gazelle. The gazelle, wild with terror, ran in all directions, frantic and without any restraint, but remained imprisoned until the following morning, when the hunter renewed the straw on the ground for the cows and donkeys. These crude animals devoured the straw as though it were sweeter than sugar, but the gazelle kept on running from side to side and avoided the straw altogether as the poor animal was not only devoid of the friendship of like creatures, but presented with a kind of food he could not eat.

The vigorous and high-spirited gazelle continued in torment like a fish wriggling in the death-agony of being kept on dry land, or like dung and musk tortured by being kept in the same box. The donkeys spoke mockingly with one another saying, *"This father of wild animals has the nature of a king. We better keep quiet or we will upset him. How can he possibly become like us crude folk when he was born with a pearl in his mouth? Better let him stay on his throne with his fastidious ways."*

One of the donkeys became sick with indigestion and was unable to eat, and therefore he offered the gazelle his portion of the food in the stable, making a formal invitation to him to dine. The gazelle put his head on one side as if to say, *"I have no appetite, I'm not at all well."*

"Do you refuse my invitation because you wish to maintain your reputation?" asked the donkey.

"The food that you offer me," answered the gazelle to the donkey, *"is food designed for your body, not mine. I have learned to eat from beautiful pastures, on the side of clean rivers and streams and in meadows with fresh green grass and fruit. How can I suddenly depart from all that nature that is familiar to me and find myself able to survive in this hell."*

The donkey replied:

"Boast and boast and boast away,
In a strange country there's many an idle brag."
"Truly my musk glands bear witness,
For I can't behave in any other way,
But who'll listen to me?" said the deer.
Only he who has a spiritual sense of smell.
It's taboo for the donkey who's addicted to dung.
How should the gazelle offer his musk
To the donkey that sniffs at pee on the road?

Parable of the World

And how is the Prophet in relation to this tale? The Prophet is like the gazelle, as Islam is a stranger in the world. People flee from Islam and the Prophet, while the angels are in harmony with his essence. The Prophet is perceived as any other living human, for the outward appearance is like us all, yet the inner fragrance is missed. He is a lion in the shape of a cow, behold him from a distance but do not investigate too closely, for the lion will rip the cow to pieces, expelling the bovine nature from your head and uprooting the animal nature from your head. If you are a cow you will become a lion when near him, but if you prefer to remain a cow do not seek the lion.

God has made existence magnificent,
He has made it through nonexistence.
He has concealed the sea and exposed the foam,
Concealed the wind and displayed the dust.
The whirling dust flies like a dancer,
How does it do this itself?
The wind is invisible, known only by trust,
The foam moves all about you,
But without the sea no whirling takes place.
Thought is hidden, speech is manifest.
So we believe, and believe,
That manifest only is true,
Yet nonexistence we have no eye for.
Yet which is real, and which is fake?
Why did God make reality shy?
Praise to the Lord, O weaver of magic,
That makes the dregs seem like wine
To those who turn from the truth.
Like magic we measure the moonbeams,
And gather our gains from a sleight of hand.
This world is a sorcerer, and we are the buyers,
And yet there's but emptiness there.
And when the bell tolls, and it tolls for thee,
The devil of wealth and palaces,
Stands only a while at the side of your grave,
And comes no further, no further than this.

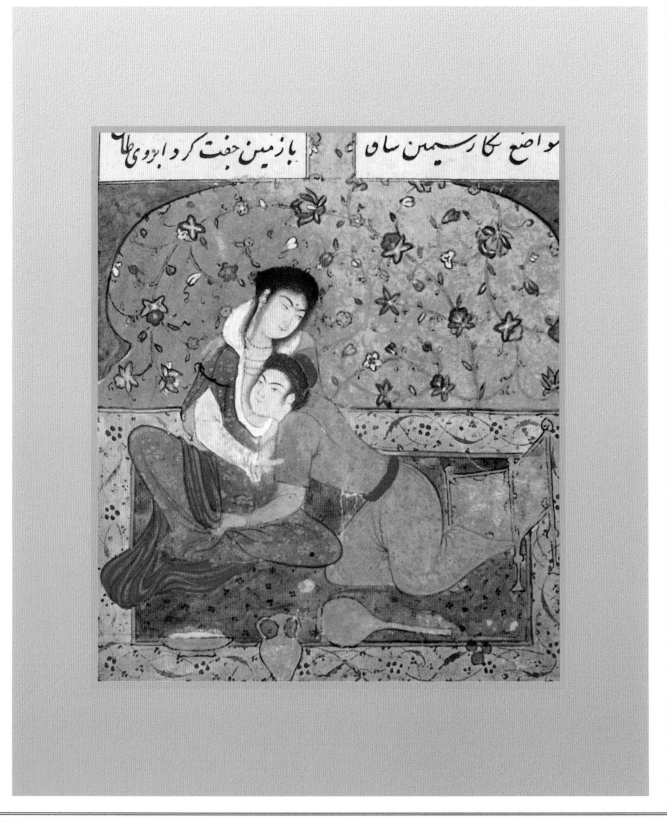

The Devoted Lover

HERE WAS A CERTAIN LOVER who in the presence of his beloved recounted his services and works saying, *"For your sake I have done so much—suffered wounds in this war of love and relationship with all the arrows and spears it engenders. My wealth and my strength are gone, my fame is gone, and on account of my love for you many a misfortune has happened to me. No dawn has found me sleeping or laughing, and no evening has discovered me with capital and means."*

He continued to tell her of all the bitterness and difficulties he had experienced, in great detail, though not reproach her, but to display the extent of his devotion to her and the trueness of his love.

The young woman waited patiently, and then replied to him after he had continued with his stories of difficulty and problems endlessly. She said:

"You have done all this, yet you have done nothing,
 For you've missed
the root of the root of love and faith,
 That which you've done
is only the branch of love."
 "So what is the root?" declared the man.
 "To die and be nothing at all," she said.
 "Everything else you have done, but still you live.
 Everything else you have done, except die.
 If you are self-sacrificing, then die you must."
 Instantly there, before where she sat,
 The youth lay his body upon the ground.
 Without another breath he gave up the ghost,
 And played his life away,
still laughing, still rejoicing.
 And his laughter was heard as endowment in spirit,
 For how should the light of the moon defile,
 How should the roar of the sun be heard,
 But come back in haste to its source?

The Creation of Adam

WHEN THE MAKER willed the birth of mankind into existence to see what he would do with good and evil, God commanded the angel Gabriel to take a handful of clay from the earth as a deposit that would have to be returned. Gabriel went to earth, which was afraid and withdrew begging the angel not to place mankind on the surface and giving all manner of reasons why it should not be done.

So God sent Michael instead and told him, *"Go down there and seize a handful of clay, and do it forcefully like a lion."* So Michael went and thrust his hand toward the earth to take up a piece of clay. But the earth trembled and recoiled again, and shed many tears. Her breast burned with grief and she begged earnestly to be spared, making Michael feel far too bad to do it by force. So he returned to God as Gabriel had, and said that he too was unable to do the deed, for the earth cried and wailed like nobody's business and he felt bad.

So God sent Seraphiel instead, but the same thing happened. The earth wailed and groaned in utter discomfort, begging Seraphiel to desist and not fulfill his quest for he was the angel of mercy and he should be merciful now.

So poor Seraphiel also returned to God and excused himself by relating what had passed, for he could not do it either.

And this was getting boring, but nevertheless God sent Azrael instead, this time with a greater push and more urgency to succeeed. And Azrael was tougher than the first three and would hear none of the earth's entreaties and cries for mercy. Azrael explained carefully that there was no way God's command could be avoided and the clay was needed for the creation of mankind. The earth should simply give in and obey for it was not Azrael's wish that this should happen, but God's wish, and although the first three emissaries had given earth the impression of their own wills and determination, for Azrael it was not a matter of personal will, but of the will of God.

But the earth remained suspicious and would not accept the entreaties of yet another of God's emissaries, for the earth knew that she would not be ruled or honored or provided for by any less than God Himself.

"Don't ask me again," said the earth to Azrael,
 "Don't ask me to take on your quest.
 I am slave to no one but Him,
 The one who raised dust from the sea,
 My ear is deaf to all words but His,
 He is dearer to me than my own sweet soul,
 The soul that came out from Him,
 I am deaf and dumb and blind to all but Him,
 For I am as the spear in His hand."

And so the clay was gathered by God Himself, and mankind was born by the will of God alone.

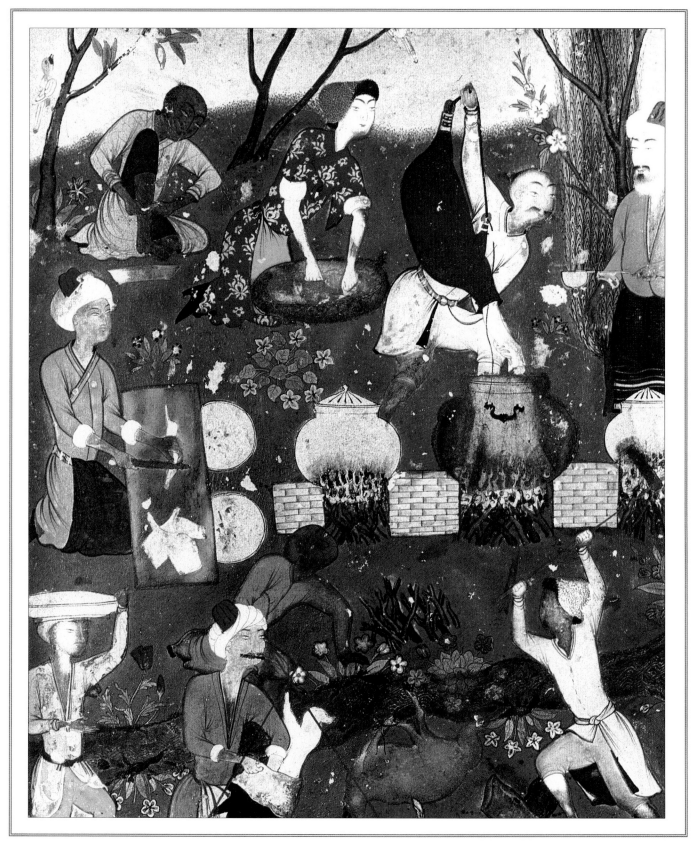

The Body a Prison—Rumi's Diet

If you eat too little,
you'll remain hungry like a crow.
 If you eat to your fill,
you will suffer from stomach pains.
 If you eat too little,
the result will be ill temper, dryness, and indigestion.
 Eat the Food of God instead
and you'll easily digest the nutriments,
 And ride like a ship on the spiritual ocean.
 Be patient and persistent in fasting,
 And you'll receive without expectation,
 For the full-fed man
does not wait expectant of bread,
 Wondering
whether his meal will come sooner or later.
 Unless you're expectant,
the bounty of God's Food will not come to you.
 Practice expectation, like a true being,
for the sake of the dishes of bliss.
 Every hungry person finds food at last,
for the sun shines upon us all.
 When a grand guest will not eat poor food,
bring better food.
 Do not hesitate to be a generous provider.
 For the lofty mountain slope
expects always the dawn's bright sun.

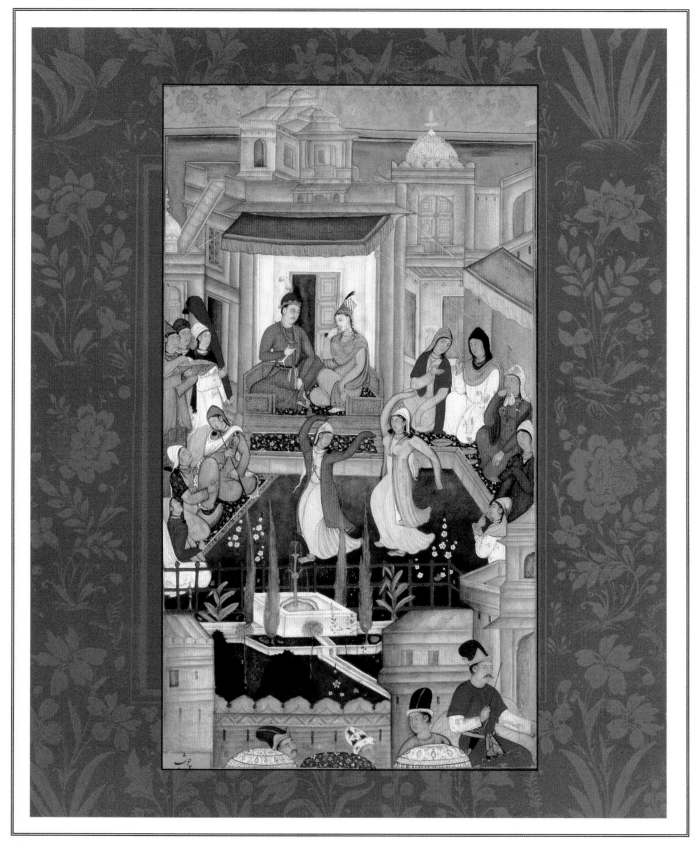

From The Lover and the Beloved Are One

In the early morning, a lover asked her beloved, "Do you love me more than yourself?"

"More than myself?
For sure I have no self anymore
—I am you already.
The 'I' has gone; the 'you' has come about.
Even my identity is gone.
The answer is taken for granted.
You and I' has no meaning.
The 'I' has vanished
like a drop into an ocean of honey."

From The Hypocritical Ascetic

When love prevails, fear departs.
In the law of love—give all, sacrifice all.
Gain is irrelevant, so what is there to fear?

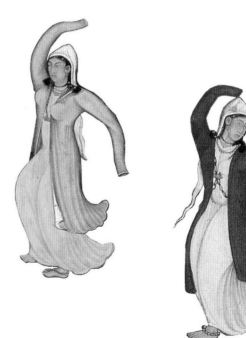

The Fox and the Mule

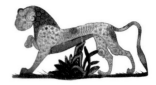

*O*NCE THERE WAS a washerman who had a mule with a sore on its back and a lean empty belly. He kept it on ground covered in stones where no grass grew and from morning till night it went without food or shelter. Except for water there was nothing for it to eat or drink and the mule was in a miserable state all day and all night.

Nearby there was a reed bed and a jungle where a lion lived, a ferocious lion who loved to hunt, but the lion had been involved in a terrible battle with an elephant and could not hunt for some time because of his wounds, so that the smaller animals in the area were deprived of their breakfasts, as they were accustomed to eating from the lion's leftovers. Everyone was most upset by these circumstances, so the lion gave orders to the fox that he should go and hunt for a mule and bring its to him.

"If you find a mule," said the lion, *"somewhere around here in the meadow, go and charm him with your spells and specious talk, beguile him and then bring him here. As soon as I gain strength from eating the flesh of the mule then I will be able to return to my hunting and bring more food for everyone. I will eat only little and you can all have the rest, for I have been appointed as the supplier of your food."*

The fox said to the lion, *"I will serve you obediently. I will rob the mule of his wits with my cunning and enchantment, for this is my business, to beguile and lead astray."*

The fox left on his quest, and along the way found the miserable emaciated mule. He saluted him cordially and came closer to the poor simple animal, saying, *"How are you in this arid desert, surrounded by all these stones and sterile ground?"*

The mule replied, *"Could be worse. I give thanks for what I have, and I have patience for the reward I will one day receive. I am satisfied with my lot because with every pleasure comes a pain."*

The fox didn't think much of what the mule had said and answered to him:

You have the right to seek provision,
 God has said by divine command.
 This world is a world of means,
 And nothing is gained except by this.
 Seek you the bounty of God,
 Or others will do it instead.
 For they will seize it with the strength of lions,
 And you will be left for dead.

The mule replied:

Your words are the words of the weak of faith,
 For He who gives life gives also bread.
 Whoever seeks spirit, whoever seeks gain,
 A mouthful of bread will follow.

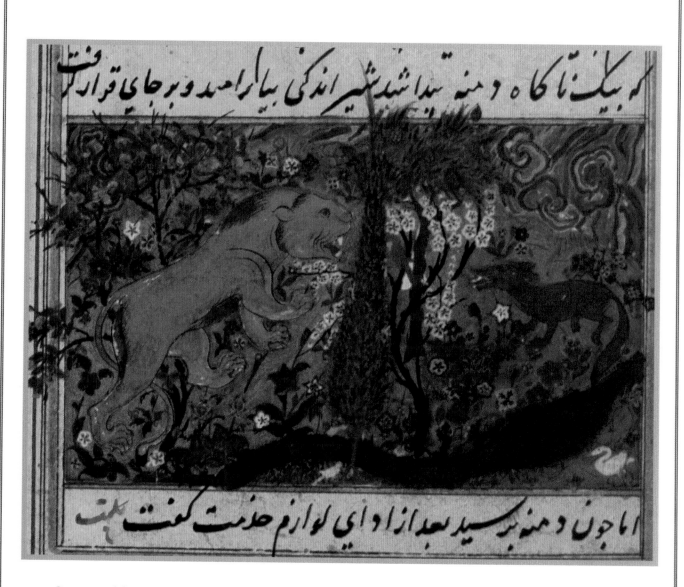

Our animal friends never work for reward,
Nor support any burden as such.
For the Provider gives always some daily bread,
Laying our needs before us all.
Only patience is needed, and clearly my friend,
You have none of this.

The fox replied that these words from a mule were clearly exceptional. He had never met such qualities in a mule before, but cautioned that such behavior was perhaps not suitable for a simple animal, and that such attitudes were reserved for higher beings, and in any case, how could treasures be available to all. There clearly were not enough to go around. *"Recognize your proper limits or you'll fall into the abyss of conceit."*

But the mule would have none of this and remained content with his situation and his patience abounded, for he was convinced of how he felt.

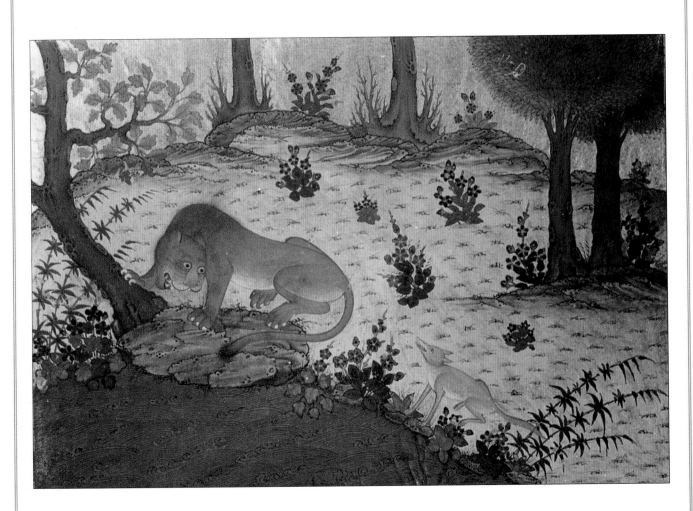

And the fox and the mule debated for awhile but neither was getting anywhere with it. The mule was content to remain where he was, but the fox determined to get him to move to the meadows, where he tried to tell him there was food and friendship. But the mule would not budge, as mules do. The fox even described the meadow for the mule in the most devilishly delicious terms:

A meadow verdant like Paradise,
 Where the grass grows as high as your waist.
 Happy creatures dwell thereabouts.

A camel would be lost in the growth.
There flows a rushing fountain,
And the animals rest in peace.

But the mule looked at the fox and asked himself the questions silently, *"If this creature has come from such a place, how come he looks so wretched?"*

Where is your gaiety, fatness, and strength,
 How come you're so skinny and starved?
 If your picture of meadows and rivers is true,
 Then why does your eye not reflect its delight?

Those greedy looks that you display to me,
Don't tell me of any high places.
Since you came from a fountain,
How come you are dry?
The story you tell me is lies, I think.
The stories you tell me show no trace in your face.

But sadly for the mule, his spiritual arguments were not entirely genuine. The water in the spout was borrowed, so to speak, and although he argued with the fox over quite a long period, because his experience of the nature of God was only superficial, he was eventually beguiled by the arguments of the fox. The mule did not have the glorious power of total perception possessed by the true believer, and eventually the fox's palaver began to take its toll. Greedy desire to eat and drink made him weaken.

So the fox embarked on his quest and grabbed at the beard of the mule and dragged him away. So remember at this point in the story:

Since a hare brings a lion to the well,
Why should a fox not being a mule to grass?
Why not indeed? Let the fox seduce the mule,
So do not be a mule, and be not troubled.

The fox brought the mule up the hill to the meadow so that the lion could rush out and pulverize him with his sudden charge (this way the lion would not need to use so much strength, which he hadn't anyway). At this point in the story, the lion was still a long way from the mule, but being so dazed from starvation and wounds, he could not wait for the mule to come near before attacking. In short, the lion missed the mule, who turned and ran like mad, dropping his shoes on the way! The plan to expend the lion's energy to the minimum therefore utterly failed and the fox chastised the lion for acting prematurely.

Precipitation and haste is the Devil's work,
While patience and cause is God's grace.

By now the mule was far off and figured out what the plan had been. What should he do but depart in realization?

The lion made his excuses of exhaustion and eagerness, urging the fox to go once more after the mule and try it all again! The fox cautioned the lion, however:

If God give me strength and make him blind,
Then he'll forget his terror on seeing you once.
You never know your luck I guess,
But let me tell you this, O lion,
Please keep in mind what I say.
When I bring him again, again,
Do not rush about my friend,
Lest we lose him once more by over haste.

The lion agreed that this would not be wise, and proposed to lie still. Given the fact that he was exhausted from lack of food and from his battle wounds with the elephant, the lion proposed to lie still as though asleep, until the mule was close by. So the fox went off again, murmuring his prayers to God to muffle the mule's reason once again and make him vulnerable to further persuasion.

The mule, in the meantime had also made a number of prayers to the Creator and wasn't currently intending to be duped a second time. The fox, however, had other ideas. He came to the mule again and said to him:

Ignoble creature, what did I do to you,
That you brought me into the presence of a dragon?
How could you do such a thing to me?
You know of course, my subtle mule,
That that was no lion in truth,
But a spell so strong
that you missed the whole point.
After all, I feed there each day, and I'm still alive,
So how could there be a creature so fearsome as he?
Of course I should tell you, the nature of this,
And yet I forgot, in the light of your need,
So painful it is to behold you,
That you might see a lion instead of a ghost.
I saw you so hungry and starving for food,
I made haste to satisfy this.
Or else I had helped you to understand,
It is nothing but fantasy, nothing but mist,
No absolute lion exists.

The mule was so furious that he almost burst a blood vessel at the audacity of the fox to continue his trickery. He cursed and swore that he would never be fooled by such nonsense again, that a child would have died at the sight of the lion, and the fox had no moral right to deprive him of his life, however pathetic he may have become. For sure the fox could go to hell before the mule would be fooled once more by such nonsense. And the fox continued, never abating his arguments that all he had seen was a phantasm, and not a real lion, and they jousted and battled, and argued and fought over this constantly complex condition. And the mule grew hungrier and hungrier, his reason and faith constantly eaten away, until he gave way under the pressure once more, thinking that death might, in any event, be better than this terrible famishing desire.

So the fox dragged him there to the lion's lair,
And the mule was torn to shreds.
While the lion took rest from his rapid digest,
Quenching thirst by the side of the stream,
The fox ate his fill from the liver and heart,
And quickly departed to hide,
While the lion returned
and found the mule less a liver and heart,
So the fox had to talk once again.

"How could the mule have still had a liver and heart after being here twice, and seeing you, O Lion, so terrifying and powerful? He must surely have lost his liver and heart on the second way here." And this story could go on and on, for now came the guile of the fox directed at the lion to persuade him of further fantasy, none of which we believe....

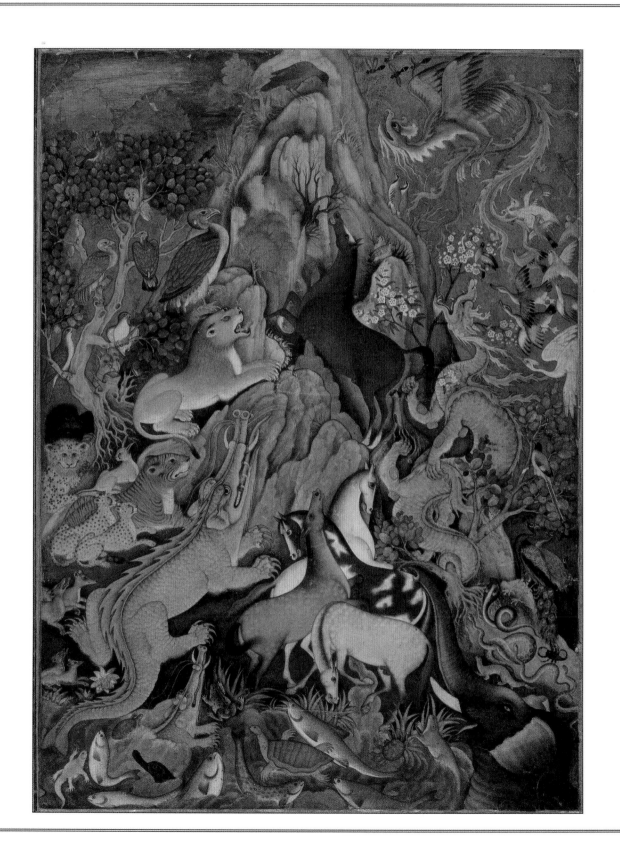

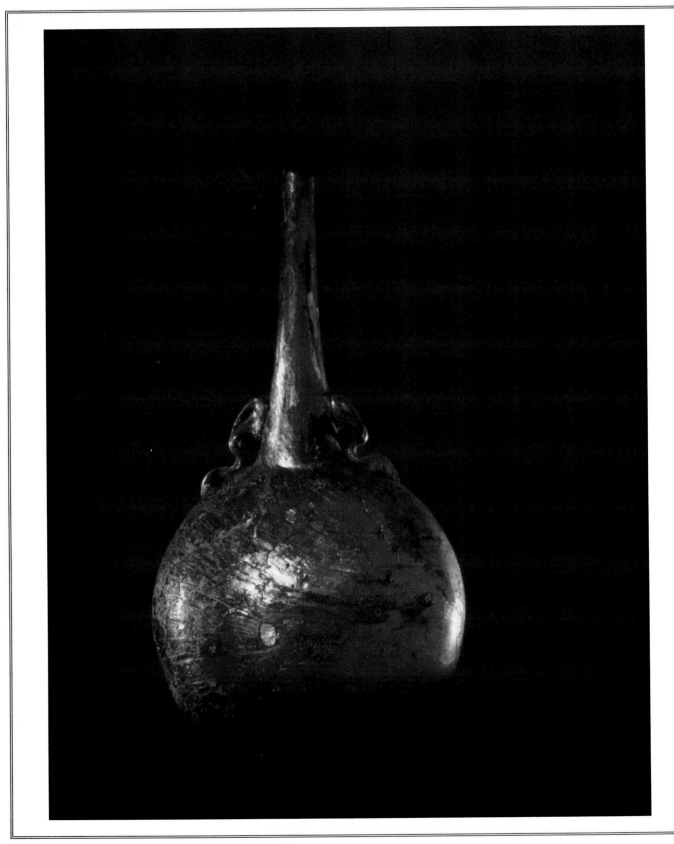

The Plea of Necessity

A THIEF SAID TO A MAGISTRATE in court, *"My Lord, what I have done was decreed by God."* The magistrate replied, *"And what I am doing has also been decreed by God, my dear friend."*

He who steals goods from a shop, my friend,
This is decreed by God.
He who punches the thief, my friend,
This is also decreed by God.
Put the goods back my friend,
Or I'll punch you again, my friend.

The magistrate, after illustrating his point, asked the thief why he imagined his excuse was going to get him anywhere but into worse trouble than he was in already. The magistrate was, after all, well known in the neighborhood for being a bit of a dragon! *"Giving such an excuse is going to mean everyone around here will punch and pinch you and use the same excuse that they are simply acting under involuntary compulsion, you fool. In fact, if you can give me chapter and verse of this decree of God, I'd be delighted, for there are many things I'd like to do by such a decree. I'm prevented only because I fear God and don't know his singular decrees."* Everyone laughed at this!

So the magistrate told the thief another story of a thief to illustrate the plea of necessity.

A certain man climbed a tree and vigorously scattered the fruit like a thief from the branches.

The owner of the orchard shouted up from the ground, *"What are you doing, you rascal?"*

The man in the tree shouted back, *"I am merely a servant of God in God's orchard, and I have the right to take and eat God's fruits, which were given to me by Him. How can you blame me and be so stingy at the table of the all-rich Lord?"*

The owner grabbed the leg of the thief and dragged him down to the ground, then bound him with a rope to the tree and beat his legs with a club. The thief cried horribly, *"Stop, stop, have some reverence for God. You're killing an innocent."*

The owner yelled, *"With God's club I beat you. It's God's club, and the wood and shape of it belongs to God. I am only the instrument of His command."*

"OK, OK," cried the thief,
"I agree there is free will.
There is free will, there is free will,
Please God there is free will."

The joiner has the will of his wood,
While the artist the will of his paint.
The craftsman powers the iron,
And the builder will wield his tools.
Remember my friend, O thief in my court,
The oil that devotes itself to the rose,
Smell the oil or the rose as you please.

The Starved Mule and the Arab Horses

HERE WAS A MULE, bent double like a hoop from sickness and affliction, so hard had he worked all his life. He passionately desired the day of his death, for he was utterly exhausted by his lifetime of labors carrying great weight.

The master of the royal stable saw the mule and took pity on it, bringing it to the stables and lodging the creature with the stallions that made up the sultan's troop. The mule saw his surroundings and wondered at those incredible creatures he lived with, Arab horses, well fed and strong and handsome and glossy.

He saw that the ground of the stables was clean under their feet and sprinkled with fresh water each day, and that food was provided when they needed it. He saw the horses combed and rubbed with such devotion, and he eventually lifted his head and asked of God:

Am not I your creature too my God?
I know that I am a mule,
But wherefore am I wretched

With sores on my back and lean,
And wishing to die each night my Lord,
Why am I sad, where all these steeds are so happy?

But one day there came a great war, and the Arab horses of the sultan were quickly taken out to work as mounts for the terrible battles that would ensue. They rode forth and were wounded and broken, bloody and gored by the battle, until their return when they collapsed on the straw and were broken and smashed by the spears and arrows of the battlefield. The surgeons pierced their bodies with scalpels to extract the barbs of the arrows, and they squealed and cried in agony as the mule watched. Their fate was truly terrible that day and over the coming time. And the mule said to himself:

O God I am happy with poverty,
I'm happy with the spiritual health you gave.
I have no taste for plentiful food,
For it comes with those hideous wounds.

The Cat and the Meat

THERE WAS A MAN, a householder, who had a very sneering, dirty, and rapacious wife. Whatever food he brought home, his wife would eat it and snarl at the man if he objected.

One day, the husband brought home some meat that he had bought after a long day's work, intending to dine with a guest. The wife ate the meat and much wine and when the man came back from preparing for the guest, she made all sorts of excuses for her behavior.

The man said, *"Where's the meat? My guest has arrived, and we should prepare a good table for his visit."*

"The cat ate the meat," his wife declared. *"Go and buy some more."*

The husband instructed his servant to bring the cat and weigh it, and they discovered that the cat weighed less than the meat. *"You deceitful person,"* he said to his wife. *"The cat could not have eaten something that weighs more than its body!"*

If this is the cat, then where is the meat?
 Or if this is the meat, then where is the cat?
 Try searching for each of these, one or the other.
 Like body and soul, how is one without the other?
 You have a body, but where is the soul?
 If you have a soul, where is the body?
 It isn't this way, of course,
 For the body and soul are one and the same.
 Corn and stalk are both corn.
 God the butcher never cuts one part,
 But gives us the whole.
 Throw dust at a head and it will not break.
 Throw water instead and the same is true.
 But combine them together to clay,
 And the head will break from the marriage.

The Mathnawi

BOOK SIX

In The Name Of God
The Compassionate,
The Merciful

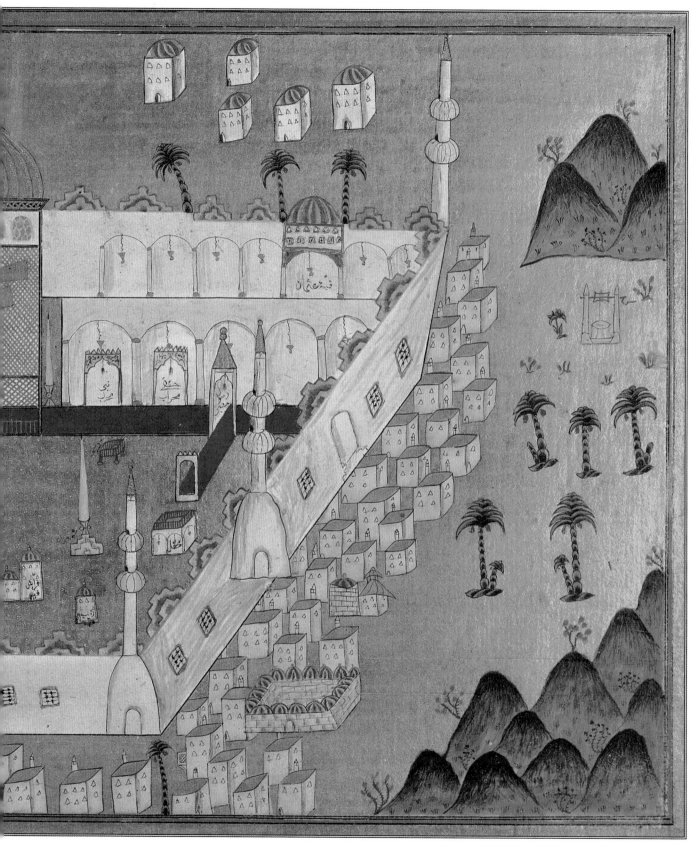

Worth Depends on Aspiration

NE DAY, A MAN ASKED A PREACHER, a most eminent expounder, to answer a question in religious assembly. "A bird has settled on the city wall. Which is better, the bird's head or its tail?"

The preacher answered, *"If its face is to the town and its tail is to the country, then its face is better than its tail. If the tail is toward the town and its face toward the country, then the dust is on the tail and spring is away from its face."*

A bird flies to its nest by means of its wings,
The wings of humankind is its aspiration.
In the case of the lover
who is soiled with good and bad,
Think not of the good and bad,
Only regard the aspiration.
If a falcon is white and beyond compare,
Is it bad when it hunts for a mouse?
And an owl, when desiring a king,
Is it noble as a falcon's head?
Does the bodily form mask its spirit?
Man is no bigger than a scoop in a log,
Yet he has surpassed the heavens above.
Did heaven ever hear "We have honored"?
Which this sorrowful man heard from God.
Did anyone offer to earth and sky,
His beauty and reason and expressions of speech?

Did you ever display to heaven,
Your beauty and sureness of judgment?
Did you ever, O Son, offer silvery limbs
For the pictured forms in the gallery?
No, for sure, you left out the figures,
Except to a half-blind old woman.
Old women have soul that mingles with body,
While pictures have nothing that moves.
Conscious of good and evil both,
Rejoicing in kindness, weeping from pain.
The more conscious we are, the more soul we have.

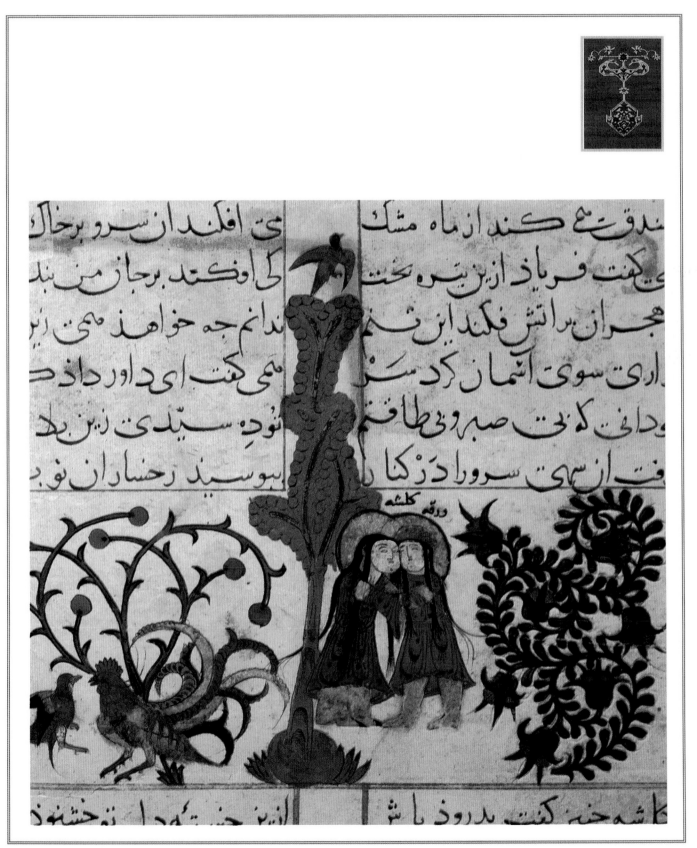

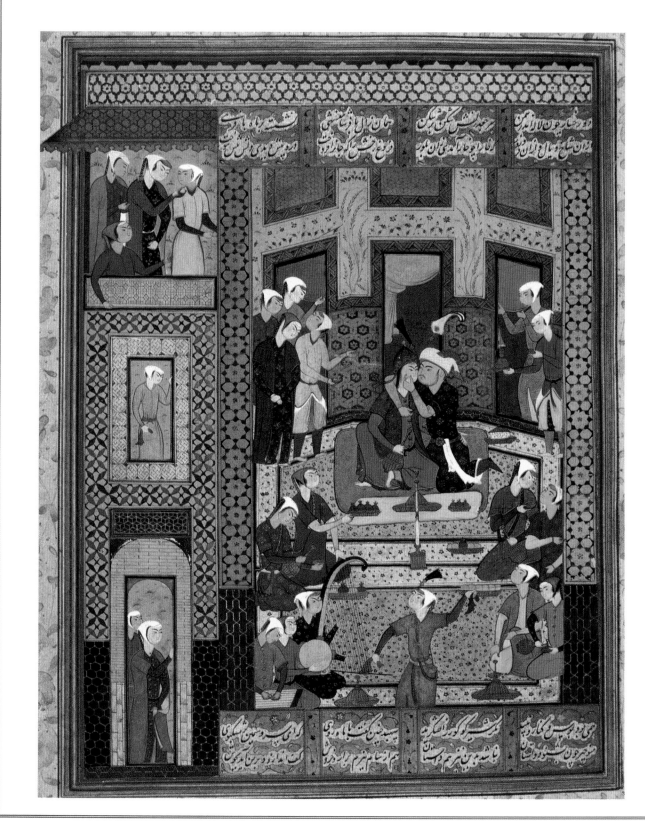

The Slave and His Master's Daughter

HERE WAS A KHWÁJA with a Hindu slave whom he had educated and enlivened with knowledge. He had taught him science and polite, social accomplishments, and he had lighted the candle of erudition in his heart. The beneficent man had brought the Hindu up from childhood in the lap of kindness.

This Khwája had a beautiful daughter, silver-limbed, lovely, and of excellent disposition, and when the young woman had almost reached womanhood, suitors were offering heavy dowries and continuously coming to the Khwája from every noble to ask for the girl's hand in marriage. The Khwája said to himself:

Wealth has nothing constant,
 It comes in the morning and is gone at night,
 Physical beauty has no importance,
 For a rosy face is yellow from a single scratch.
 Noble birth is of small account,
 For nobility is fooled by money and horses.
 Many a noble's son
disgraces his father with wicked deeds.

So the Khwája chose a pious son-in-law who was the pride of the whole clan and stock of his family. His daughter said, *"But he has no wealth, no nobility, and no beauty or independence."*

The father replied, *"These things are secondary to the importance of asceticism and religion. He is a pious man, even though he has no wealth, there is a treasure in his eyes and on the face of the earth because of his life."*

Once it was established that the daughter would definitely be married to the pious suitor, the servant in the Khwája's house became sick and weak and poorly. He was wasting away like one suffering from the worst disease for which there was no cure, and no physician could recognize his ailment.

Eventually, it was clear that the ailment derived from his heart and that no medicine could cure such an illness. The slave said nothing, either of his condition or the cause. The Khwája asked his wife to question the slave about his condition, saying, *"Ask him privately what is wrong with him. You are like a mother to him, perhaps he will disclose the trouble to you."*

The Khwája's wife went to the slave the following morning and combed his head with two hundred fondnesses and with much endearment and friendliness. In the fashion of a fond mother she soothed him and with this he began to explain the source of his condition.

"I did not expect this from you. That you would give your daughter to a stranger. She is my master's child, and I am heartsick for her. Isn't it a shame that she should go elsewhere as a bride?"

The Khwája's wife, impelled by extreme anger at this response, was about to strike the slave and throw him down from the roof, thinking, *"Who is this whoreson Hindu, that he should desire a Khwája's daughter?"*

But she restrained herself and said instead, *"Patience is best."* But to her husband she told the story and called the slave wretched.

The Khwája advised his wife also to be patient, and that he would arrange things in a way that would not disadvantage them.

So he spoke with the Hindu slave saying, *"We will break off the match with the prospective bridegroom and give our daughter to you. We didn't know that you desired her, but now that we do, we consider you the most notable of her suitors."*

The marriage is a family affair,
The fire is in our own hearth,
The bride is ours and you are our bridegroom.

So the Khwája told the slave this so that his happy fancies and thoughts might affect him, for sweet thoughts make a fat man.

An animal is made fat by fodder,
As man is fattened by honor and fame.
Man is fattened through his ear
As an animal is fat through his gullet.

The Khwája's wife wanted simply to kill the Hindu slave, for she asked why on earth she should take such trouble for such an unimportant individual. But the Khwája said, *"Have no fear—wheedle him and give him empty breath so that his illness will depart by virtue of this sweet flattery he is getting."*

And once the slave had received the flattery from the Khwája's wife, his swagger was so great that there was no room for him on this planet. He grew stout and fat and

red-cheeked and bloomed like a red rose and gave a thousand thanks. Once in a while he doubted, however, saying to the mistress, *"I am afraid that maybe all this is a deception,"* but the Khwája gave a party and feast announcing the match between the Hindu slave and his daughter.

The result of all this attention was that the illness of the slave vanished, root and foundation, and so the Khwája continued the deception by arranging the marriage itself, but using a youth, whom he dyed with henna and bedecked to look like a woman to lie with the slave on the honeymoon night. He displayed to the slave a hen, when actually giving a cock, and their night together was a travesty.

All this made the Hindu slave into a laughing-stock, and when he came back from the bath, where he had received the ritual bridegroom's bathing, he sat with the Khwája's daughter, and the mother sat to make sure that nothing would happen between them during the day.

The slave eyed them both sulkily and gave the sign of ten fingers in derision.

"May no one live in wedlock with an evil bride like you," he declared.

By day thy face is of fresh young beauty,
 By night it is naught but a lie.
 See the world at a distance and all is well,
 But close up all is a mirage.
 The world is a stinking bag,
 Though she appears so much as a bride.
 Don't be deceived by the rouge,
 Nor taste the sherbet mixed with poison.
 Have self-restraint, for patience is the key,
 Lest you fall like the slave into grievous pain.
 The bait is clear while the trap is hidden,
 Don't believe in the sweetness first sight.

The Ram and the Thieves

 CERTAIN MAN HAD A RAM that he was leading along behind him, and while he took a rest, a thief came and cut the halter and stole away the ram. As soon as the owner saw what was happening he began to run about the area trying to find out where the ram had gone. Soon he came to a well where the thief sat wailing, *"Oh dear oh dear, what shall I do?"*

The man approached the thief and asked him what was the matter.

The thief replied, *"My purse has fallen into the well. If you'll go in and fetch it I'll happily give you one fifth of its contents. There are a hundred dinars in the purse, so you'll receive twenty dinars for your efforts."* The owner of the ram calculated that this was the price of ten rams, and danced in delight, crying, *"If one door shuts, ten more are opened. If a ram is gone, God gives a camel instead."* So he took off his clothes and jumped into the well, at which time the thief ran off with his clothes also.

> *A prudent man finds the way to the village,*
> *If prudence is absent, cupidity brings disaster.*
> *The Devil's a mischievous thief,*
> *Like a phantom his shape always changes.*
> *None but God knows his cunning.*
> *Take refuge with God,*
> *And escape from that dreadful imposter.*

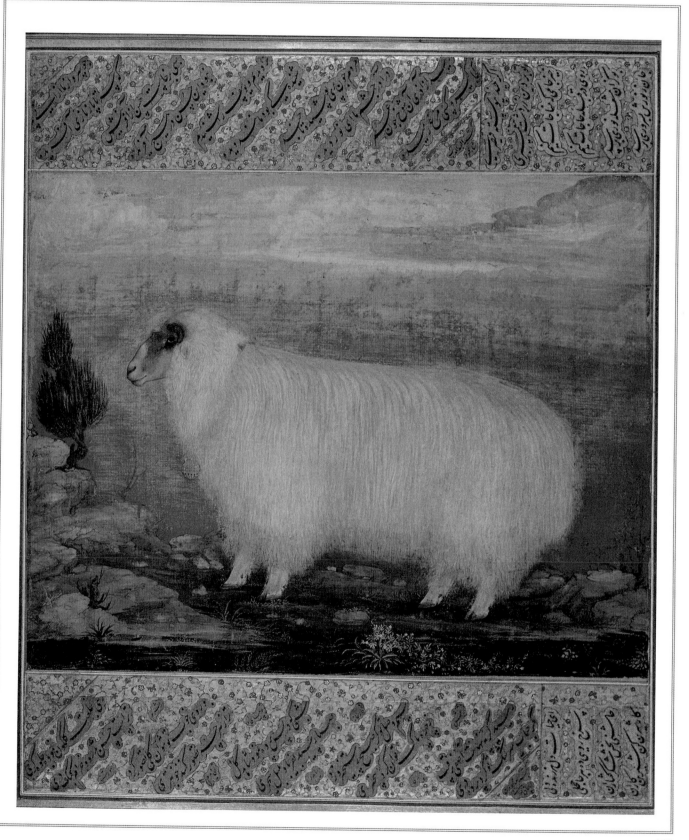

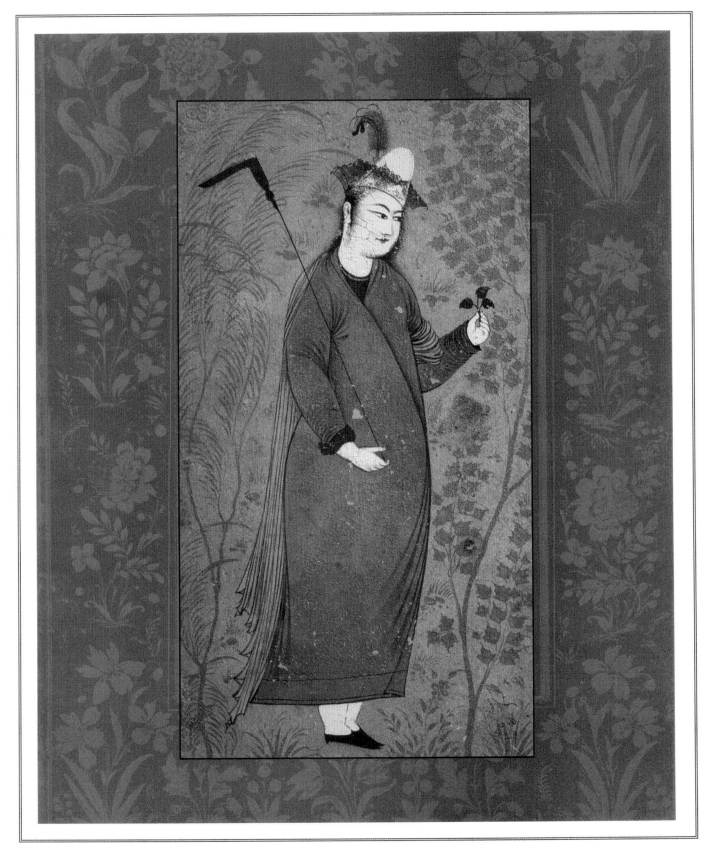

The Lover Who Fell Asleep

I N DAYS OF OLD THERE WAS A LOVER who for years had failed to join in love with the one he desired. In the end, though, the seeker is the finder, for from patience joy is born.

One day his friend said, "Come tonight to this address and I will cook for you. Sit in this room till midnight so that I may come to you unexpectedly."

The man was delighted and joyful
He gave thanks and made charitable gifts,
Since the moon of good fortune
had finally appeared
From beneath the dust of bad luck.

The appointed night the passionate lover seated himself in the room waiting in hope for the tryst promised by his friend. Just after midnight the friend, the charmer of his heart, arrived punctually as those who are true to their promises. He found his lover lying asleep, so he tore off a small piece of his lover's sleeve and put some walnuts in his lap.

The passionate lover awoke at dawn and saw the torn sleeve and the walnuts. He said, *"Our king is entirely truth and loyalty: all disgrace that comes upon us is grown only from ourselves."*

O sleepless heart, we true lovers are secure from this:
We play our rattles like guards upon the roof.
Our walnuts are crushed in this mill:
Whatever we tell of our pain, it's nothing.
O railer, how long will you continue to give
Your invitations to join in the world.
From now please don't give this madman advice,
For I've had enough of deceitful talk
That departs me from my Beloved.
I've had it enough, how long shall I have it more?
Only if I go insane will I grow closer to Him.
Fetter my leg, for I've torn the chain of reason.
Bring two hundred ties, and I'll rip them all,
But for the one that is the curls of love.
For the time is come for me to quit the human form,
And take to my spirit.

The Man Who Drummed At Midnight

*A*MINSTREL WAS DRUMMING outside a palace at midnight, announcing the meal that was normally taken at daybreak during Ramadan. While he beat his drum vigorously in the middle of the night, another man came to him and asked why he would make such a din in the middle of the night, and also whether he had considered if there was anyone in the palace in the first place.

Why are you trifling your time away?
Beating your drum for the sake of an ear,
Where is the ear?
Announcing your presence for intelligent souls,
Where is the intelligent soul?

The drummer answered that although in his opinion it was midnight, in the drummer's view the dawn of delight was near at hand, every defeat had been turned to victory, and all nights turned into days.

To you the water of the river Nile is blood,
To me it's water, noble friend.
That object there may seem to you
A block of iron or stone, but not to David,
Great Prophet he,
it's soft as wax and malleable too.
To you the mountain's greatly solid,

To David it's a song of songs.
To you the ground's as still as still,
To Ahmed it's quite filled with prayer.
To you the Mosque's gold pillar's dead,
To Ahmed it's a lover bleeding.

You tell me that there's no one in the house that I beat my drum to. But I know the spirit that lies in there. All the Mosques that worthy pilgrimages are made to—are they empty too, or are they filled with the spirit of the Lord of the House of God? Many a house that is filled with throngs of people is empty because it is empty of the spirit.

The scent of this house is filled with God,
A banquet of the soul, its dust and elixir of life.
I'll strike my copper
till treble and bass rebound everlasting,
Scattering pearls and lavish with bounty,
For God is my best customer.

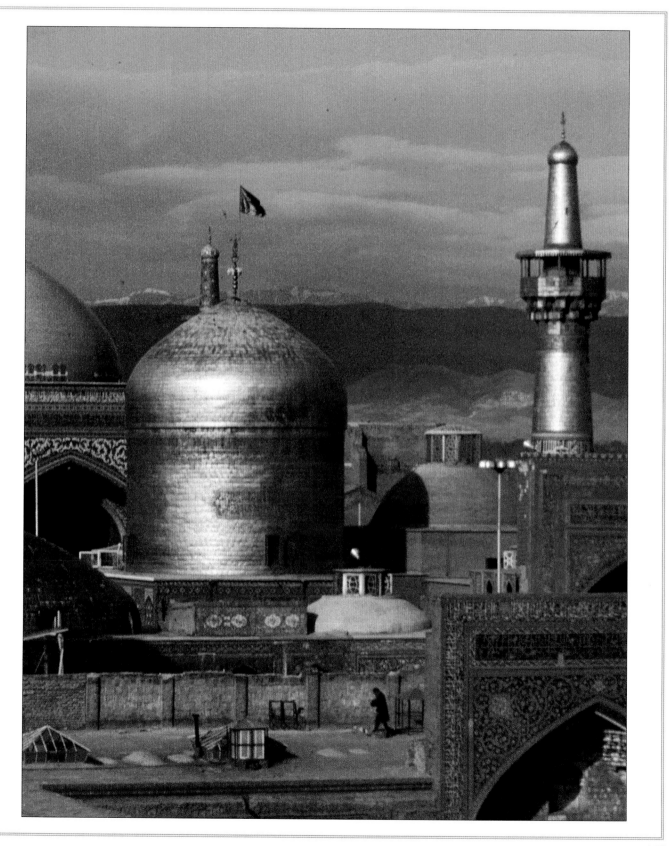

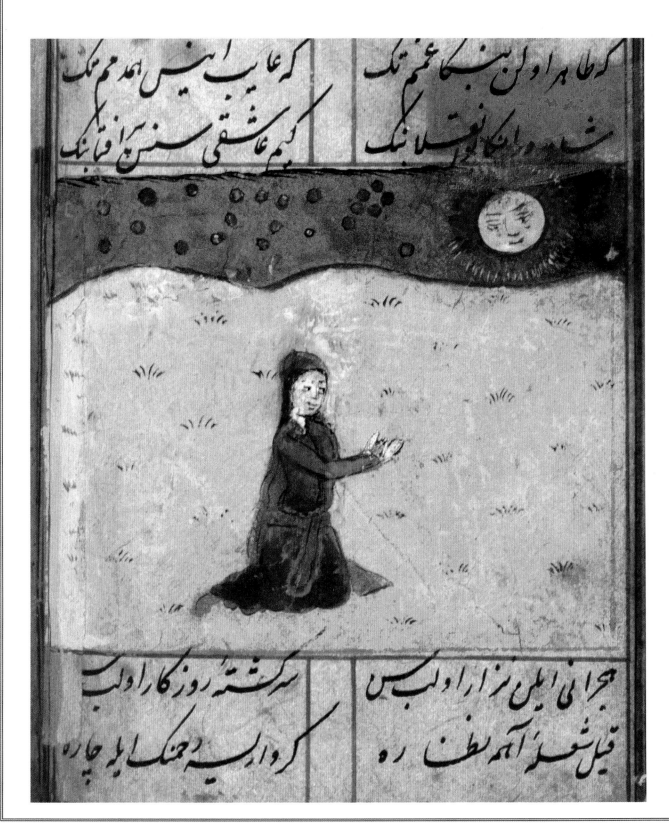

The Ugly Old Woman

THERE WAS A DECREPIT OLD WOMAN of ninety years, her face covered in wrinkles and her complexion saffron colored.

> *Her face lay in folds like an ancient purse,*
> *But close to her heart the desire for a man.*
> *Her teeth had dropped out*
> *and her hair become white,*
> *Her figure was bent like a bow.*
> *All the senses she owned had decayed.*
> *But her passion for love and desire for a mate*
> *Were within her still burning with force.*
> *The urge to ensnare had never grown less,*
> *But the trap had fallen apart.*
> *She crowed like a cock, an untimely bird,*
> *A road leading nowhere,*
> *a fire beneath an empty kettle,*
> *Like one who is fond of the race,*
> *But the horse has gone missing,*
> *and nowhere to run.*

But the old woman, faded through autumn, still desired to be wed, still plucking her eyebrows and looking at herself constantly in the mirror, to beautify her cheeks and face and mouth. She would rouge herself gleefully many times a day but the creases, like a crumpled tablecloth, were never concealed, even though she would stick pieces of the Holy Book on her skin to cover it up! But they would quickly fall off when she added her veil. So she would pick them up and with lots of spittle, stick them back again. Eventually, with the falling paper and the tangled veil, she would start to curse loudly at this impossible situation, swearing against Iblis, until one day Iblis appeared before her in visible form and said to her, "*O luckless dried up old woman, I have never seen anyone behave in this way except you. You have torn all the books in the world and never left one page behind. You're like a hundred devils, troop on troop, let me alone, foul hag!*"

> *How long will you act in this way,*
> *Taking bits of the Holy Book,*
> *Just to make your face red like an apple?*
> *How long will you steal the words of God*
> *To sell them and gain applause?*
> *This daubing, in any case, never quite worked.*
> *This bough with the fruit only ends as a stump,*
> *And at last when the veil of death arrives,*
> *The bits drop away, away from your face.*
> *When the call to depart, these false arts disappear.*
> *Be still, be quiet! Find acquaintance with silence.*
> *Go inside; delve into your heart,*
> *Take a day off from clamor,*
> *Make your mirror your play, your meditation.*

The House with Nothing In It

BEGGAR CAME TO A HOUSE and asked for a piece of bread—fresh or stale. The owner of the house said: *"What do you think this is, a bakery?"* The beggar replied, *"At least grant me a small piece of fat."* And the owner replied, *"What do you think this is, a butcher's shop?"*

"So give me a pittance of flour?"
"What do you think this is, a mill?"
"So how about some water from the well instead?"
"You think this is a river, or watering hole?"

Whatever the beggar asked for, the owner of the house was sarcastic and deriding of him. So the beggar went into the house and threatened to defecate on the floor, and the owner shouted at him to stop.

Are you a falcon that catches its prey,
A falcon hand-trained by the King?
Are you a peacock that's painted with joy,
A hundred and varied designs?
Are you a parrot with sugared tongue,
That all ears will listen the delighted talk?
Are you a nightingale worthy to sing,
The sweetness, plaintiff and meadowed delight,
The presence of tulips and garden?
Or bringer of messages meant for the King,
Or storks for the nest of the highest?
In what work are you employed,
What purpose brought? What bird are you,
With what digestive eaten?
Go up to the shop of the ultimate buyer,
Where the gracious one
buys all the goods that are left,
No coin is rejected for profit dismissed,
All that would sell is bought by this King.

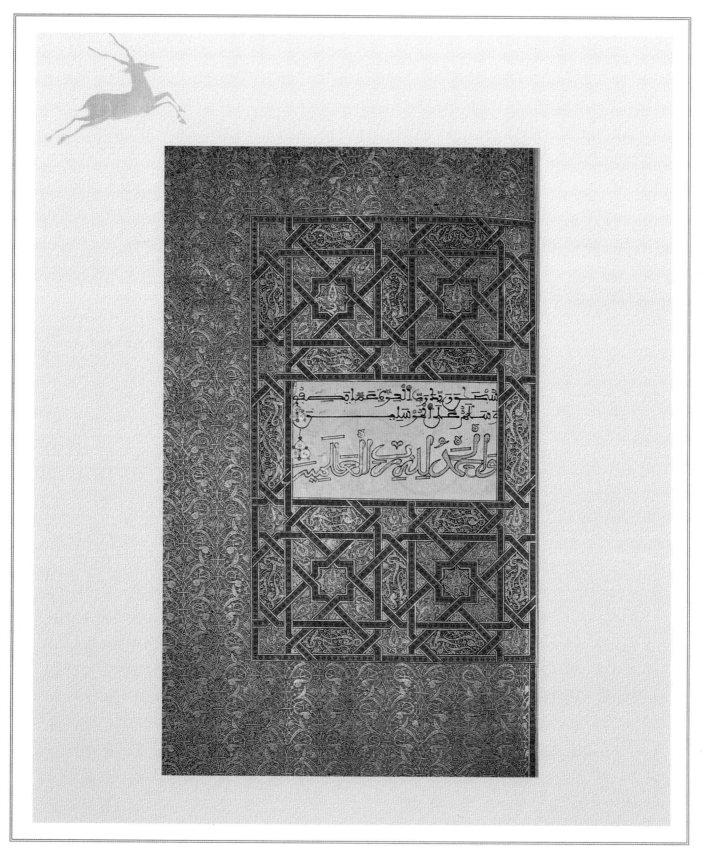

The Spiritual Physician

A SICK MAN WENT TO a physician and asked him to feel his pulse, saying that by doing so, the physician would diagnose the state of his heart, for the hand-vein was connected to his heart.

Given that the heart is invisible,

To find its symbol, seek he who is connected.

The wind is hidden from the eye,

But you can see it

in the dust and the movement of the leaves.

Is it blowing from the left or right,

here you find its state.

How is bread without the dough?

How is the Messiah without the Qu'ran?

How is Mary's fruit without the orchard?

How is my heart without your touch?

So the doctor felt the sick man's pulse, and in so doing realized that there was no hope for the man's recovery. So he told the man: *"Do whatsoever your heart desires, so that you have the best chance of getting rid of the sickness. Don't hold back on anything that you desire, because if you do, your self-restraint may exacerbate your sickness.*

"This disease flourishes on self-restraint, so don't allow it." The doctor advised the sick man.

So the man went for a walk by the side of the river, as this was what his heart desired, and in the hope that this would cure his sickness. On the river bank where he walked he found a Sufi seated, washing his hands and face and cleansing himself more and more. The sick man gazed upon the Sufi's neck, and like a crazy man, longed suddenly to strike it. So he raised his hand, remembering that the physician had instructed him never to repress his desires, and hit the Sufi. The Sufi's response was immediate—*"You rascal."* He turned upon the sick man and was about to hit him and tear at his beard, but hesitated.

Now most human males love to fight. It is their instinctive practice to beat each other up at any opportunity, and there is no remedy to this propensity, particularly as there is also another human male habit of finding fault in others at every chance. And blame leads to more beating if there is no intelligence to prevent it.

In the case of the slapped Sufi, the man was quite ready to follow his natural instincts and beat the sick man to a pulp, but for some reason he considered the consequences and stopped. He did not take the bait.

If safety you desire,

Close your eyes to the start,
And contemplate the end.

The Sufi considered the situation carefully. *"It does not make sense for me to lose my head in retaliation for a single slap on my neck. I am a Sufi, I can suffer blows."* So he looked at the sick man who had landed the blow and saw that he was very fragile, and realized that if he hit him back the poor man would probably crumble like lead and then he, the Sufi, would suffer the consequences of murder.

The tent is quite ruined.
If the tent-pins fall, I will follow,
And the tent seeks excuses to collapse.

"It would be sad for me to have to take responsibility for someone who is already dead and seeking only the last hit." So he decided to take the sick man to the judge, walked toward the man and took him gently by the shoulder and led him toward where the judge resided.

Arriving there, he told the judge what the sick man had done and explained that he felt injustice at the blow of the sick man, and what did the judge suggest. He encouraged that the sick man should be punished by public humiliation or whipping or some such punishment, but the judge took one look at the man and told the Sufi that he did not judge those that were already dead.

"This man is not living. If the living had struck you a blow you would not be standing straight as you are. I do not judge the dead, and this man is already passed beyond."

The Sufi objected, but while he was making his case against the sick man, the sick man was gazing longingly at the neck of the judge, and trying to resist striking it. The neck of the judge looked even more tempting than the neck of the Sufi. To make matters worse, the judge asked the sick man how much money he had, and the sick man answered that he had six dirhems. So the judge told the sick man to pay three of them as punishment to the Sufi for the slap (considering that so sick a man might need three dirhems to keep him in loaves and other food). But the sick man considered: *"If it costs only three dirhems to pay for a slap, why not slap the judge too? After all, the doctor told me that I should be healthier by not resisting my desires. How cheap is three dirhems for a longer life?"*

So as the Sufi and the judge talked together, deliberating on the fate and punishment of the sick man, the sick man struck the nape of the judge's neck also—a resounding blow, and spoke aloud to them both:

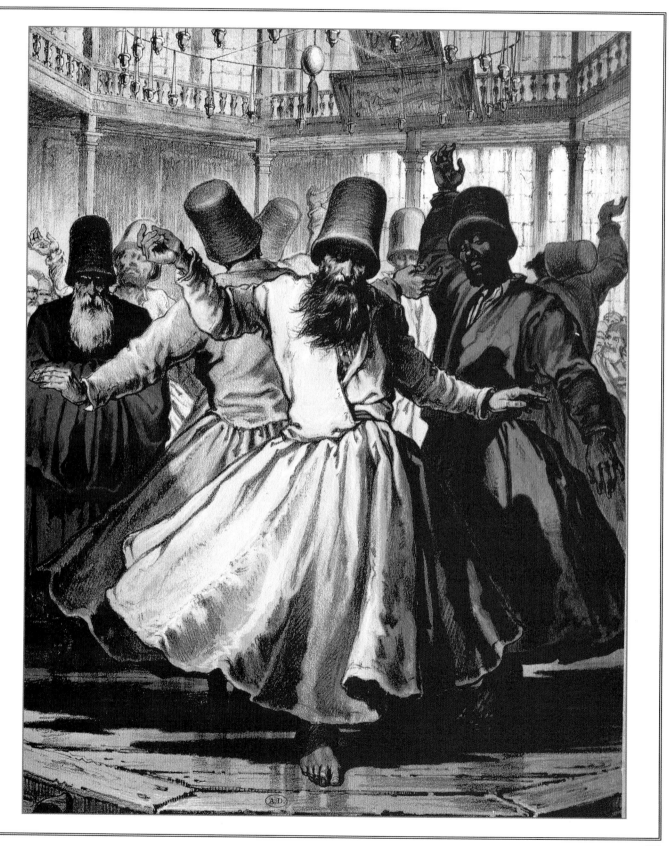

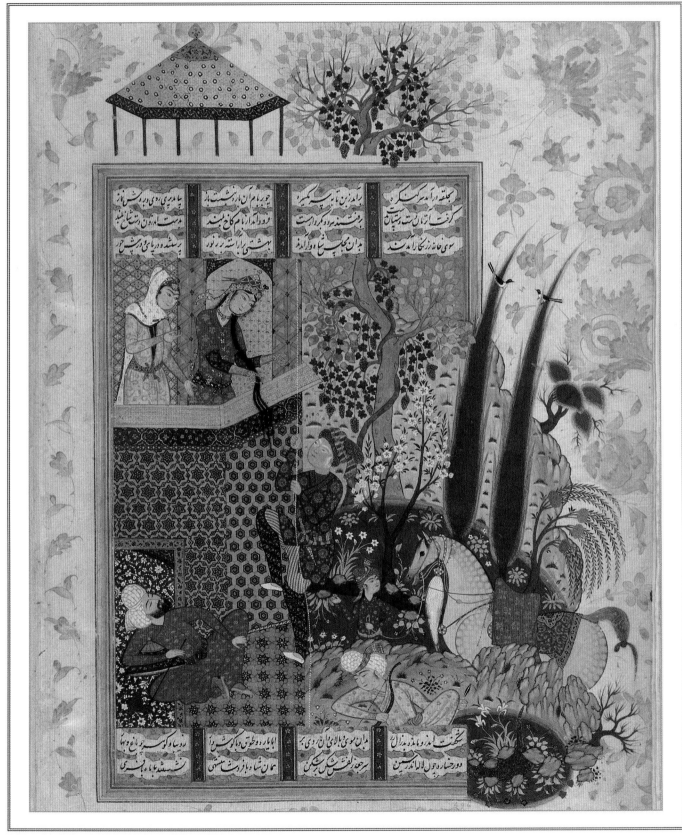

"Hey, my two enemies, take three dirhems each, then I shall be free from guilt and without trouble and anxiety, worth every penny."

The judge was incensed by the slap. So the Sufi said to him:

"Oh judge of the Muslim faith,
 How do you prove to be right for me,
 What you prove to be wrong for yourself?
 If you dig a deep pit for another,
 Fall into it quickly right now.
 Your decision for me,
brought the slap on your neck,
 What place your fine judgments with this?
 What will other past judgments bring you?
 Cut off his hand; don't give him more power,
 Oh you for whom justice is lost.

But the judge said to the Sufi:

It is our duty to acquiesce,
 Whatever slaps destiny brings us.
 I am inwardly pleased with the judgment,
 Made in the heavens above,
 Though sour my face may be with the truth,
 For truth is bitter, but my heart is an orchard,

My eye like a cloud.
When the cloud weeps, the orchard laughs.
In the year of drought the orchards die,
Their agony from the sun's laughter.
You know the joy of laughter,
But forget not the pleasure of weeping
For it is a mine of sugar.
In tears come laughter concealed
Seek the treasure beneath the ruins
Oh simple man.

The Turk and the Tailor

HERE WAS A TAILOR who was said to beat all others in the art of light-fingeredness and thievery. A Turk swore that even with a hundred attempts the tailor would not be able to take a coil of thread from him without him knowing.

Others told him that many others more intelligent than he had been beaten by the tailor, and that he should not imagine himself so great, for his ego would only give him worse troubles in competition with the tailor. With this the Turk became still more competitive and made a wager that the tailor would not be able to rob him of anything.

He wagered an Arab horse with those who taunted him if the tailor stole anything, and that if he failed to steal, then they would have to give a horse instead. And that night the Turk lay awake troubled by the situation; not one wink of sleep could he find.

In the morning he put a piece of satin under his arm and went to the bazaar and entered the shop of the cunning rogue, saluting him warmly. The tailor sprang up from his seat and opened his lips to bid the Turk welcome, inquiring about his health with cordiality exceeding even that of the Turk, planting in his heart great feelings of affection for him. When the Turk heard these songs of sweetness from the tailor he flung down the piece of silk saying, "Cut this into a coat for me and make it wide below my navel so as not to hamper my legs and tight above it to show off my figure."

The tailor answered, "O kindly man I will do you a hundred services," and accepted the order. He measured the satin and inspected the working surface and all the time chatted away to the Turk in idle gossip, about other amirs and of bounties and gifts he had received from them, and about misers and their mean ways, and made the Turk laugh with his tales. As he uttered all this beguiling talk he was also snipping away with his scissors so rapidly, cutting as fast as his lips moved.

The Turk was laughing, the tailor was cutting,
　The Turk he closed his eyes in joy,
　The tailor cut extra pieces,
tucking them under his thighs,
　Hidden away from all but God,
　And God he saw but covered the sin,
　Though carry the sin beyond the bounds
and God will tell all right then.
　From his delight at the tailor's tales,
　The Turk's former boast went out of his mind.
　What satin? What boast? What wager?
　The Turk was drunk with the jokes.

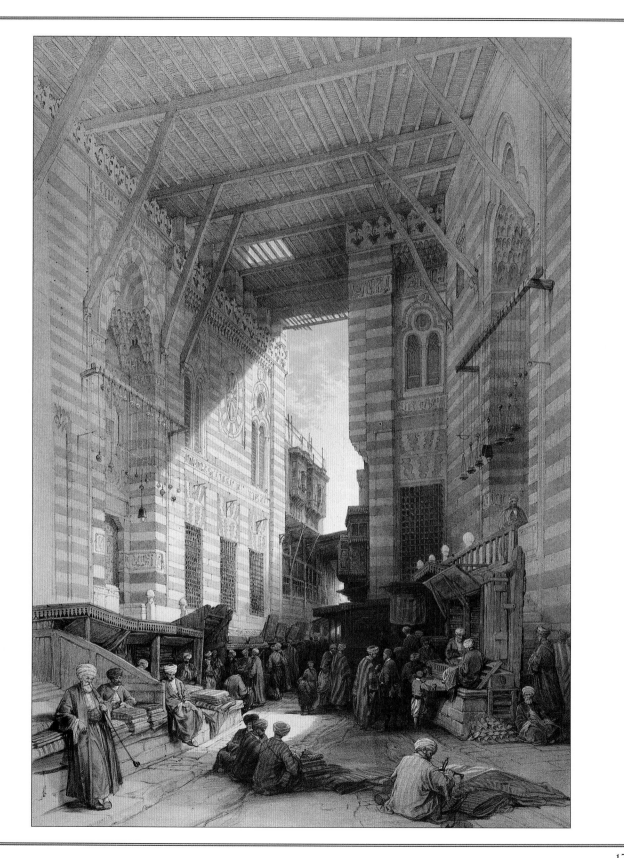

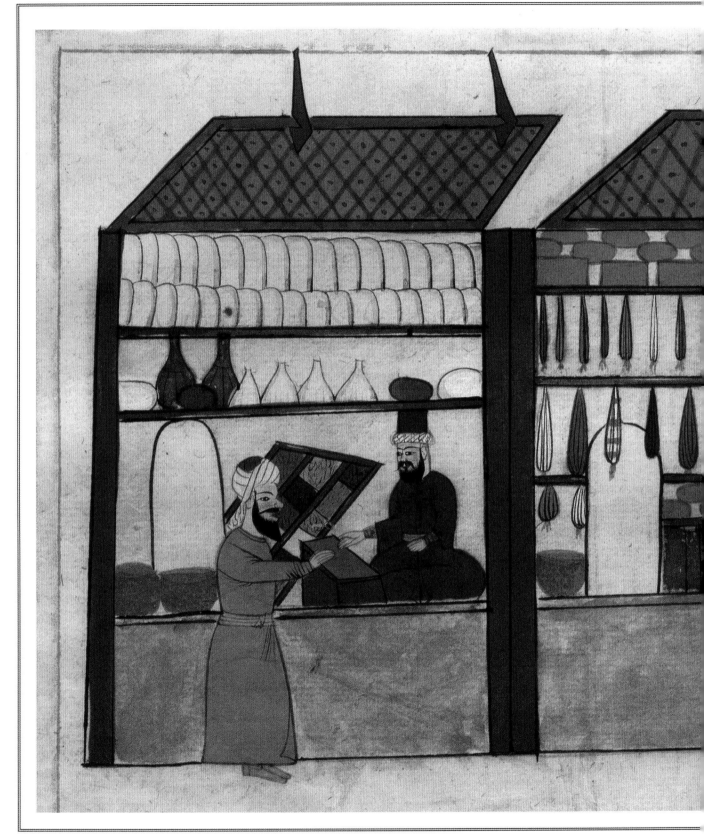

Then the tailor told such an incredible story that the Turk fell over on his back with laughter and the tailor swiftly stitched a swath of the satin to the hem of his underpants while the Turk was paying no attention at all, greedily sucking with every guffaw at the jests the tailor told. And the tailor continued to tell funnier and funnier tales and jokes until the Turk was completely within his power.

> *His eyes were shut, his reason was flown,*
> *Bewildered and boastful*
> *the Turk was drunk with joy.*
> *And the tailor continued to cut,*
> *Filching yet more of the beautiful cloth,*
> *With nothing to stop him now.*
> *And still the Turk begged for more.*
>
> *You who becomes the slave of the jest,*
> *No story's more laughable than you yourself,*
> *Think on this at the edge of your grave.*
> *How long will you listen to the lies of this world*
> *That leave your mind and spirit unhinged?*
> *The Universal Tailor will cut and stitch the hems*
> *Of a hundred travelers, silly as children.*

Eventually the tailor became bored with the whole story and told the Turk that he had better leave before another tale was told, "For if I tell another one, the coat will be too tight for you, and you will stop laughing and weep tears of blood."

The Fakir and the Buried Treasure

A HEAVENLY VOICE sounded in a Sufi's dream, saying: *"You who have seen many difficulties in your life and deserve some reward. Go search among the loose leaves of handwritten paper sold by your neighbor the stationer. Do not let him see what you are doing. You will recognize a particular scroll by its colors and shapes, the which I will relate to you. Do not read it there in the store, but take it away somewhere private and read it in secret, and do not seek any partnership in this. However, don't be anxious about it, for even if someone else does see the scroll, no one but you will see its significance. And if it all takes much time to unfold, don't despair, but endure whatever toil occurs.*

The young man came back from his vision and was beside himself with excitement and agitation, not only because of the promise of some special treasure, but also that he had heard the word of God and was to be brought through the veil of suffering to enlightenment. So he rushed off to the stationer's store and for some long time he rummaged through the scrolls and papers. After awhile he came upon the special script that the voice in his vision had specified. He slipped it under his arm and left the shop discretely, telling the stationer that he would return shortly.

He took the scroll to a solitary nook and sat there lost in amazement and bewilderment, unable to believe that such a valuable item had been left among loose papers in a stationer's store. But then he considered:

God is the guardian of all things,
How can the Guardian let anything recklessly free?
Though the desert were filled with gold,
Not a single cent would be carried off
Unless it was His decree.
And though you read hundreds of books all day
Not one word of them stays in your mind
Without the divine decree.

Written in the scroll were the words: "Outside the town there is a buried treasure. Go to the domed building where there is a martyr's shrine with a door facing toward the desert. Turn your back to the door and face Mecca, let an arrow fly from your bow and where the arrow falls, dig right there."

The youth did as the instructions told him, letting an arrow fly into the air, then ran with his pick-axe and dug up the spot where it landed. And he dug and he dug all round the place, eventually becoming exhausted and finding nothing at all. Everyday he did the same, shooting arrows all over the place from the designated spot but never finding a single bit of treasure.

Eventually, after this had been going on for some time, a rumor began to circulate in the town, until soon enough the story reached the ears of the king that a young man had found a treasure scroll. Being not entirely stupid, the youth figured out that he could not continue what he had been doing and

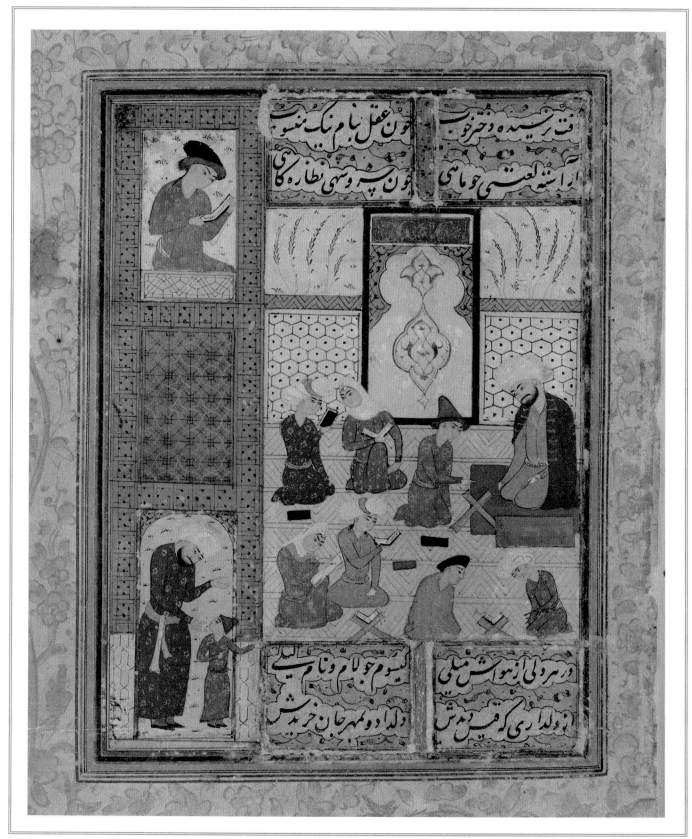

 for fear of being punished, he brought the scroll to the king himself and told him the story:

"Since I found this scroll I have discovered no treasure but infinite trouble instead, for more than a month I have writhed and struggled for no result. Perhaps your fortune will disclose this amazing mine of wealth O great king and warrior."

So the king also went to the shrine and fired arrow after arrow into the air, and for six months repeated what the youth had done, digging pits all over the desert and searching for the treasure in all directions. The result was nothing but frustration, grief, and futility.

Eventually the king became sick and exhausted and handed the scroll back to the youth, telling him that it was a useless thing and that he granted the young man complete rights over it forever, and wanted nothing more to do with it.

The young man swore that he had learned from the scroll that nothing ever comes to us unless we labor for it, and with this he settled back to forget about the whole event but prayed to God to receive some understanding of what had come about. He remembered also what the king had said to him:

Reckless love is not afraid to explode,
while reason seeks profit.
As love suffers,
she remains steadfast, solid and strong.

Risking everything,
she lies beyond self-interest, seeking nothing,
Betting on every glorious gift life brings.
Without reason, life gives life
—without reason, give it back.

Then one night inspiration came to him unexpectedly. The scroll had instructed him to take bow and arrow, but it had not instructed that he should pull back the bow with great strength, or fly the arrow a great distance. It simply said that he should put the arrow to the bow and pull, but not with great strength. It had been him, the youth, through his ego and pride of strength, who had decided to pull so hard and send the arrow so far.

So he rushed back again to the shrine and pulled the bow only slightly so that the arrow fell but a few feet away, and there, of course, was the treasure.

That which is real is nearer than your head,
But you shoot the arrow of thought far afield.
The farther you shoot,
the farther you are from the treasure.
The philosopher kills himself with thinking,
Let him run on in vein,
for his back is turned on the treasure.
The stronger you draw the bow,
the worse your luck in discovery.

The Three Travelers

MUSLIM, A JEW, and a Christian traveled together on a journey and eventually stopped at an inn along the way. The innkeeper brought them halva as a gift, with warm bread, and laid it before them. The Jew and the Christian had already eaten much food and were suffering from indigestion, but the Muslim had fasted that day and was hungry. The Jew and the Christian said, *"We have eaten our fill, let's put the halva and bread aside for tomorrow."* The Muslim disagreed and suggested that they should eat the food that night and put away self-denial until tomorrow instead. The other two suggested to the Muslim that his plan was transparent and that he planned to eat all the food himself.

"My friends," said the Muslim, *"there are three of us and if we're in disagreement then surely it's simple enough—we share equally. Let he who wishes to eat his own share take it, and he who wishes to save put his share in hiding."*

But the Jew and the Christian wanted to make the Muslim suffer from lack of food and so found all manner of religious questions to prevent his sensible response. *"Sharing is denied by the Prophet,"* they said. *"Hiding cannot be the right solution,"* they said cunningly. And eventually, the good-natured Muslim gave in and said, *"My friends, I hear and obey."*

So they slept all night and in the morning rose and dressed, washed their faces and mouths and each one had a different practice and devotion, seeking favor from God.

True believer, Christian, and Jew,
 Each faced the mighty Sultan.
Stone and earth and mountain,
Each have their recourse to God.

And after this time of ritual, each looked more in friendship upon the others, and one said, *"Let each of us tell the others our dreams from last night. Let him who had the best dream eat the halva, the most excellent dream carries off the share of the others."*

He who mounts highest
in the scale of reason,
 His eating is equal to all the rest.
 His luminous spirit is supreme.
 All others will tend to his needs.

So the Jew related his dream and told the other two where his spirit had wandered that night. He said, *"Moses met me along the way according to the adage: the cat sees a fat sheep's tail in his dreams. I followed him to Mt. Sinai and all three of us (Moses, Mt. Sinai, and me) vanished. All our three shadows disappeared in the sun, and after that there was a revelation.*

From the heart of that Light, another Light sprang,
 And quickly the second transcended.
Both I and Moses and also the Mount,

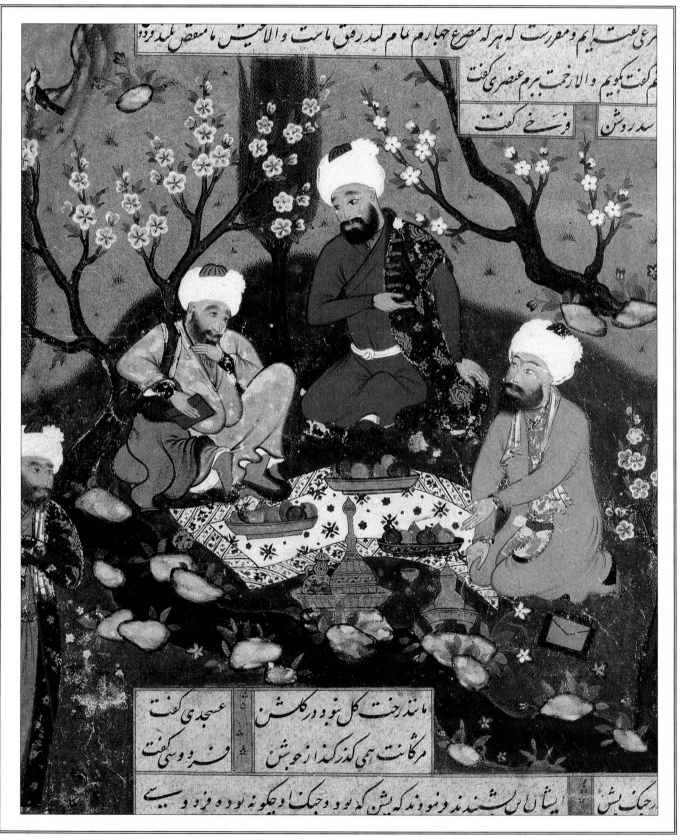

185

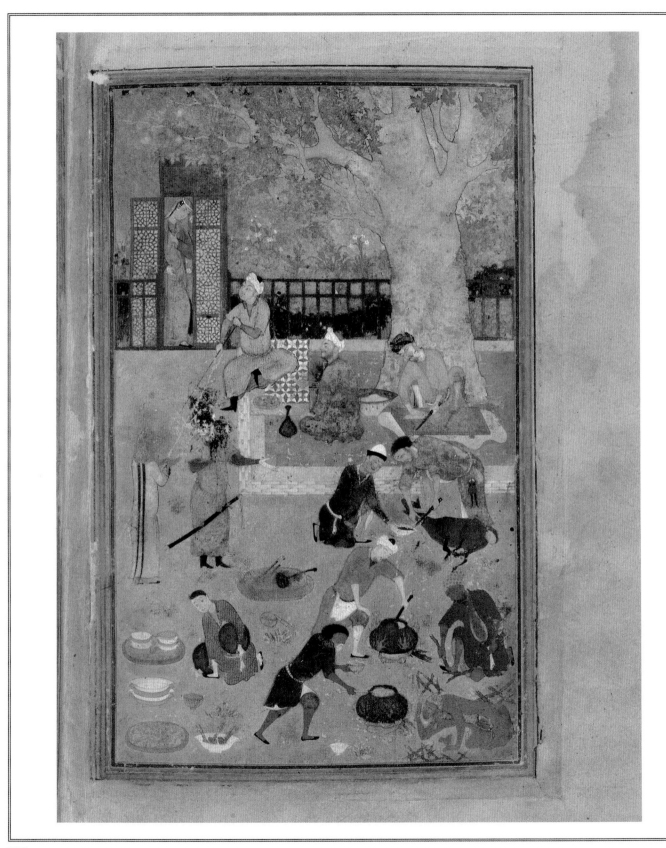

Broke into three pieces and vanished.
One piece of the mountain fell into the sea,
And the bitter salt ocean was sweetened.
One piece of the mountain sank into the earth,
And medicinal springs gushed forth.
Its waters a cure for all the sick
From the blessedness of the revelation.
The third portion flew on a wing to Ararat
And Sinai restored as the mountain.
But under the foot of Moses,
The vision was melting like ice,
No spur or peak remained.
The mountain was leveled to the earth with fear,
It was turned upside down by that lawful God.

After all this scattering of my senses I came back to normal again and saw that Sinai and Moses were unchanged and that the desert skirting the mountain was filled from end to end with people resembling Moses in their illumined faces. They carried mantles and staffs like Moses did and all of them were moving joyously toward Mt. Sinai. They all carried the beauty of Moses, and even though they were different people they carried the look of the Prophet in their eyes, endowed with love." And this was the dream of the Jew.

The Christian then told his dream. "The Messiah appeared to me in my dream. I went with him to the Fourth Heaven that is the center of the abode of the sun in this world. There is no greater place than this on earth, and that I need not say more, for my head is held up high and I am superior in this vision to anyone else. Everyone knows that I am not smaller than you. All know that those possessed of such intelligence are by nature superior to you."

So, with this brief tale it came to the Muslim to tell of his dream.

"To me came Mohammed my sovereign, and he said to me, 'The Jew has gone to Sinai with Moses and has played the game of love. The Christian has been carried to Jesus, the Lord of the happy star at the zenith of the Fourth Heaven. Arise, you who have been left behind and have suffered injury, eat up the halva and bread! Those other two talented and accomplished men have read the book of fortune and honor. They have attained to their proper eminence and because of their talents have attained to the angels. Hark O foolish simpleton left behind, jump up and seat yourself beside the bowl of food.'"

The Jew and the Christian jumped with astonishment when they realized that the Muslim had already eaten the food. "What was I supposed to do?" said the Muslim. "If the sovereign orders something, I must obey. Would you have had me disobey his commands? Would you Jew disobey the commands of Moses, fair or foul? Would you Christian spurn the commands of Jesus, whether good or evil? How then should I rebel against the Glory of the prophets? I have eaten the halva and now I am happy."

So they said to him:

You have dreamed a true dream
And better this dream than a hundred of ours.
Your dreaming is waking, O gleeful one,
For its reality is made clear by your waking act,
The eating of sweetmeats galore.
We bow to your superior nature.

The Mouse and the Frog

A MOUSE AND A FROG had become friends on the bank of a river. Both had agreed to keep a faithful tryst and meet each morning in a private nook, where they played heart and soul with one another and emptied their hearts of evil and suspicious thoughts. From this they both swelled with joy from their relationship and recited stories and listened to one another, telling secrets with and without the tongue, knowing one another often without words, such was their intimacy.

> *They shared the longest tales they did,*
> *The flow of talk between friends.*
> *How should the heart of intimacy rise,*
> *Except without strain and device?*
> *When the nightingale sees the rose,*
> *How should it remain in silence?*
> *To the friend when seated beside the friend,*
> *A thousand mysteries arise.*

So one day the mouse said to the frog, "O lamp of intelligence, there are times when I want to talk with you in secret and you are gamboling in the water. I'm on the riverbank crying loudly for you, but you do not hear my wailing. When we meet at the appointed time I never tire of our exchanges and so hope for more of the same."

> *Ritual prayer is five times a day,*
> *But the guide for lovers is more.*
> *The wine-headache that is in our heads*

Is not relieved by five times a day,
Nor five hundred if truth be known.
Once a week is not for lovers,
The lover's soul has a craving to drink,
The fish can't be outside the sea.

So the mouse said to the frog, "O dear and affectionate friend, without seeing your face I have no moment's rest. By day you are my light and power, acquisition and strength, and by night you are my rest and comfort in sleep. It would be greatly appreciated if you remembered me both early and late in the day. Up to now, during the whole day and night, you have allowed me only breakfast time for meeting—well-wishing friend of mine. I may be ugly and hateful, and venomous as a mountain snake, but bestow on this thorn the beauty of a rose, on this snake, the loveliness of a peacock! Bestow your favors on me."

So the result of all this adoration and debate was that the mouse and the frog agreed that they would construct a long piece of string that either one could tug on to tell the other of the need to meet.

> *One end must be tied to the foot of this slave,*
> *While the other to your foot secured.*
> *That by this device we two will engage,*
> *And mingle as soul and body.*
> *The body is like a string to the soul,*
> *That draws it down from Heaven to earth.*
> *When the frog-like soul escapes,*

From the mouse-like body,

It falls into the water unconscious,

And enters the happy state.

But the mouse-like body

pulls it back with the string,

How much better's the soul from the pulling.

Were it not for the tugging

of the scatterbrained mouse,

How the frog would enjoy himself drowning.

So the mouse said, *"Knot one end of the string on my foot and the other end on yours. Then I can pull you onto the dry land."* But the frog was troubled by this idea because he feared that the mouse would drag him into a condition he was unfamiliar with. And whenever an uncertain feeling enters into the heart of a good man, it isn't devoid of significance. Some useful knowledge may be acquired by it.

But the plan went ahead and the string was attached between the frog and the mouse, and the mouse sat by the side of the pond and kept tugging on the string in hope of being united with his right-eous frog, perpetually harping on the heartstring saying, *"I have got the end of the string in my paw, and my heart and soul have become frail as this thread in con-templation of seeing the thread always available to me."*

But then came a raven and grabbed the mouse and carried him off from the spot, and as the mouse was picked up and carried into the air so the frog was also, dragged up from the bottom of the water with the string attached to his leg. People who watched this strange affair asked the question, *"How can the raven be so crafty that he can carry off a mouse and a frog together?"*

"O sirs," said the frog,

"seek a friend, who does not behave,

like a rascal devoid of honor."

Seek friends not of water and clay.

For the spirit's like an ant,

And the body like wheat

that the ant can carry about.

The ant knows the grain of which it has charge,

Until it joins one and the same.

The celestial bird carries the soul to the fortress,

As the raven carried the frog.

Sultan Mahmud and the Thieves

HILE KING MAHMUD was roaming about alone at night he came upon a band of thieves. They said to him, *"Who are you, honest man?"*

"I'm a thief like you," replied the king.

One of the thieves then suggested that they all gather together and tell each other of their particular skills as thieves and robbers, swapping their talents as an entertaining way to pass the night together.

So the first one spoke:

Friends of mine, all you with such gifts,
My specialty lies in my ears.
With this great gift I can tell from a bark,
What a dog is saying even far away.

And the party all shouted that his talent was little, they were not impressed by the ears of the thief. So another thief said:

Great company of gold lovers,
all you with such gifts,
My specialty lies in my eyes.
Those I see in the night,
I know in the day, no doubt of identity
And another declared that his gift lay in his arms.
I make holes through walls
by the strength in my hand.

And another declared that his gift was his nose,
That he could tell from the smell,
all things you could sell,
All things you could buy,
for the Prophet had said this gift to be great.
"I can smell-out a mine that's filled up with gold,
Or a mine that will bring only dirt.
I can dig out potential and smell what is trash,
So that nobody wastes any time with me,
Nobody knows what my nose knows."

And another thief declared that his specialty lay in his fist, that he could lasso a mountain, and like Mohammed he could lasso himself up to heaven, and then they turned to the king and asked him what his special talent was, and the king declared that his talent lay in his beard. He told them that a nod of his beard would save the life of any criminal from the executioner, and that all mercy derived from the movement of his beard.

The thieves immediately declared the king as their savior and leader, for he would give them what they needed on the day of judgment and tribulation.

As the thieves traveled toward the king's palace, the thief whose talent was in his ears heard the bark of a dog, which he said told of the presence of the sultan among them. The thief whose talent lay in his power of smell knelt to the ground and told

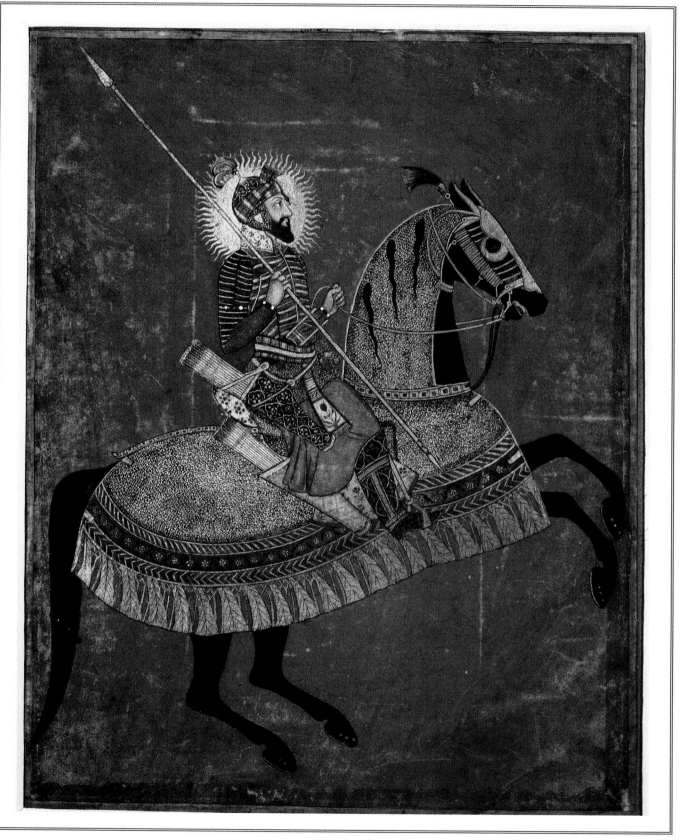

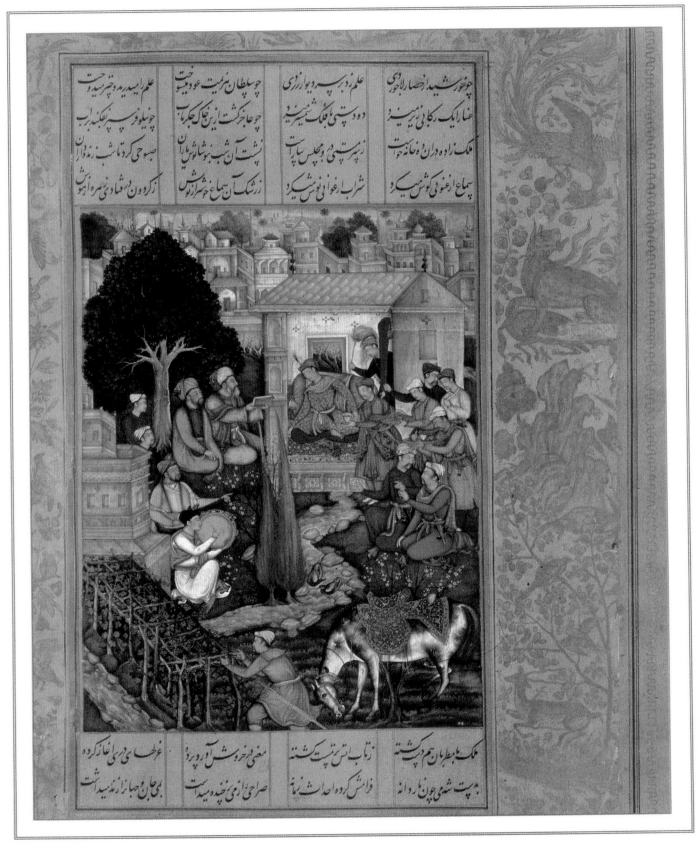

them that this was where the treasury of the sultan lay, so the thief with the lasso brought them over the palace walls. Then the tunneler made a tunnel to the treasury, and everyone carried off goods from the treasures of the sultan.

There was gold, and gold-embroidered cloth and pearls and jewels for everyone, and when they returned to their homes, the sultan witnessed their lodgings, their faces, and the way they went home, then stole away back to his palace, and the following day told his ministers all that had happened. His soldiers and officers rushed immediately and held the thieves, bringing them in handcuffs to the council chamber, where they stood trembling with fear for their lives.

And in the chamber, standing before the throne of the king, the king that was their last-night's companion, the thief who specialized in the talents of his eyes recognized the king in the day that had been with him in the night, and told his companions so.

"This was the man who came with us last night,
The man who walked as our friend.
He is the one with the talented beard,
Our arrest has derived from his knowledge of us,
I know of this king and the way he behaves,
Of the mystical ways of a sultan of men,
For he watched all our actions and secrets within

And he never averts his face from the Knower,
And the eye of the Knower is salvation enough,
Where each sovereign obtains all the help he needs.

And the thief spoke boldly to the sultan, saying: *"We have been bound in chains like the spirit in its prison, and you are the Sun of the spirit on this Day of Judgment. Great king whose journey is hidden from view, the time has come for you to move your beard in clemency as you told us you could. Each one of us has displayed his specialty and talent, and all those talents have done is to increase our bad fortune. Only my talent of recognizing you from night to day has the potential to help us, while all the others were like ghosts on the road frightening travelers as they past by. But be merciful to all of us, and look upon our inner talents and spiritual qualities, for many a piece of gold is made black iron so that it may be saved from pillage and calamity."*

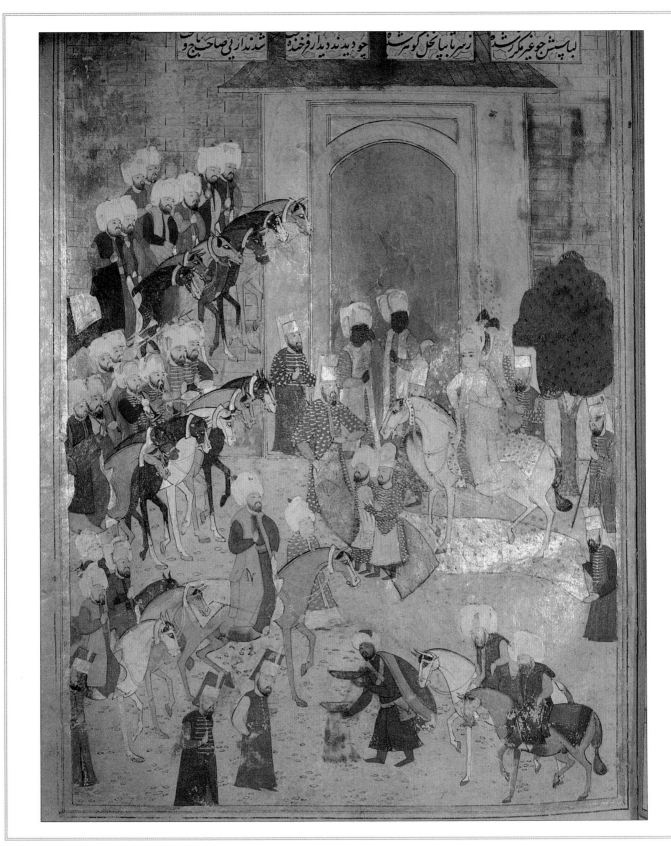

The King and the Beautiful Horse

*A*CERTAIN AMIR had a fine horse. There was no equal to it in the sultan's troop. Early one morning he rode out in the royal cavalcade and the sultan noticed its supreme beauty. Its color enraptured the his eye, and he followed it all the way home. On whichever limb he gazed, each seemed to him more pleasing than the last, its exquisite qualities completely beguiling.

The sultan vowed that he would learn what the reasons were for this extraordinary seduction, saying:

My eye is full and satisfied and wanting nothing.
It is illumined by two hundred suns.
I have looked upon kings,
who are pawns in my sight,
Yet this horseflesh enraptures my sight.
The creator of witchcraft has caught my sight,
It must be some magic I know not.

The sultan was convinced that this effect was from beyond and that God was somehow pronouncing marvels to him at that moment, through the beauty that he saw in the horse. So on his return to the palace he conferred with his nobles and they immediately ordered his officers to fetch the creature from the household of the amir who owned it.

Quick as a flash, the party of officers arrived there and the amir, who was a fiery and powerful individual, was quite bereft at the prospect of losing this one horse. He went for advice to his priests and advisors, for he was a generous and noble man and would never deprive his sultan of anything he wanted. He would have given his harem or any gift that the sultan desired, but for this one horse, whom he loved beyond anything he owned.

So the amir went before the sultan and, as the beautiful horse was brought before him, he remained still and silent as the sultan looked upon it and wondered. The amir had brought his most important advisor, who stood before the sultan as he viewed the fabulous horse.

"O vizier," said the king,
"is this not the most beautiful horse?"
"My emperor," said the vizier,
"a demon is made angelic by thy fond inclination.
Thine eyes make beauty intrinsic.
This steed is most handsome and graceful,
Yet maybe the head is alike to an ox."

What the vizier said made the sultan's mind consider, turning the perfect horse's looks into something less than true and beautiful.

When prejudice goes between that of beauty,

You may get a Joseph for a roll of linen.

When the hour arrives for the spirit's parting,

The Devil brokers the pearl of Faith.

And then in that moment of pain,

The fool sells his faith for a jug of ale.

The aim of the Devil is trickery.

The king viewed the horse with regard to the present,

While the vizier thought of the future.

And thus was the story so easily killed,

For the vizier blind-eyed the king's desire,

And he who created deceit in the heart,

Set the sackcloth of lies on fire.

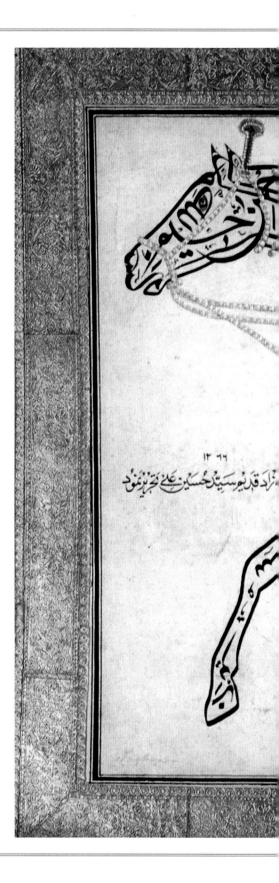

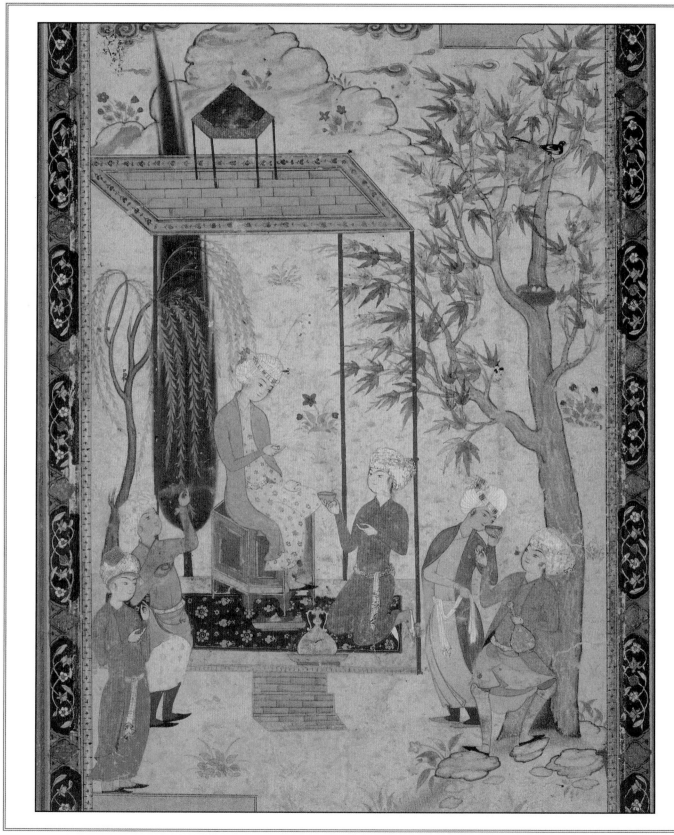

The Story of the Three Princes

HERE WAS A KING WITH THREE SONS, all of whom were endowed with great wisdom and discernment. Each had great skills in all manner of sovereign knowledge, battle, and carried with them great generosity and praiseworthiness. They stood together before the king like three candles in his eye, much to his delight, and the father's source was greatly fed from his love of his sons.

As the water of life runs swiftly from the son
 To the garden of mother and father,
 So the garden stays fresh forever.
 But if sickness in the fountain of youth
fails the child,
 So the leaves and boughs
of the parents grow withered.
 So the withered tree in the garden of the father,
 Drew stock from the presence of the child.
 How many hidden conduits
draw such-like from the soul?
 All this is a loan that will pay back in time,
 Only the breath of the divine comes free.
 How good is the source of all things?
 How strong and singular you become
from this source alone?
 Independent of all others sources.
 You quaff from a hundred other sources,
 And as each diminishes, so you suffer.

And so it was with the king and his three princes.

One day the king sent the three sons out equipped to visit their father's distant possessions. They would make a tour of the cities and fortresses to regulate all administration and economy in the realm. They all three kissed the king's hand and bade him farewell, and as they were about to depart the king, who is obeyed by all, said to them:

"Direct your travel wherever your heart takes you under the protection of God, dancing with joy. Go anywhere but to one fortress, the name of which is "the robber of reason." This place will tighten your reason and restrict your generosity. Stay away from it, for God's sake, for God's sake, keep away from this castle adorned with visions, beware of its peril. The front and back of its towers and its roof and floor are covered with images and decorations, like nothing you have seen. Keep your face safe from this special fortress, for if you do not you will fall into everlasting misery."

Now, if their father had not warned them against this fortress, none of them would ever have noticed its existence, for it was extremely remote and would never have been seen by any of them. But because he warned them against it, their hearts lifted and their imaginations soured to the quarter of fantasy, and so, because of the prohibition their hearts were thrown into vain desire to investigate the secret of that forbidden fortress.

Who is to be found
that will refrain from the forbidden?
Since man longs for the illicit.
The veto causes the devout to hate,
The veto brings the sensual to covet.
Therefore God leads us all astray by this means,
And leads the devout and knowing heart
to fulfillment.
How should the friendly dove
be scared by the fowler's pipe?
Only the wild dove flying frights from the pipe.

So the princes set off on their journey saying to their father that they would perform all that he asked and be intent on hearing and obeying his commands.

But in the event, the first place they headed for was the one forbidden castle that their father, the king, had told them to avoid. They approached first the tree of the forbidden fruit. They went forth from the source of the sincerity, encouraged by their father's prohibition.

The fortress stood magnificent with five gates to the land and five to the sea, five like the external senses facing toward color and perfume, the material world, and five like the interior senses seeking mystery. The fortress was filled with pictures and designs, decorations and beauty so that the three princes were bewildered and intoxicated by the contents, wandering to and fro on every level.

Among all these amazing sights the three brothers found a beautiful portrait that plunged them into a deep, opium-like sea, a sea of tribulation, causing them to shed tears, like clouds, gnawing at their hands and crying with pain and sadness. The fortress had wrought its work, the fortress called the destroyer of reason. It cast them into a pit of tribulation. They had literally fallen in the love with the picture, and they began to realize what their father had meant when he told them to stay away from this place.

"We have transgressed his command and are fallen into a moat, killed without combat."

Moved by sorrow and by the beauty of the portrait they began to ask around who this person was in the portrait. Eventually they learned from a shaykh of great wisdom that she was the Princess of China and was kept in a secret palace.

"Neither man nor woman's admitted to her presence,
Concealed by the king because of her beauty.
The king has great envy to protect her good name,
So that not even the birds fly over her roof."

So the three afflicted brothers put their heads together. They all three were feeling the same grief and sorrow, all three with the same passion and all three sick with one disease and one malady.

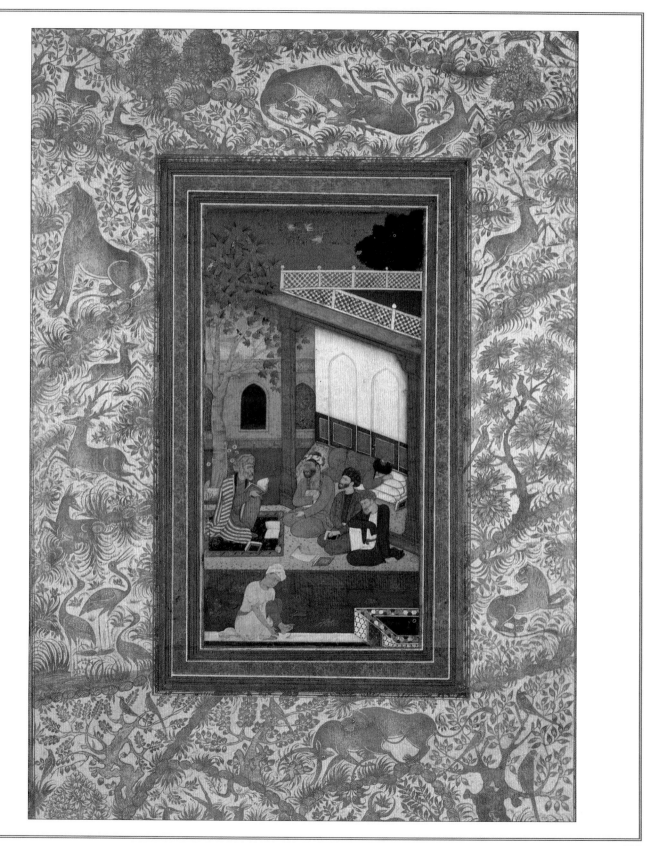

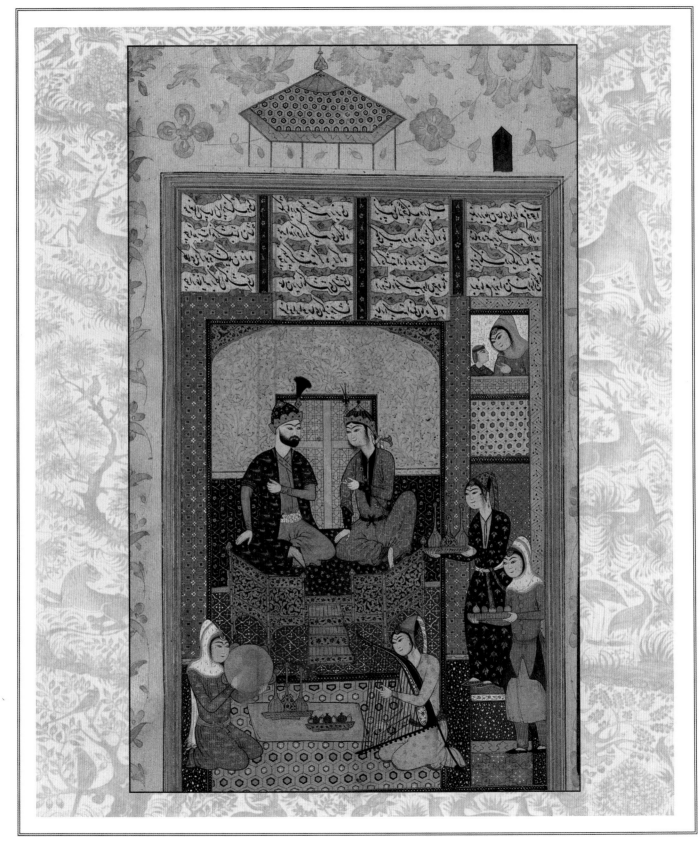

At this time of silence all three had one thought,
 At the time of speech, all three had one word.
 At the same moment all three shed tears and wept,
 The tears of blood on the table of calamity.
 At another time all three,
from the fire of their hearts,
 Heaved burning sighs, as hot as a chafing-pan.

The eldest son said to the others that they should take heed of their own advice, that when in their own home they would give counsel to others to be patient in adversity, and yet here they were behaving like idiots and completely lacking in either patience or fortitude.

"*What has become of our advice now?*" he said. "*We used to tell the soldiers in battle never to lose courage. Where is our courage now?*"

And so they decided to set off to China, leaving parents and kingdom, they took their way toward the hidden princess whose beauty had been shown to them in the picture of the fortress.

Once in the capital of China where the emperor lived, the eldest son became impatient to see the face of the one he had fallen in love with and spoke to the other princes telling them that he was going to visit the palace come what may.

"*I can endure no more,*
 It has set me on fire.
 My strength is exhausted by this fortitude.
 My plight is a warning to all lovers.
 I am weary of separation

From the one that I love,
 It's a lie to live in this way.
 Cut off my head, so that love can give,
 A new one in place of the old.

He resolved that it was better to go to the emperor and have his head cut off, than to sit around waiting with this passion in his breast. But the other brothers were concerned with his madness and counseled him to wait and speak to someone wise, someone who was not so drunk from lack of discernment, not caught in his heart like the eldest son.

They advised him in this way and also told him that as far as they could tell, the king had never had a daughter, never begotten a child of any kind because he had never allowed a woman in his bed. They further told him that if anyone came to the king and told him that they believed he had a wife and child, he immediately lopped off their heads unless they were able to prove it. As witness to this they had been told that there was a moat about the palace filled with severed heads, and all the heads were the result of the false assumption that the king had a daughter!

But all this warning made no difference. The eldest prince was mad with desire and repulsed by their attempts to stop him from going to the king.

"*My bosom is full of fire like a brazier*
 The crop is ripe, it's time for the sickle.
 Love has emblazoned the place of strength
 It died when my love was born.

I am passed beyond all fear,
Do not beat a piece of cold iron.
I am rushing headlong and you hold my feet
There is no understanding in any of my limbs,
For I'm like a camel carrying my load
When I fall down exhausted
I'll be glad to be killed.
I prefer the ghastly moat that is filled with heads
To the fear and dread and the anguish I have now.

And with this the eldest prince darted away from his brothers so they could not have the opportunity to speak more and persuade him against his ardent desire to see the daughter of the king.

He came to the palace and prostrated himself on the ground, kissing the feet of the king with incredible passion and enthusiasm. The king was not unfamiliar with the ardency of the young men who came to his palace, burning and flaming before this exalted monarch. But the king did not speak with the eldest prince of any daughter or family, but of many other matters. He held the eldest prince at bay with his graciousness, and became fond of him and granted him privileges, though the prince never had the opportunity to speak of his beloved and the picture he had seen in the palace.

And this continued for years and rather than being beheaded by the king himself, the eldest prince eventually died of natural causes.

So there was a great funeral, and the youngest brother was ill, so the middle brother came to see his brother buried and met with the king, and the king laid similar charm and care upon the second prince in the same fashion as he had done with the eldest prince. The second prince was also caught in the warmth and good nature of the king. In consequence of the kindness shown to him by the king, the second wretched prince, who had been roasted in the fire of love, found that his body contained a soul other than the animal soul.

But he could not maintain the spirit that had entered him and became indignant and angry at the king for putting him in this unwelcome state. He became resentful and angry at his condition, and the king was also angry and jealous that this prince, to whom he had given such favor, did not appreciate it at all, so they became parted within the same palace and the same kingdom of China until the second prince also died of his condition.

But the third prince, who had done nothing to follow his passion, and had lazily remained outside the power and passion of the portrait he had seen, kept his life intact and did not die of the influence of the Emperor of China and his fantasy daughter. His laziness made him win the day, for God works for the lazy.

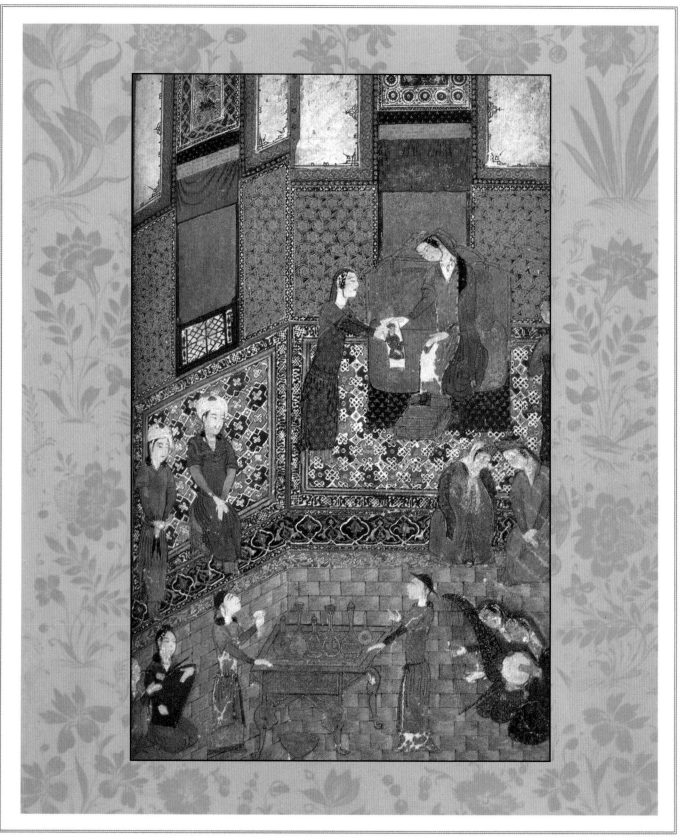

God Works for the Lazy

THERE WAS A MOTHER and her child and one night, when the child was suffering from nightmares, she told her that: *"If a ghost comes to you in the night, or if you see a dreadful and terrifying ghoul in a graveyard, full of nastiness and rage, keep a strong heart and rush at it, and immediately it will turn and run away."*

But the child wasn't convinced and replied: *"But suppose this frightening ghost has a mother that has told it the same thing, and if I rush at it, it might fall on me instead — what shall I do then? You teach me to stand my ground, but the ghost has a mother too."*

He who teaches all devils and humans
* is the One God,*
* Through Him the enemy prevails*
even if he is small.
* On whichever side that teacher is,*
* Be also on that same side.*
* "And if the other has already seen my trick,*
* How will I know his nature then?"*
* "Sit before him in silence,*
make patience your ladder
* That climbs toward the higher place,*
* His presence there will gush into your heart,*
* A speech past realms of joy and sorrow,*
* In that higher place, then listen in this space,*
* To the words from heart to heart.*
* Be sure, do nothing, God works for the lazy."*

From the Power of Truth

*T*ruth lifts the heart,
Like water refreshes thirst.

*O*ld news
makes headlines from passion.
 Old trees make new roots from passion.
 Old men wake up with passion.
 Don't sigh, don't yawn,
 Seek passion, passion, passion.

From the Story of the Three Princes

*T*he spirit advances
as the lover retreats.
 The shining, fresh-faced moon
eclipses with the cloaking sun.

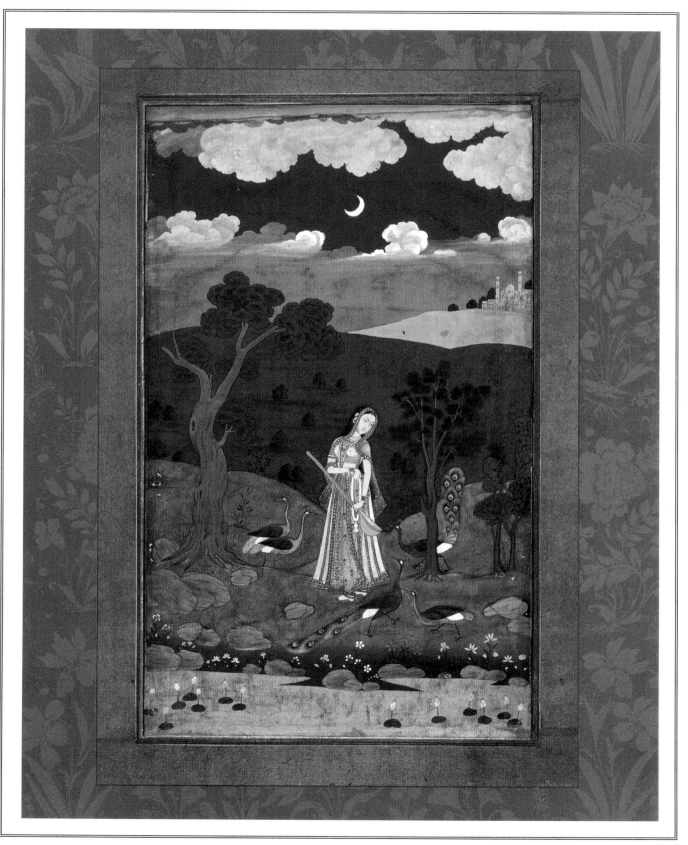

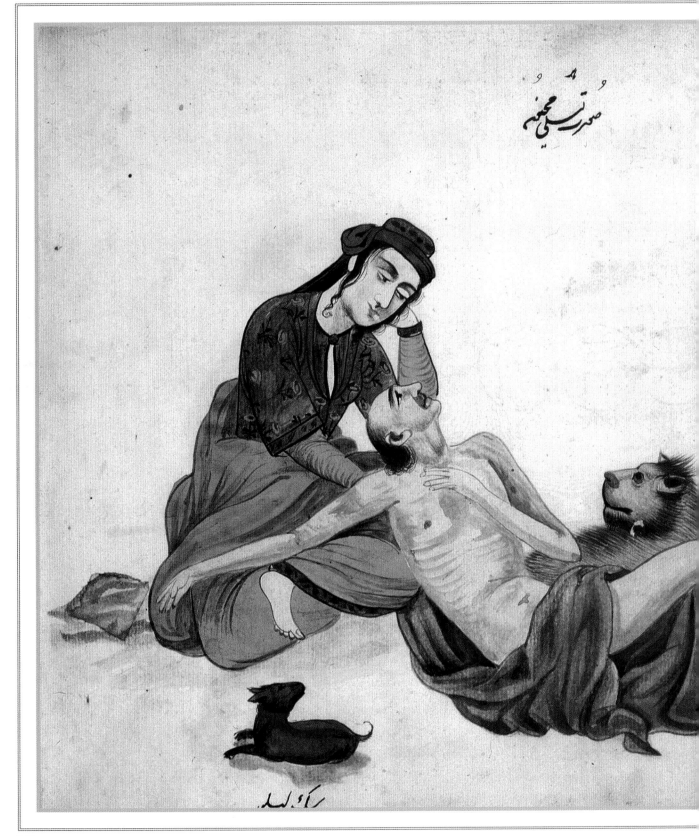

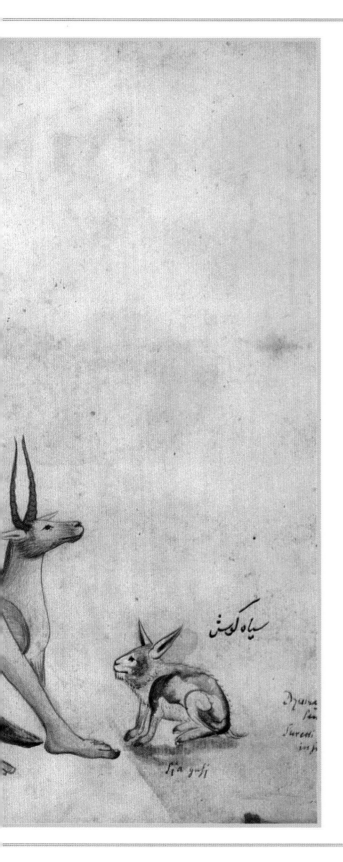

From the Ruba'iyat of Jalalu'ddin Rumi

FOLLY

*We make pathways in our lives
and follow blindly till death.*
 Pride lifts our heads,
blinding us to all but the stones we stumble upon,
 Till Fate brings us down with a sudden blow.

*The plundering moon
Came down to me last night:
"Be off with you, and soon,
"You're not welcome here tonight."*

*The departing moon cried back to me:
"Your crazy ways will make you sore,
Great fortune you'll not see,
Remains behind your door."*

*Wanting always something more,
Brings slavery alone.
Seeking Heaven outside your door,
Will turn your heart to stone.*

213

WINE

*D*eath gives birth
to the breath of Love,
 Its wine illuminating the darkness
where hearts unite.
 That same wine, blessed by faith,
 Shall never be slaked till death dawns again.

But this intoxication is not of crimson wine,
 For it is drunk in passion's glass.
 My friend, would you help me spill the nectar?
 A wine that moves my heart—not of this world.

LOVE AND LIFE

*I*f I die, take me to my lover,
There let me rest,
And should she kiss me once,
Don't be surprised if I live again.

*T*he source of life that never dies,
Is but a fraction of your grace.
The moon that lightens all the skies,
A pale reflection of your face.

*H*ow long
and dark the night can be,
 How bright the moon I long for.
 That night the tresses of your head,
 That moon the luster of your cheek.

ECSTATIC MOMENT

This is not spring but another season;
Behind each passionate eye, another harmony lies.

Though every branch of every tree is dancing now;
They dance from another root.

Your passion seemed to fire my soul,
Your sweetness drowned my heart.
But the burning turned to snow,
And the sweetness to vinegar.
Perhaps I dreamed and waken now.

When first the body clothed the soul,
The ocean swelled, divine.
When first the cup imbibed the heart,
It sang the blissful song.

Your footsteps made the earth delight,
Pregnant with mirth, she offered fair flowers to you.
And as all worlds sang songs of joy,
The moon alighted on a star.

Poems from the Mathnawi

REMEMBERED MUSIC

t's said,
the sounds that charm our ears
 Derive their melody from rolling spheres;
 But Faith surpasses the boundaries of doubt,
 And sees what sweetens everything.

When life began, its earliest times,
 We heard the angels sing.
 Our memory, though dull and sad, retains
 Some echo still of heaven.

Music is the meat of all who love,
 Music uplifts the soul to realms above.
 The ashes glow, the latent fires increase:
 We listen and are fed with joy and peace.

LOVE IN ABSENCE

*H*ow should I not mourn,
like night, without day
and the favor of illuminating countenance?
 His unsweetness is sweet to my soul:
my soul is sacrificed to the Beloved
who grieves my heart!
 I am in love with grief and pain
for the sake of pleasing my peerless King.
 Tears shed for His sake are pearls,
though they are thought to be tears.
 I complain of the Soul of my soul,
but in truth I am only telling.
 My heart says he torments it,
and I laugh at this poor pretence.
 Be fair at the threshold of your door!
 Where is fairness in reality?

A SLEEP AND A FORGETTING

One who has lived many years in a city,
as soon as he goes to sleep,
 Beholds another city full of good and evil,
and his own city vanishes from his mind.
 He does not say to himself,
"This is a new city: I am a stranger here";
 He thinks he has always lived in this city
and was born and bred in it.

 What wonder, then, if the soul does not remember
her ancient abode and birthplace?
 Since she is wrapped in the slumber of this world,
like a star covered by clouds?—
 Especially as she has trodden so many cities
and the dust that darkens her vision
is not yet swept away.

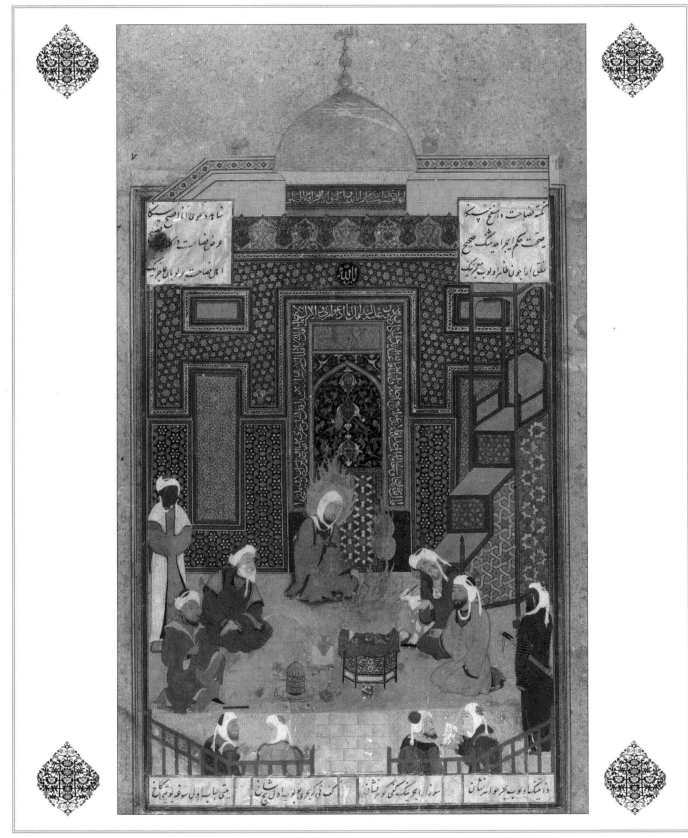

THE GRIEF OF THE DEAD

The Prince of mankind said truly
that no one who has passed away from this world
feels sorrow and regret for having died;
but he feels a hundred regrets
for having missed the opportunity,

Saying to himself, "Why did I not
make death my object—
death which is the store-house
of all fortunes and riches,

And why, through seeing double,
did I fasten my lifelong gaze upon those phantoms
that vanished at the fated hour?"

The grief of the dead is not on account of death;
it is because they dwelt on the phenomenal form
of existence and never perceived that all this foam is
moved and fed by the Sea.

When the Sea has cast the foam-flakes on the shore,
go to the graveyard and behold them!

Say to them,
"Where is your swirling onrush now?"
and hear them answer mutely,
"Ask this question of the Sea, not of us."

How should the foam fly without the wave?
How should the dust rise
to the zenith without the wind?

Since you have seen the dust, see the Wind;
since you have seen the foam,
see the Ocean of Creative energy.

Come, see it, for insight
is the only thing in you that avails:
the rest of you is a piece of fat and flesh,
a woof and warp of bones and sinews.

Dissolve your whole body into Vision:
become seeing, seeing, seeing!

One sight discerns but a yard or two of the road;
another surveys the temporal and spiritual worlds
and beholds the Face of their King.

THE UNREGENERATE

THE BURDEN OF EXISTENCE

*If any one were to say to the embryo in
the womb, "Outside is a world well-ordered,*

*A pleasant earth, broad and long,
wherein are a thousand delights
and many things to eat;*

*Mountains and seas and plains, fragrant orchards,
gardens and sown fields,*

*A sky very lofty and full of light, sunshine
and moonbeams and innumerable stars;*

*Its wonders are beyond description:
why do you stay, drinking blood,
in this dungeon of filth and pain?"*

*The embryo, being what it is,
would turn away in utter disbelief;
for the blind have no imagination.*

*So when the saints tell of a world without smell or
color,*

*None of the vulgar hearkens to them:
sensual desire is a barrier huge and stout—*

*Even as the embryo's craving for the blood
that nourishes it in its low abodes*

*Debarred it from the perception
of the external world,
since it knows no food but blood.*

*From You first came this ebb and flow
from within me; else, O Glorious One,
my sea was still.*

*Now, from the same source
from which You brought this trouble on me,
graciously send me comfort!*

*You Whose affliction makes men weak as women,
show me the one path, do not let me follow ten!*

*I am like a jaded camel:
the saddle of free will has sorely bruised my back*

*With its heavy panniers
sagging from this side to that in turn.*

*Let the ill-balanced load drop from me,
so that I may browse in the Meadow of Your Bounty.*

*Hundreds of thousands of years
I was flying to and fro involuntarily,
like a mote in the air.*

*If I have forgotten that time and state,
yet the migration in sleep recalls it to my memory.*

*At night I escape from this four-branched cross
into the spacious pastures of the spirit.*

*From the nurse, Sleep, I suck the milk
of those bygone days of mine, O Lord.*

All mortals are fleeing from their free will

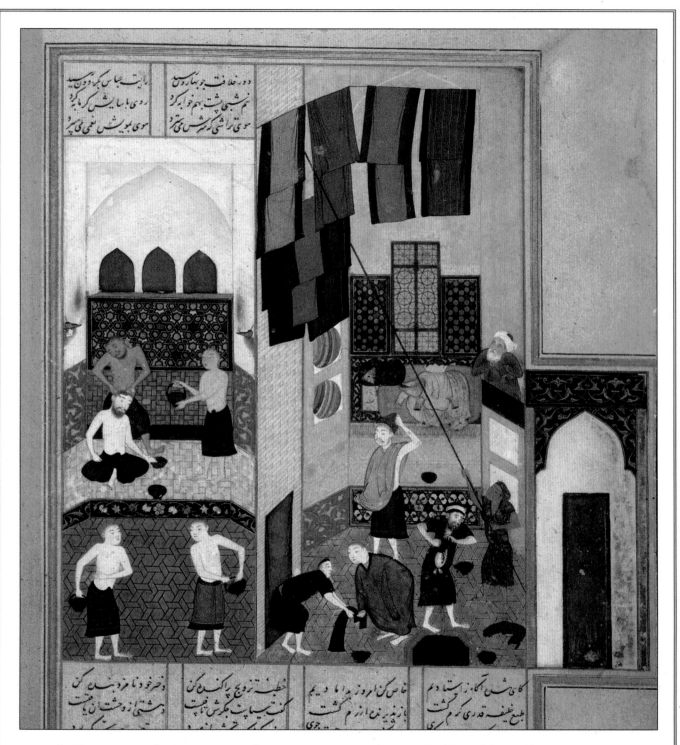

and self-existence to their unconscious selves.

They lay upon themselves the opprobrium of wine
and minstrelsy in order that for a while

they may be delivered from self-consciousness.

All know that this existence is a snare,
that will and thought and memory are a hell.

THE SPIRIT OF THE SAINTS

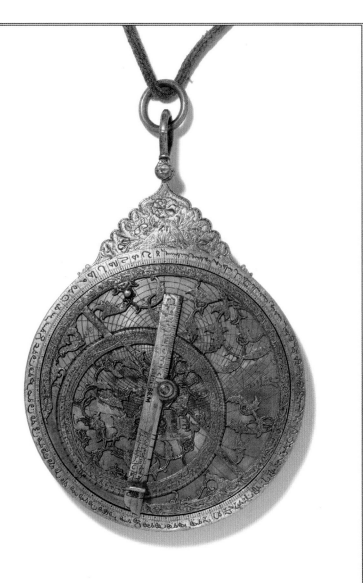

*T*here is a Water
that flows from Heaven
 To cleanse the world of sin
by grace Divine.
 At last, its whole stock spent,
its virtue gone,
 Dark with pollution not its own,
it speeds
 Back to the Fountain of all purities;
 From which, freshly bathed,
earthward it sweeps again,
 Trailing a robe of glory
bright and pure.

This Water is the spirit of the Saints,
 Which ever sheds,
until itself is beggared,
 God's balm on the sick soul;
and then returns
 To Him
who made the purest light of Heaven.

THE CHILDREN OF LIGHT

*B*eyond the stars are Stars
in which there is neither combust nor sinister aspect,
 Stars moving in other Heavens,
not the seven heavens known to all,
 Stars immanent in the radiance of the light of God,
neither joined to each other nor separate.
 Whoever has fortune from these Stars,
his soul drives off and consumes the unbelievers.
 God sprinkled His Light over all spirits,
but only the blest held up their skirts to receive it;
 And, having gained that largesse of light,
they turned their faces away from all but God.
 That which is of the sea is going to the sea:
it is going to the place from where it came—
 From the mountain the swift-rushing torrent,
and from our body the soul
whose motion is inspired by love.

LOVE THE HIEROPHANT

*I*t's heart-ache
lays the lover's passion bare:
 No sickness with heart-sickness may compare.
 Love is a malady apart, the sign
 And astrolabe of mysteries Divine.
 Whether of heavenly mould or earthly cast,
 Love still leads us Yonder at the last.
 Reason, explaining Love, can do nothing but flounder
 Like ass in mire: Love is Love's own expounder.
 Does not the sun himself the sun declare?
 Behold him! All the proof you seek is there.

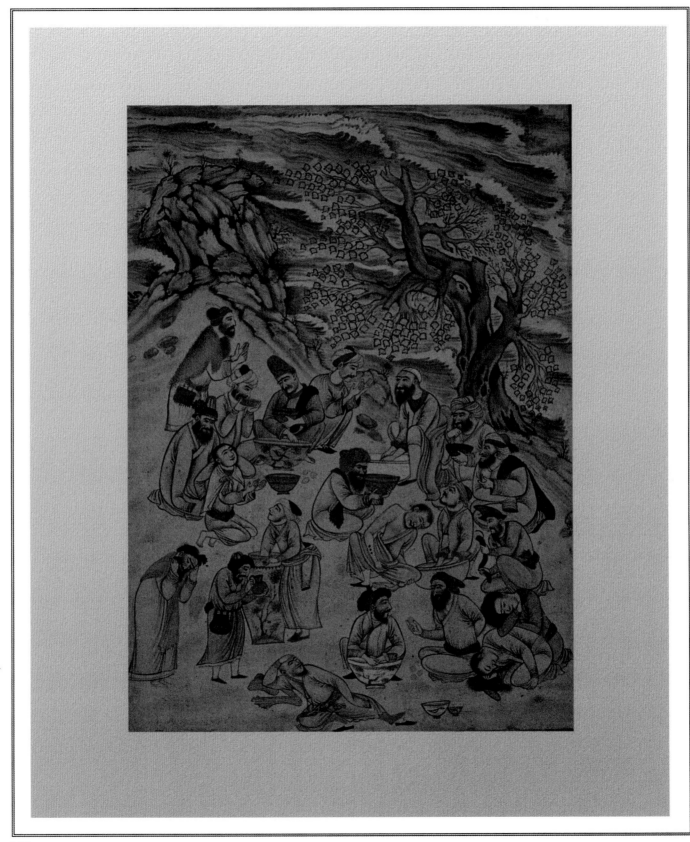

THE TRUTH WITHIN US

T was a fair orchard,
full of trees and fruit
 And vines and greenery. A Sufi there
 Sat with eyes closed, his head upon his knee,
 Sunk deep in meditation mystical.
 "Why," asked another, "do you not behold
 These signs of God the Merciful displayed
 Around you, which He bids us contemplate?"
 "The signs," he answered, "I behold within;
 Without is nothing but symbols of the Signs."

What is beauty in the world? The image,
 Like quivering boughs reflected in a stream,
 Of that eternal Orchard which abides
 Unwithered in the hearts of Perfect Men.

MYSTICS KNOW

S ince Wisdom
is the true believer's stray camel,
he knows it with certainty,
from whomsoever he may have heard of it,
 And when he finds himself face to face with it,
how should there be doubt? How can he mistake?
 If you tell a thirsty man
"Here is a cup of water: drink!" —
 Will he reply "This is a mere assertion:
let me alone, O liar, go away."
 Or suppose a mother cries to her babe,
"Come, I am mother: hark my child!" —
 Will it say? "Prove this to me,
so that I may take comfort in milk?"
 When in the heart of a people
there is spiritual perception,
the face and voice of the prophet
are as an evidentiary miracle.
 When the prophet utters a cry from without,
the soul of the people falls to worship within,
 Because never in the world will the soul's ear
have heard a cry of the same kind as his.
 That wondrous voice is heard by the soul in exile
—the voice of God calling, "I am near."

ASLEEP TO THE WORLD

*E*very night You free our spirits
from the body's snare and erase all impressions
on the tablets of memory.

Our spirits are set free every night from this cage,
they are done with audience and talk and tale.

At night prisoners forget their prison,
at night governors forget their power.

There is no sorrow, no thought of gain or loss,
no idea of this person or that person.

Such is the state of the mystic,
even when he is not asleep:
God says, "You imagine them awake
while they slept."

He is asleep, day and night,
to the affairs of this world,
like a pen in the hand of the Lord.

God has shown forth some part of his state,
inasmuch as the vulgar too
are carried away by sleep:

Their spirits gone into the Wilderness
that is beyond words, their souls and bodies at rest.

Till with a whistle You call them back to the snare,
bring them all again to justice and judgment.

At daybreak, like Israfil,
He bids them return from yonder
to the world of form:

The disembodied spirits He confines anew
and causes each body to be laden
with its good and evil works.

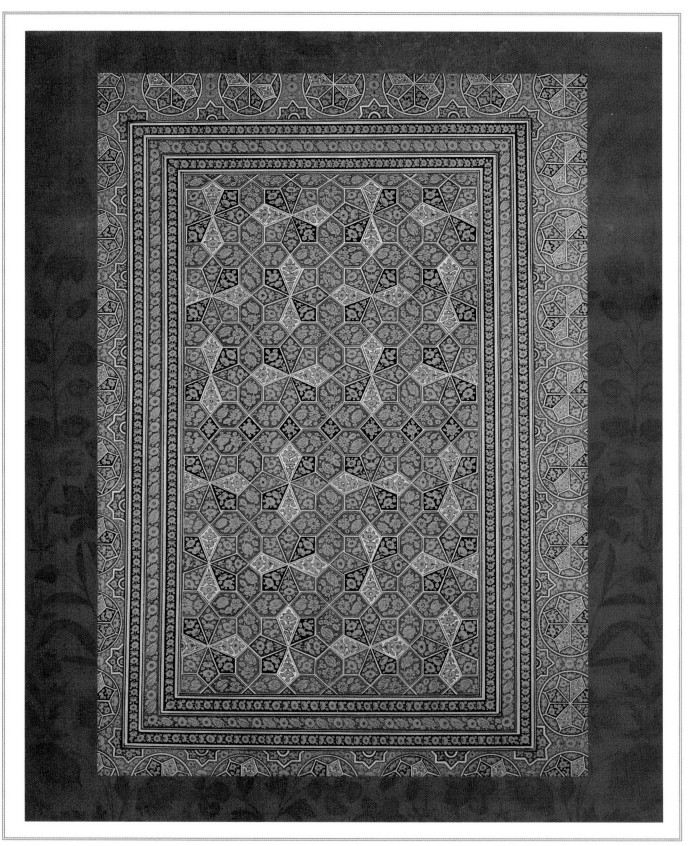

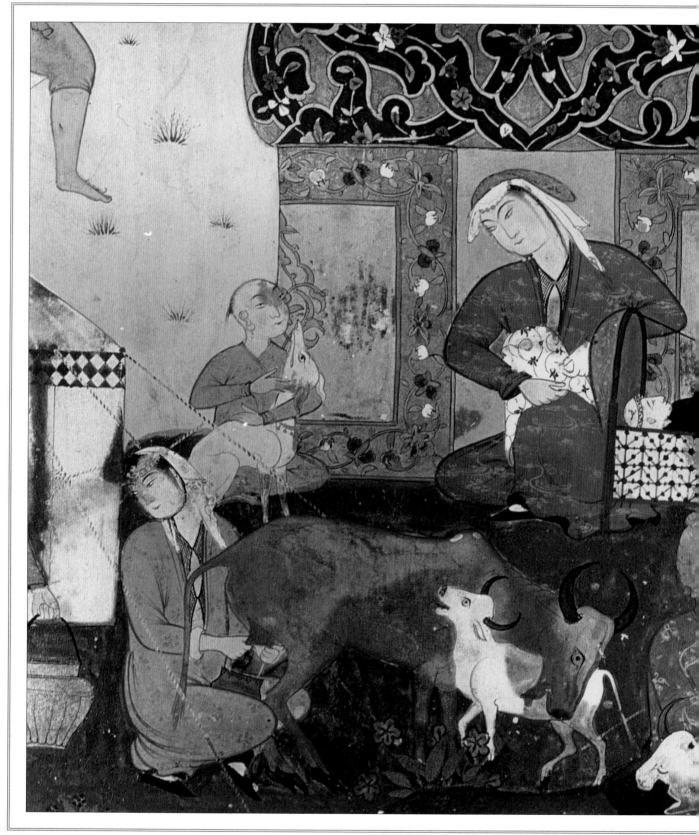

THE FAITHFUL ARE ONE SOUL

T*he Faithful are many,
but their Faith is one; their bodies are numerous,
but their soul is one.*

*Besides the understanding and soul
that is in the ox and the mule,
Man has another intelligence and soul.*

*Again, in the owner of the Divine breath,
there is a soul other than the human soul.*

*The animal soul does not possess oneness:
do not seek oneness from that airy spirit.*

*If its owner eats bread, his neighbor is not filled;
if he bear a load, his neighbor does not become laden;*

*But he rejoices at his neighbor's death
and dies of envy when he sees his neighbor prosperous.*

*The souls of wolves and dogs are separate;
the souls of the Lions of god are united.*

*I speak nominally of their souls in the plural,
for that single Soul
is a hundred in relation to the body,*

*Just as the single light of the sun in heaven
is a hundred in relation to the house-courts
on which it shines;*

*But when you remove the walls,
all these scattered lights are one and the same.*

*When the bodily houses
have no foundation remaining,
the Faithful remain one soul.*

THE LADDER TO HEAVEN

*The worldly sense
is the ladder to this world;
the religious sense is the ladder to Heaven.*

*Seek the well being of that sense from the physician;
beg the well being of this sense
from the man beloved of God.*

*The spiritual way ruins the body and,
having ruined it, restores it to prosperity;*

*Ruins the house
for the sake of the golden treasure,
and with that same treasure
builds it better than before;*

*Cut off the water and cleanse the river-bed,
then cause drinking-water to flow in it;*

*Cut the skin and draw out the barb,
then make fresh skin grow over the wound;*

*Raze the fortress and take it from the infidel,
then rear a hundred towers and ramparts.*

*Sometimes the action of God appears like this,
sometimes the contrary:
true religion is nothing but bewilderment.*

*I mean not one bewildered
in such wise that his back is turned on Him;
but one bewildered and drowned and drunken
with the Beloved.*

*His face is set toward the Beloved,
while the other's face is just his own.*

*Look long on the face of everyone,
watch attentively: it may be that by doing service
you will come to know the face of the Saint.*

*Since many a devil has the face of Adam,
you should not put a hand in every hand;*

*For as the fowler whistles
to decoy a bird he is bent on catching,*

*Which hears the note of its mate
and comes down from the air
and finds itself entrapped,*

*So does a vile man steal
the language of dervishes
to fascinate and deceive one who is simple.*

*The work of holy men is as light and heat;
the work of the ungodly is trickery and shamelessness.*

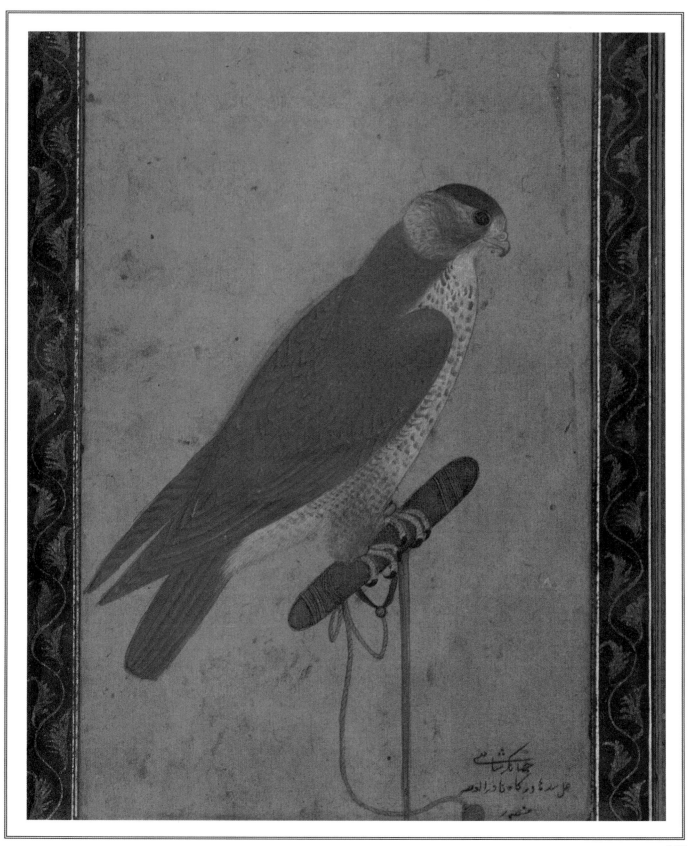

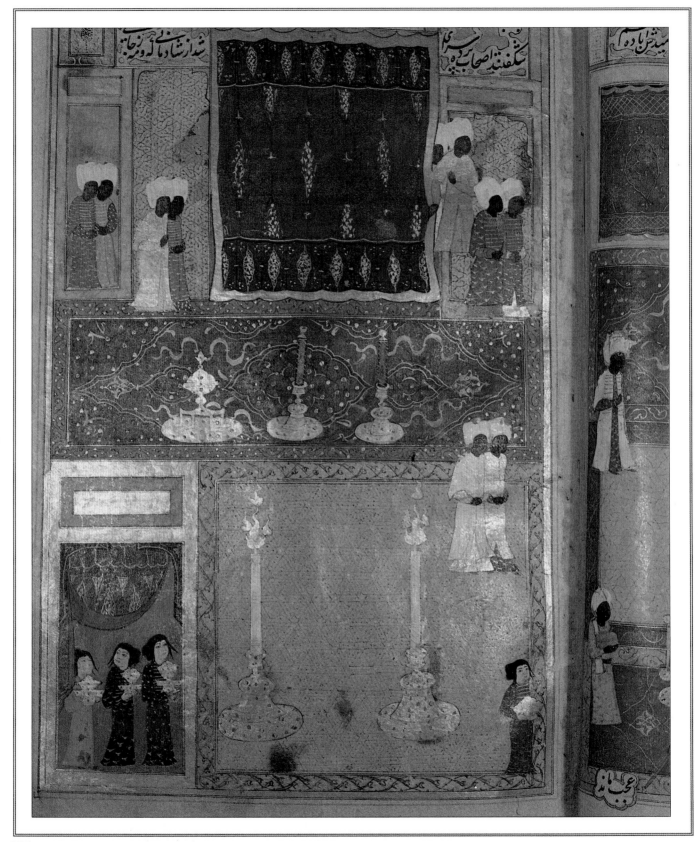

THE MAN WHO LOOKED
BACK ON HIS WAY TO HELL

he guardian angels,
who used to walk unseen before and behind him,
have now become visible like policemen.

They drag him along,
prodding him with goads and crying,
"Be gone, O dog, to your kennel!"

He looks back toward the Holy Presence:
his tears fall like autumn rain.
A mere hope—what has he but that?

Then from God in the realm of Light
comes the command Say you to him:
"O ne'er-do-well destitute of merit,

You have seen the black scroll of your misdeeds.
What do you expect?
Why are you tarrying in vain?"

He answers: "Lord, You know
I am a hundred hundred times worse
than You have declared;

But beyond my exertion and action,
beyond good and evil and faith and infidelity,

Beyond living righteously
or behaving disobediently—I had a great hope
of Your Loving-kindness.

I turn again to that pure Grace,

I am not regarding my own works.

You gave me my being as a robe of honor:
I have always relied on that munificence."

When he confesses his sins, God says to the Angels,
"Bring him back, for he never lost hope of Me.

Like one who thinks of nothing,
I will deliver him and cancel all his trespasses.

I will kindle such a fire of Grace
that the least spark
consumes all sin and necessity and free will.

I will set fire to the tenement of Man
and make its thorns a bower of roses."

From the Divani Shamsi Tabriz

Carry the bier
when I die, and forget about my heart,
 For it's gone from this world.
 Never cry for me,
for this is the Devil's work.
 Don't follow my hearse with your eyes or heart,
 For union and meeting are mine in this hour.
 When you watch my coffin disappear,
forget your goodbyes to me,
 The grave simply hides Paradise.
 Don't look down; look up,
 at the sun and moon, who set in joy for me.

The buried seed is growing,
why doubt this growth, the seed of man?
 Lower a bucket and it comes up full,
 Who complains at the well?
 Be quiet on one side of death, wake up on the other.
 Your sounds will be heard in the airless air.
 The moon appears at dawn above the waves,
 Gazing upon me.
Then, like a falcon taking a bird in flight,
 It takes me instead and flies away.

Looking up I could see
 myself no more,
 My body gently eased
 into the moon.
 By God's revelation.
Nine spheres of Heaven were in the moon;
And the sea washed over me still,
Its waves washing over my soul.
And the voice of wisdom told me,
As above, so below.

On the foam of the ocean a form appeared,
 Rising and falling, rising and falling.
 On the foam of my body came a sign,
 Melting me, and transforming me within,
 Missing the power of Shams of Tabriz,
 Who held the moon, and now is pure fantasy.

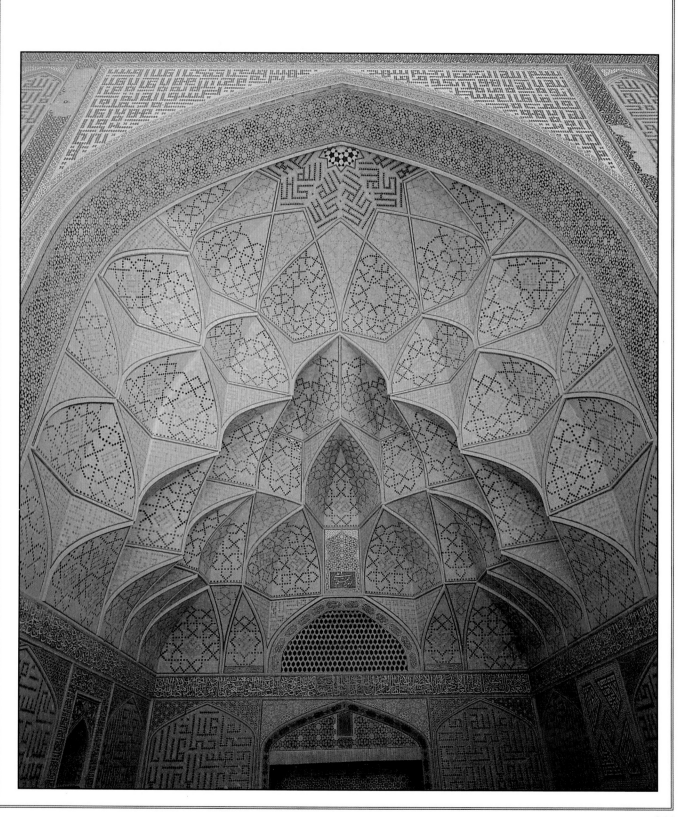

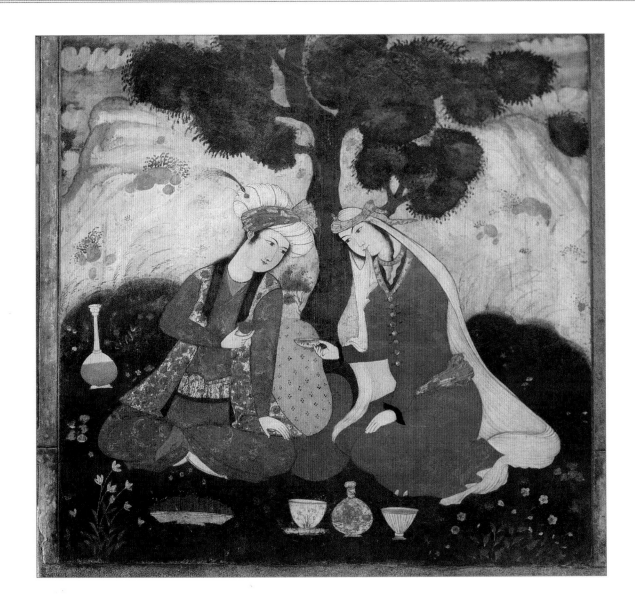

*B*y seeking the Lover's Love,
you must cut your throat with a blade.

Knowing too much hinders knowing at all;
and thought brings no comprehension.

Does the crazy man show how he's crazy?
Does the Wild Man show his reason?

No, he rends his clothes and climbs mountains,
drinks venom and chooses death.

As the spider tangles the victim,
so God will have us in his web.

In Laila's face reflecting true Love,
where is the Wild Man we knew?

Take off your clothes and plunge into the sea,
Take the drunkenness of Love as waves
that rise and fall,
And rock in the arms of all lovers,
A rock too and a slave to them all,
and they to you.
As the earth is slave to the sky,
as the spirit enslaves the body,
The earth is not lost in this binding of love,
nor the limbs by the sweetness of the heart.

Don't beat a drum beneath a blanket,
be brave and make yourself plain in view.
Let your soul listen to the sounds
that echo like a lover's lament.
So your breast is bursting your shirt wide open,
caused by the madness of love.
Heaven's victory, Orion's delight,
everyone is troubled by love.
Yet its purity shines like the sun,
killing night, all suffering chased by joy.
Leaving us still, Wild Man,
whose face the universe adores.

What house is this, master,
where the violin is always playing,
Is it a treasure trove too big for the sky?
Or acting and pretense, both roof and owner.
Don't enter the sanctuary through these doors,
Don't speak with the master for he drinks all day.
The garbage is musk and scent,

the roof and door are poetry and song.
But if you find your way in,
you are sultan and king of your time.
So bend your head low at the door,
for I see good fortune for you.
The sight of your face
is enough to discard earth's kingdom,
For even the garden is tangled,
knowing not leaf from bud,
Nor can the birds tell snare from bait.
Such is our Lord's design for the planets,
The house of Love deprived of gravity.

Your heart is mirrored in your soul,
the curls of your hair combed deep.
All who enter the house are drunk,
ignorant even of their names.
So don't lie at the door, come in,
or sit in the dark outside.
Be drunk with us in God, not lust,
or there you'll drink alone.
No fear in the forest of lion's fury,
a figment of your imagination.
But fire up the forest from silence,
hold your tongue and speak not.

*M*y pictures are nothing,
and melted away,
though I shape them at every moment.
 Imbuing my phantoms with spirits,
they vanish in sight of your ghost.
 Tell me, are you the cupbearer
or do you take the cup from my sober lips?
 Perhaps you are both,
the builder of all that I build.
 You soak up my soul and mingle me,
your perfume is fragrant therein.
 Each drop of my blood cries out to the earth,
we are partners, blended as one.
 Alone, so alone my heart becomes,
please enter my house or I'll go from here.

A soul not cloaked with inner love
is cold from shame.
 Be warmed with love, for only love exists.
 Where is intimacy except in giving and receiving?

*D*rain out your desire
till the cup carries grace,
 There is no one there looking back.
 Look only here.

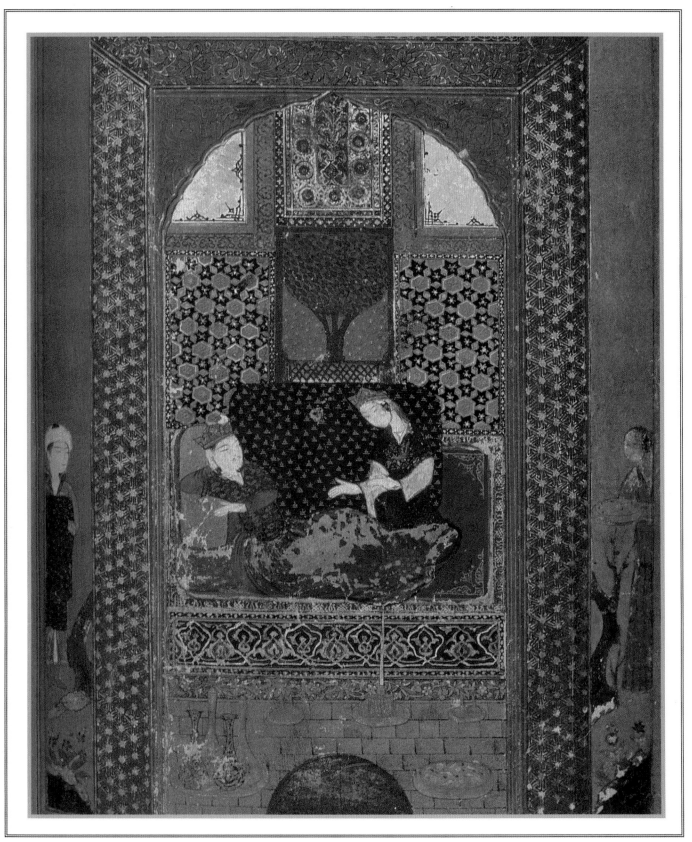

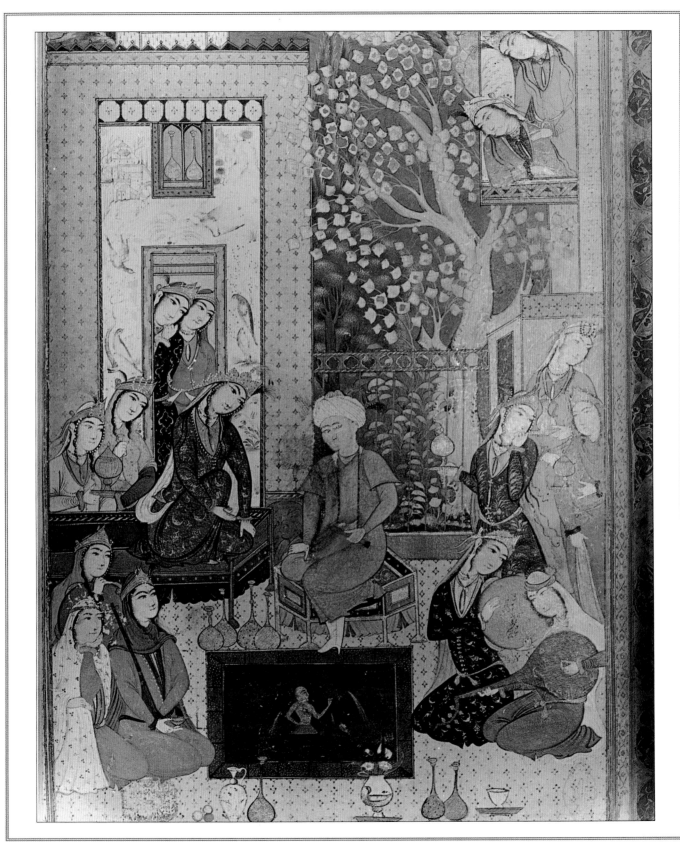

*W*orry not from a clear heart,
Like the polished glass of innocence.
The innocent mirror contains all, unashamed.
For this clarity, see yourself shamelessly.
This is truth.
As a glass shines bright with polish,
So the heart's mirror will shine,
the deeper you look.
 Between the glass and the heart
there are only secrets.

*I*n your face,
fraud and fantasy reflected.
 In the garden of your expressions,
 your eyes, lies bewilderment,
 Are there thorns or blossoms
in the nature of the world?
 Your darting flight,
does it find refreshment or traps?

*T*he garden of the world has no limits
except in your mind.
 Its presence is more beautiful than the stars,
 With more clarity
than the polished mirror of your heart.

*W*ho's there?
Thy humble slave.
Why?
To find you.
How long will you insist?
Until you accept.
How long will you stay?
Until I am enlightened.

In this way I insisted on love.
And gave up all independence.
Show me reason for this,
See my tears, my pale sadness.
This is not true, your eye is corrupt.
I answered my innocence.
What is your desire?
Constant friendship.
But what should I provide?
Universal grace.

Where was your support in this?
The thought of you,
Whose call came to you?
The smell of your holiness.
But where is the joy?

In the palace of heaven.
And what did you see?'
Millions of miracles.
So why the desolation?
Fear of the end.
And what is the end?
Guilt and blame.

And where does the fear end?
In abstinence and piety.
And what are these?
The path to salvation.
And where is disaster?
In the neighborhood of Love.
And how do you live there?
In steadfastness.

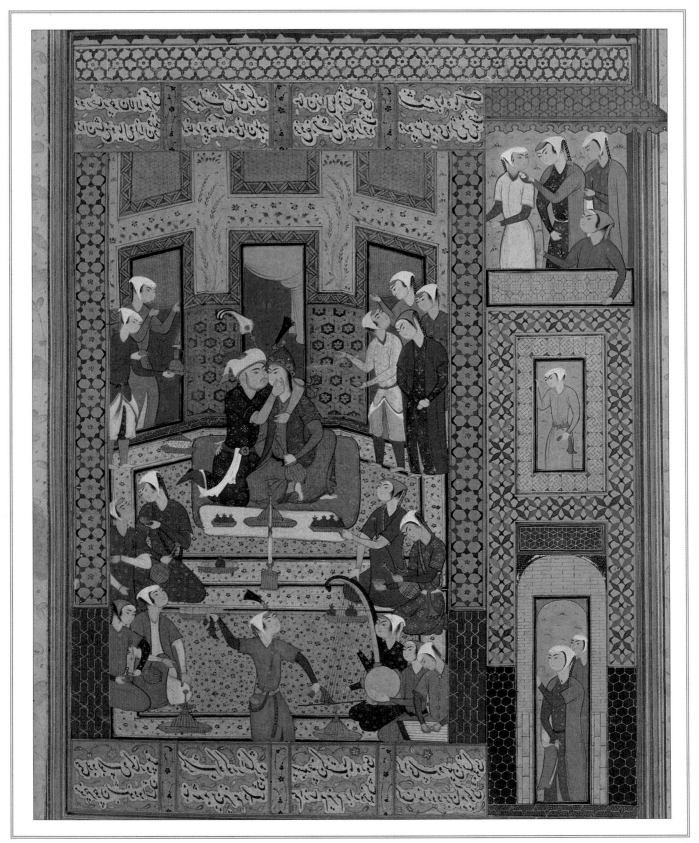

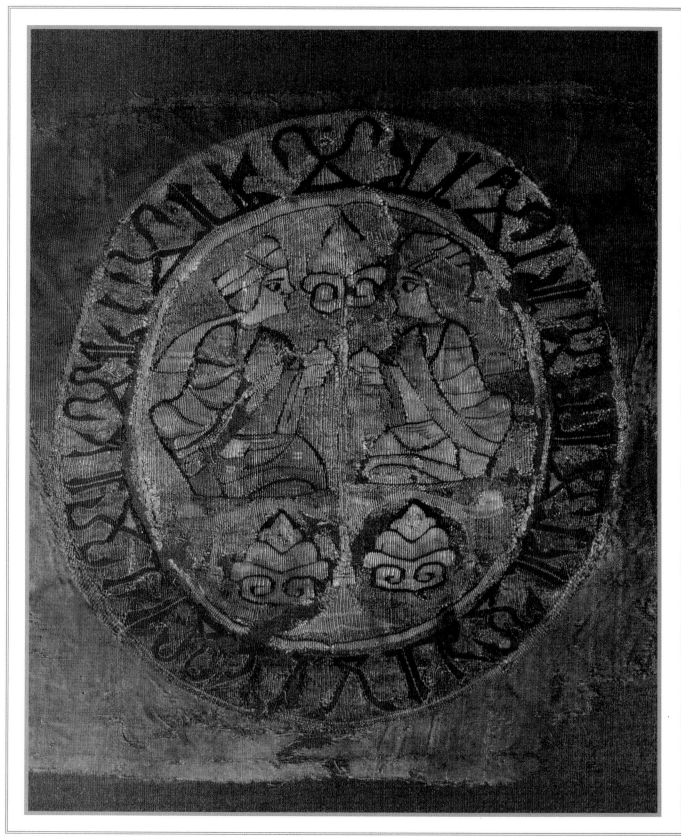

Master Sana'i is dead.

Don't think it insignificant.

He wasn't chaff in the wind,

Nor water frozen in winter.

He wasn't a comb in ruffled hair,

Nor was he crushed soil.

But a treasure of gold in dust

Who valued the world as barley-corn.

The earthly flame he flung to earth,

Soul and intellect he carried to Heaven.

That pure elixir mingled with the dregs of wine

Rose to the surface, the sediment settled.

Unknown soul surrendered to the Beloved.

Yet each man eventually returns home;

How is satin matched with wool?

Remain silent like a compass points; your name

The King has erased from the book of speech.

There was no favor

that his beauty did not bring.

It's not our fault his gifts to you were unrewarding.

You're abused and terrored by charm;

But don't the fair act the tyrant?

His love is like sugar, though he gave no sweetness;

His beauty is perfect faith

though he was unfaithful.

What home was not lit with his lamps?

What entrance is not filled with his beauty?

When the spirit was lost in meditation

didn't it say:

'Only God has faced the beauty of God.'

This eye and that lamp are singular lights;

No one could tell them from one another.

Each metaphor shows and tells;

By morning light splendor God reveals,

By the expression of light on his face.

Never did Destiny, the tailor, stitch a shirt

To anyone's measure. He tore it in pieces.

Shems' sunny face, O glory of all horizons!

When it shone on the empty it made them eternal.

*W*hat do we do
when we don't see ourselves?
 Not Christian, Jew, Magian or Moslem.
 Not East nor West, nor land or sea;
 Not Nature, nor the stars in Heaven.
 Not earth, water, air.

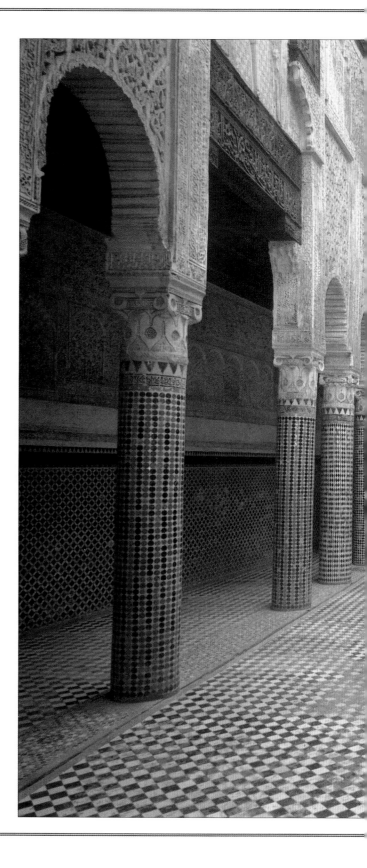

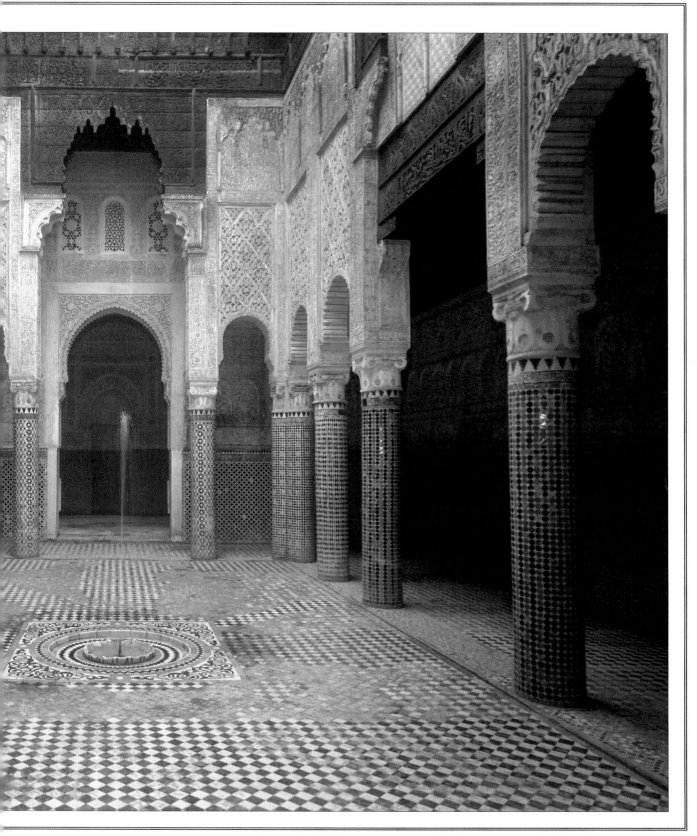

Suggested Further Reading

The Essential Rumi – Translations by Coleman Barks with John Moyne, A.J. Arberry, Reynold A. Nicholson. Published by HarperSanFrancisco, a division of HarperCollinsPublishers, 1995.

Mystical Dimensions of Islam – Annemarie Schimmel. Published by The University of North Carolina Press, 1975.

Rumi Daylight, A Daybook of Spiritual Guidance. Three Hundred and Sixty-Five Selections from Jalaluddin Rumi's Mathnawi. Translated by Camille and Kabir Helminski. Published by Threshold Books, 1994.

Signs of the Unseen - The Discourses of Jalalu'ddin Rumi. Introduction and Translation by W.M.Thackston, Jr. Published by Threshold Books, 1994.

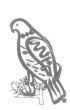

Bibliography

Masnavi – Mavlana Calal-ad-Din Rumi – Publication of the Ministry of Culture/1667, Directorate of Publications – Turkish Classical Series, 1993.

The Mathnawi of Jalalu'ddin Rumi – Volumes 1 – 6, edited and translated by Reynold A. Nicholson Litt.D., LL.D., F.B.A., from the oldest manuscripts available: with critical notes, translation, and commentary. Published and distributed by The Trustees of The "E.J.W.Gibb Memorial," 1925.

The Rubaiyat of Jalalu'ddin Rumi Translated by A.J. Arberry. Published by Emery Walker, 1949.

Picture Acknowledgments

Front cover , Corbis: Two Sufis. Backcover, British Library: Sufis in ecstasy

British Museum, London: 1, 19, 154 Angel Gabriel, 13 Rumi portrait, 69 Seated dervish, 79 Seated dervish, 85 Birds and flowers, 91 Jackal, 119, 121 Dancing Dervishes, 203 Mulla expounding in mosque, 212 Layla tending Majnun, 222 Tughra and script, 230 Dervishes on mountain with tree, 237 Falcon.

Robert Harding: 6 Isfahan Mosque, 3 Falcon, 10, 11 Dervishes on stage, 8 Illustrated Manuscript, 51 Harper and listener, 75 Man bowing, 82 Embroidery, 116 Birdcatchers, 152/3 Media Mosque, 160, 161 Ram, 165 Shrine of Iman Reza, Iran , 169 Script for Sultan, 185 Islamic poets, 224 Mohammed & companions, 233 Cover of Koran, 240 Falcons. Detail, 241 Friday Mosque arch.

Corbis:17 Two Sufis, 14 Rumi mausoleum, 104, 123 Composite camel, 208 Clocks at mosque, 229 Astrolabe, 242 Couple in Garden

Victoria & Albert Museum, London: 20/21 carpet, 30 Girl with parrot, 70 Court scene, 71 Courtscene detail, 76, 77, 80, 81, 84 Mss, 88/9 Carpet, 94 Elephant, 120 Topiary tiles, 123 Illustrated Mss, 127 Carpet, 128 Tiles, 130 Black buck, 143 Lion and jackal , 162 Dervish holding leaf, 181 Mss, 198 Calligraphic horse, 228 Astrolabe.

Axiom: 22 Water wheel, 64 Sweet stall, 87 Tree, 102 Camel train, 115 Camel.

British Library: 2, 18, 19 Angel, 24 Handmaid, 25 Woman, 34 Lion & tree, 36 Hares, 37 Hares eating berries, 44, 54, 125 tree, 45 Lion, 47 Hare, 52 Musicians, 56 Woman reclining, 62/3Dervish teacher, 66 Preparation of sweets, 75 Book page, 97 Girl writing, 108 Layla repels husband, 110 Couple on a swing, 134 Bahrum Gur and Russian Princess, 137 Angels pay homage to Adam , 140, 141, 157, 158 Nishkander with Nushabeh, 147 Raven addressing assembled animals, 156 Marriage, 166 Woman and moon, 174 Rudaba lets down her hair, 177 Bazaar of the silk merchants, 182 School, 186 Preparation of a banquet, 190, 191 Gazel, 193 Aurangzeb on horse, 194 Garden meeting, 200 Garden scene, 04 Couple listening to musicians, 206 Tree, 207 Princess accepts portrait, 210 Lion, 211 Woman and moon and peacocks, 227 Rashid at barber, 245 People in pavilion, 249 Zal & Rudaba

Werner Forman Archives: 26 pharmacist, 29 couple in garden, 33 A lion, leopard, wolf, jackal and bear, 34 Lion & tree, 39 Stone lions attaching gazelles, 40 Lion and ass, 42 Hare, 43 A bottle with hares, 46 Lion and ass, 55 Casket with harpist, 59 Door knocker, 60/61 Man in bed & dog, 90 Peacock Mss, 98 Dioscoride, 105 Alhambra, 107 Bazaar, 112/3 Koran, 114 Mosque, Baghdad, 131 Bowl with gazelle, 133 Clock, 138 Preparation of food, 144 Lion and jackal, 148 Flask, 150 Fight on horseback, 151 Cats fighting, 155 Lovers and birds, 163 Lion, leopard, wolf, jackal and bear, 170 Saffron, 189 Tile of Medina, 196 Cavalcade, 218 Adam and Eve, 215 Youth with cup and flask, 216 Poets, 220 Kufic script, 234 Women, 238 Evening reception, 246 Couple at feast, 250 Silk hanging, 252 Madrasa.

The Art Archive: 48 Paradise, 93 Giant reptile, 106 Merchants, 172, 173 Dervishes, 178 Fabric merchant.